LOOKING HIGH AND LOW

LOOKING HIGH AND LOW

ART AND CULTURAL IDENTITY

Edited by Brenda Jo Bright and Liza Bakewell

The University of Arizona Press Tucson

The University of Arizona Press
Copyright © 1995
Arizona Board of Regents
All rights reserved

⊗ This book is printed on acid-free, archival-quality paper.
Manufactured in the United States of America

00 99 98 97 96 95 6 5 4 3 2 1

Library of Congress Cataloging-in-Publication Data

Looking high and low : art and cultural identity / edited by Brenda Jo
Bright and Liza Bakewell.
p. cm.
Includes bibliographical references and index.
ISBN 0-8165-1311-2. — ISBN 0-8165-1516-6 (pbk.)
1. Arts and society—United States. 2. Popular culture—United
States. I. Bright, Brenda Jo, 1955–. II. Bakewell, Liza.
NX180.S6L66 1995
700'.1'030973—dc20 94-48508
CIP

British Library Cataloguing-in-Publication Data
A catalogue record for this book is available from the British Library

CONTENTS

ACKNOWLEDGMENTS

In addition to the editors and the staff of the University of Arizona Press, several other individuals and organizations facilitated the preparation of this volume. Brenda Jo Bright's efforts were sustained in part by the Luce/American Council of Learned Societies Dissertation Fellowship in American Art, and Liza Bakewell's by a grant from the Fulbright Program and the National Science Foundation. The staffs of the Departments of Anthropology at Brown University and Mount Holyoke College provided assistance. Sarah Noble provided important editorial services. Five Colleges, Incorporated, provided a grant for reproducing some of the photographs that appear in the volume. Our thanks to them all.

LOOKING HIGH AND LOW

1 INTRODUCTION

ART HIERARCHIES, CULTURAL BOUNDARIES, AND REFLEXIVE ANALYSIS

BRENDA JO BRIGHT

And so the anger, the pride and self-healing had to come out as Chicano art—an art that was criticized by the faculty and white students as being too political, not universal, not hard edge, not pop art, not abstract, not avant-garde, too figurative, too colorful, too folksy, too primitive, blah, blah, blah!
—Carmen Lomas Garza, *Pedacito de mi corazón* (A little piece of my heart)

In recounting the connection of her artwork to her cultural heritage, and the work's identity as Chicano art, Lomas Garza cites the above series of critical distinctions made against her work in an institutional setting—in this case, a university art department.[1] Attending art

school in South Texas 120 miles from the Mexican border, Lomas Garza learned about European, Egyptian, Greek, and Roman art and mythology, but not about the Aztec, Pre-Columbian, and Mexican traditions of her own heritage. The criticisms of Lomas Garza's work, while symptomatic of distinctions made by art institutions, scholars, and critics about the markers and functions of "high" art, are part of an "art culture system" that perpetuates domination and subjugates difference. The criticisms indicate de facto the styles, forms of representation, and social critique considered conventionally appropriate to high art practices. These conventional distinctions, in the name of universal "humanistic" standards, perpetuate limited definitions of high art and provide the grounds for discounting and disregarding other art forms.

In contrast, Lomas Garza argues for understanding the contextual relevance of art practices and their historical and cultural necessity. In her own work, she re-members Chicano communities through the use of memories of significant events in her life. She uses memory to heal and transform Chicano culture while simultaneously blocking its historical erasure. Her detailed images are personal, everyday, rural, and regional. As the epigraph indicates, in some circuits Lomas Garza's work is discounted as "low," as a form of genre painting that is too figurative, too colorful, too folksy, too primitive.

As an artist, Lomas Garza works to create a public presence for Chicano culture. Her paintings work against the erasure of images of everyday events in the lives of Mexican Americans, an erasure that is often accompanied by media-produced images of Mexican Americans as illegal immigrants, as marginalized poor, and as criminals. Over the years, Chicano artists have insisted that the institutional boundaries that exist for Chicano art are integral parts of a system of racial and economic stratification. In one well-known example, in late 1972 artists Gronk, Willie Herrón, and Harry Gamboa spray-painted their signatures onto all of the entrances to the Los Angeles County Museum of Art "in reaction to a negative response of a museum curator to their query about the possibility of including Chicano art in museum exhibitions" (Griswold del Castillo et al. 1991:125).[2] And while, as of 1989, Gronk has been exhibited *inside* the Los Angeles County Museum of Art, institutional boundaries remain nonetheless salient.

In its challenge to dominant treatments of Chicano culture as invisible/criminal/exotic, Lomas Garza's is part of an exciting and growing body of work on the part of artists, scholars, curators, and critics

who are engaged in challenging the ways art categories are related to cultural boundaries and expanding our notions about the "legibility" of art. This work entails examining the processes, contexts, and politics of artistic production and display. In the United States, artists of color have long been producing art that interrogates the presence of boundaries and exclusions. Since the late 1980s, performance artist Guillermo Gómez-Peña's performances and writings have dramatically detailed the presence of borders and their disorienting and limiting effects on people (Gómez-Peña 1992). Anna Devere Smith brings together in her one-woman performances the voices and perspectives of people who witness events, such as the Los Angeles uprising, that have proven to be dramatically divisive in public life. In popular culture, rap artists work similar terrain (Rose 1994). In the words of Tricia Rose, "More often than not, rap lyrics articulate a wide range of ideas about contemporary life in urban America, usually rearticulating already existing ideas about Black identity, community, and class and gender fictions which lie just beneath the surface" (1992:227).

In the realms of art and art scholarship, scholars have engaged in projects to document the processes at work in America's multicultural and multinational reality (Lippard 1990). Museum workers, scholars, and critics have begun interrogating the presentation and interpretation of cultural diversity in museums. Two books, *Exhibiting Cultures: The Poetics and Politics of Museum Display* (Karp and Lavine 1991) and *Museums and Communities: The Politics of Public Culture* (Karp et al. 1992) elegantly detail contemporary debates taking place in museums concerning the politics of display, the rites of citizenship, and the links as well as confrontations between museums and publics, especially the communities that museums display. As Arjun Appadurai and Carol Breckenridge suggest, "museums are good to think" (1992:34), inasmuch as they are the place where the traffic in art and culture culminates and where objectification, hierarchies, and otherness are displayed. They are also the place where the most public debates about exhibiting are raised and negotiated.

These are significant developments. It is nonetheless important to remember that debates within and about museums only intermittently reveal the ways in which ordinary people act in the arenas open to them. When they do, they often focus on folk art and ethnic art (Jasper and Turner 1991), not popular arts. Only infrequently do they

take place in forums controlled by or even accessible to nonspecialists or nonconverts. Hence it is also important to pay attention to art, culture, and hierarchies outside museums. As debates about equity are far from settled in contemporary society, there remains much work to be done, written, and exhibited about the processes and politics of contemporary cultural production and display.

The essays in this volume concentrate on art as a contextualized social process and on culture as significantly influencing aesthetic production. "Culture," in the anthropological sense, is clearly the milieu in which art thrives. But "culture" is as well a social force, guiding production and consumption in particular ways (Bourdieu 1984). "Culture" also serves as a resource for negotiating issues of identity, not only for marginalized groups but for elites, nationalists, and bourgeois alike (Hobsbawm and Ranger 1983; Domínguez 1989). Anthropological and ethnographic approaches are particularly well suited for analyses of aesthetic production that stress not just art as part of a particular system of aesthetics, but the nature of the system itself.

Three convergent academic developments emphasize culture as an important area of analysis and critique in which cross-cultural and intracultural understanding have an important role to play. The first, the contemporary development of cultural studies, has played a major role in stressing interdisciplinary approaches to studies of culture in contemporary societies, with a primary focus on cultural production analyzed in relation to other cultural practices and to social and historical structures (Grossberg et al. 1992). The second development is the turn in anthropology toward theorizing and representing the complexities of contemporary social life. Projects include analyzing constructions of nationalism and ethnic identities, and transnational processes influencing the increasing movements of people, capital, goods, and media across the face of the globe (Appadurai 1991a; Domínguez 1989; Handler 1988). The third development, very much related to the second, is the theorizing of the conditions of anthropological knowledge and its potential as a form of cultural critique (Clifford and Marcus 1986; Marcus and Fischer 1986).

Cultural studies have in the main been concerned with bringing the politics of culture to the fore of academic discussions. These projects include feminist interventions in all fields, serious studies of popular culture, and challenges to traditional notions of the canon within the academy (Denning 1990; Hall 1981; Jameson 1979; Lipsitz 1990; Rad-

way 1984). Critics of cultural studies lament that its most problematic aspect is the inability to engender critical judgments. The anxiety of these critics does show the de-centering power of these projects. But such work is necessary to expose the inscriptions and erasures, the exclusionary tendencies, indeed the misjudgments and social violence engendered in dominant practices, canons, and institutions.

This volume is a further intervention in this arena, looking specifically at the politics and meanings of art forms. The contributors to this book examine the linkages and disjunctures between art categories and cultural boundaries. They argue that art is constituted *across* evaluative boundaries rather than merely inside them, and critically examine evaluative domains of high, low, and middle as to the forces they bring to bear on aesthetic production. The essays in this volume strive to expose and counter the stratifying features of existing categories. In addition to working the boundaries between evaluative categories, these essays examine art in two national contexts, the United States and Mexico. Thus they are able to examine the ways in which high art in each nation attempts to seal itself off from more popular forms, even while invoking those same forms (see Bakewell and Marcus, this volume). The essays also provide important evidence about the ways ordinary people act in the arenas open to them, using icons and images to advance their individual and collective interests.

This volume is born from the editors' and authors' desire to bring together discussions of aesthetics and anthropology in order to emphasize the social processes and problems of cultural identity negotiated through works of art, whatever their evaluative designation. These essays, covering a limited but diverse range of artistic genres—high art, popular art, ethnic and native art, and tourist art— share two operational principles. First, they foreground problems of social process addressed in the works of art, especially the representation of cultural identity. Second, they work from the premise that the now-conventional separation of high, low, popular, and ethnic arts as practiced in anthropology and traditional art history obscures and mystifies many cultural and political issues. Importantly, these evaluative separations obscure the cultural politics that inform works of art and their institutional settings. In other words, these papers make explicit the ways that meanings and valuations of art forms, however exclusive, are also complicit and interdependent. Said another way, these essays foreground the ways "high" art consistently circum-

scribes "low" art forms and the ways "low" forms ascribe to and con-
spire against "high" art's ultimatums. They also provide a point for
continuing the examination of the role that scholars and critics play
in creating, maintaining, and, here, challenging art hierarchies (Karp
and Lavine 1991; Karp et al. 1992).

The essays take as their point of departure not art history or social
history per se, but rather cultural creativity and representation as
forms of contextualized social process, be it within institutions or mi-
crocultural groups. This starting point, in contrast to that of aesthetic
criticism or museum studies, allows us to consider the importance of
culture as a social force and the dynamic nature of cultural creation
as a means of negotiating issues of identity. Given histories of colo-
nialism, international participation, and ethnic, economic, and gender
stratification that inform modern and postmodern conditions, identi-
ties on multiple registers—not just racial or ethnic—are a significant
feature of contemporary political cultures. Ethnographic approaches
to art allow important access to the conditions, practices, and mean-
ings negotiated in contemporary cultural landscapes.

One purpose of this book is to critique the conventional separations
of art genres and forms practiced in the study of aesthetics and in the
exhibition of art. These separations are evaluative and generally tend
to preserve disciplines and institutions. Through them one might see
the ways that class and social hierarchies are replicated in the axio-
logical nature of "taste" distinctions (Tagg 1992; Smith 1988; Bour-
dieu 1984). Examinations of art forms that ascribe to these sepa-
rations generally tend to lead to one-sided portrayals of cultural
process.

A well-known example of such imbalance was the Museum of Mod-
ern Art's 1984 exhibition *"Primitivism" in Twentieth-Century Art:
Affinities of the Tribal and the Modern.* "Primitivism," short for "mod-
ernist primitivism," is used as an art concept to refer only to the acqui-
sition and elucidation of Third and Fourth World objects and images
according to the representational logics of Western modernism, colo-
nialism, and hegemony. Treatments such as this tend to mystify social
stratification, practices of domination, and the relationship of repre-
sentation to local/international economic and cultural developments
(Clifford 1988; Rodriguez 1989). The *"Primitivism"* show, as is well
known by now, generated a great deal of controversy and critique
(Clifford 1988; Price 1989), noting at the least the colonialist legacy
of its premise.

In contrast, the essays of *Looking High and Low* seek to elaborate the practices and concerns from which artworks arise. They seek to retrieve the multidimensionality exhibited by the processes of cultural production. Rather than highlight conventional institutional or disciplinary concerns, each treats specific generative contexts and constraints of the forms under consideration, taking special note of the way that the forms involve an awareness of "others" and attempt to negotiate or preserve cultural hierarchies.

To engage in this project means to suspend and challenge the humanistic premises most often attached to "high" art: that art is universal or that it communicates universal human concerns; that the art of "others" contributes something lost to Western civilization (be it spirituality or "community"); that art is first and foremost the product of individual geniuses; and that art proclivities are "naturally" evolutionary. It means seeing these concerns as generated in specific historical contexts and not "naturally" attached to artworks themselves.

Advocated in this volume is a continuing emphasis on greater reflexivity on the part of critics, curators, and scholars in the field of the arts, or, put another way, a greater awareness of the roles they play in the evaluation and circulation of public culture. Art should be treated, in James Clifford's words, "as a category defined and redefined in specific historical contexts and relations of power." To engage in such a project of heightened awareness means to realize that the evaluation and interpretation of art objects "takes place within a modern 'system of objects' which confers value on certain things and withholds it from others" (Clifford 1988:188). That the development of art categories or taxonomies usually goes hand in hand with the development of ideological sympathies and aesthetic sense as well as related markets seems evident (e.g., primitive art, pop art, Native American art, and now aboriginal art). The essays in this volume emphasize that these taxonomies also necessitate definitions of artistic and cultural authenticity (folk art versus popular art, pop art versus popular, "Mexican" art versus *artesanías*) that are exclusive and therefore necessarily contested.

One example of the difficulties cultural identity presents for the interpretation and appreciation of art can be seen in treatments of the works of Afro-Cuban artist Wifredo Lam, an internationally known early modernist painter. Born in Cuba, Lam lived in Spain and France beginning in 1923 for a period of eighteen years. There he was friends with Picasso and was influenced by the surrealists. He returned to

Cuba in 1941. Lam's work circulates in a variety of art world circuits and was exhibited in a 1992 Americas Society exhibit in New York City. In a *New York Times* review of the exhibition, Holland Carter contested the "Marxist" emphasis on the artist's negotiation of his cultural concerns in aesthetic terms as an act of "disruption." Decrying art scholarship's continuing obsession with politics, the reviewer asserted, "but it would be wrong to deprive this complex and fascinating artist, with roots in Africa, Asia, and Europe, of his world citizenship and imprison him in yet another restricting version of history," as if to acknowledge and investigate the cultural references and concerns of Lam's work would limit appreciation of his contributions as a "modern artist" (Carter 1992).

Compare this to Julia Herzberg's earlier article on Lam's work in the Latin American context, which emphasizes the continuity of his aesthetic and cultural concerns as modern, and particular to Latin America. She notes, "For the Surrealist, the spiritual world was part of the unconscious. For the Afrocuban, however, it was part of a conscious, everyday reality. Lam brought this aspect of Afrocuban culture to center stage." She goes on to elaborate the intellectual context of the Cuban avant garde, of which Lam was a member after his return to Cuba. "As part of a young independent nation in search of a new voice, consciousness, and departure, the Cuban avant garde embraced the cultural heritage of Afrocubans." Yet "prevailing racist attitudes made it difficult for black Cubans to become full partners in society. As late as 1940 Cuban intellectuals were still having to refute biological determinism and social Darwinism" (Hertzberg 1990).

The Americas Society exhibition's emphasis on Lam's use of his cultural background and concerns in his art is troubling to those concerned with international modernism who think that such a seemingly parochial emphasis leads to a circumscription of the artist's influence. Yet in the exhibition and in Latin America, modernism and the relationship of cultural concerns to cultural products and to citizenship, with its racial, national, and international dimensions, is central.

In 1987, the inclusion of Lam's work in an exhibition at Miami's Cuban Museum of Arts and Culture was controversial because Lam supported the Cuban revolution. In the postrevolutionary, anti-Castro, exile-dominated Cuban community of Miami, "culture" is subject to contestations surrounding the meanings of nationalism and

identity. Since the revolution, the problem for the exile community of Miami has become how to deal with Cuba itself. The exhibition of Lam's work (among others) was interpreted by exiled anti-Castro Cuban nationalists as contributing support to the Castro regime in two ways: ideologically and monetarily as a form of trade. In this last case, the work was viewed as part of a national cultural legacy that posed difficulties precisely because of its affiliation with a nationally defined historical past and its trade value, which was seen as contributing to the Castro regime (Hanly 1992).

The controversies surrounding the exhibition of Lam's work reveal that while "high" culture embodies conceptions of national, international, and modern identities, those very conceptions are dependent upon the simultaneous representation and subordination of peoples designated as cultural "others." They also indicate the ways in which hierarchies and issues of identity may be in conflict with each other. For those concerned with international art, cultural specificities challenge the salience of humanitarian concerns for artistic expression and genius. And yet those same specificities are crucial to the meanings of art in particular contexts. They are critical for understanding that identities are never simply nor universally "human." They are always of a particular time and context.

Sylvia Rodriguez provides an excellent example of the creation of a particularly American antimodernism in the early part of this century in her essay "Art, Tourism, and Race Relations in Taos." She elucidates the process by which Anglo artists who moved to Taos, New Mexico, utilized images of the Indian "other" to create their antimodernist images of the American West. This process, as she so compellingly details it, "involves stratification, not only by class, but by race as well, and reflects the symbolic transformation of this particular [socioeconomic] arrangement into a marketable commodity" (1989:77).

The subordination and representation of cultural others is, in important ways, predicated on definitions of nationalism and the experiences of modernity and mass society, which create for many the sense of being "a people without culture," who are nevertheless "cultured" and exhibit a nostalgia for "what they themselves have destroyed" (Rosaldo 1989:69). Such nostalgia is both generated and refracted in a complicated way through what Clifford calls the "art-culture system."[3]

In the Western system, modernism and the avant-garde have historically developed an adversary culture nevertheless bound up with capitalist modernization. To the extent that modernism has been ordered as a critique of modernity, it has been critical of modern industrial mass culture. Hence the modernist emphasis on the individual and the ideology of art as a rarified, dense mode of consumption and appreciation, uncontaminated by mass media and propaganda. In contrast, anthropological treatments of art have historically focused on salvaging and documenting culturally "authentic" forms, understanding that culture contact and culture change both threaten and anachronize "other" cultural systems within nation-states. This was true of the early ethnological projects of the nineteenth century and likewise for much of the twentieth.

In both cases, objects were most often presented as part of a singular aesthetic system, and the systems were evaluatively ranked. As Clifford notes, "any collection implies a temporal vision generating rarity and worth, a metahistory. This history defines which groups or things will be redeemed from a disintegrating human past and which will be defined as the dynamic, or tragic, agents of a common destiny" (1988:13). While both "traditions" serve to valorize "authenticity," either authentic art or authentic culture, they have the important effect of marginalizing other forms associated with living in contemporary "mass" societies. Popular art, popular culture, and popular histories become especially problematic under this formulation.[4]

As Huyssen describes it, "High art had indeed become institutionalized in the burgeoning museum, gallery, concert, record and paperback culture of the 1950s," and there emerged in the United States in the sixties "a vigorous, though again largely uncritical attempt to validate popular culture as a challenge to the canon of high art, modernist or traditional" (1986:194).

While dominant artists were critical of the institutionalization of high art, minority artists were (and still are) critical of art institutional practices of exclusion or absorption. In one case, El Museo del Barrio was established in 1970 as a "museumless" museum to provide opportunities to establish living connections with one's own culture, here Puerto Rican. Founder Ralph Ortiz's purpose was to create a museum of relevant, vital culture. "Preserving culture as a vital entity demands that it be liberated from the depersonalizing values of the marketplace, the fashion-mongering of the curatorial process, and the object

notion of history" (Ortiz 1971:12). Ortiz's critique emphasizes both the hierarchical practices of institutions and the alienating, culturally devastating experience of colonialism.

Huyssen questions the conditions under which institutions engage in the very practices Ortiz is critical of: "But this nostalgia for the past, the often frenzied and exploitative search for usable traditions, and the growing fascination with pre-modern and primitive cultures—is all this rooted only in the cultural institutions' perpetual need for spectacle and frill, and thus perfectly compatible with the status quo? Or does it perhaps also express some genuine and legitimate dissatisfaction with modernity and the unquestioned belief in the perpetual modernization of art?" (1986:185). He answers that he believes that dissatisfaction with modernity is itself a genuine consideration. Yet the fact that such dissatisfactions are expressed through representations such as the Anglo artists' paintings of Native Americans from the Taos Pueblo indicates there is an important implication to these practices, as Lippard argues: "Respect for different cultures will bring along with it a greater respect for crafts and commercial and decorative and folk arts, and vice versa. But so long as the dignity offered the objects is denied to the people who make or inspire them, cross-cultural consciousness will be an uphill battle for all concerned" (1989:9). *Looking High and Low* is an intervention into this process. A focus on multiple aesthetic systems and influences will reveal the institutional disjunctions between people and objects.

It is our intention that the papers in this volume will broaden discussions concerning such disjunctions. We begin and end with essays on high art, a strategy we use to frame the questions of complicit genres, institutions, and the politics of art.[5] We undertake this strategy because as Bakewell's essay indicates, interpretive authority over art taxonomies often rests in the hands of a few privileged elites, not in those of popular sectors. How these taxonomies are generated and maintained, and how they are articulated by scholars and cultural workers in the high art world, are important issues.

The first essay is Liza Bakewell's "*Bellas Artes* and *Artes Populares*: The Implications of Difference in the Mexico City Art World." She explores the postrevolutionary high art appropriation of Mexican popular art as a strategy for creating an authentic national identity. While on the one hand "indigenous peoples" were constructed as repositories of Mexican national identity, they remain excluded by a

cultural hierarchy that conceives of them as a bridge to the past. Bakewell argues that the building of postcolonial nations is often one that constructs an all-inclusive ethnic authenticity within an exclusive bourgeois hierarchy. This hierarchy, she notes, is sustained by a visible presence of Indian culture and artifacts that connotes Mexican postrevolutionary racial identity. But it depends upon a nature/culture dichotomy that conceives of the artist as a cultured intellectual creator and the artesan as more "natural," earthbound, and "unconscious" in his or her creations. Her essay explores the racial thinking underlying these distinctions in the Mexican national context.

Marcos Sanchez-Tranquilino, in "Space, Power, and Youth Culture: Chicano Graffiti and Murals in East Los Angeles, 1972–1978," examines the negotiations of space, power, and identity that took place between two contending systems of signification, namely, graffiti and murals in the Estrada Courts Housing Project in East Los Angeles. Critical of the ways that scholars and artists conceive of the relationship between Chicano muralism and graffiti, he refutes the traditional art-historical distinctions that reduce the analysis into divergent status-laden categories positioning muralism as "art" and graffiti as "vandalism." Within these evaluations, muralism is valued as more social and more communitarian than graffiti, which is conceived of as the self-aggrandizing acts of aggressive, asocial individuals. By analyzing both forms as signification, Sanchez-Tranquilino indicates the process by which the graffiti writers—youth who lived in the Estrada Courts Housing Project—participated in mural projects and invested the murals with meanings relevant to their lives and communication needs. He thus indicates the necessity of understanding the social process involved in the making of the murals for interpreting their meanings.

My essay, "Remappings: Los Angeles Low Riders," examines the ways that surveillance, social class, and ethnic identity are addressed in the ironic and playful images of Chicano customized cars known as low riders. Here ethnic popular art has created an alternate cultural space for performance, participation, and interpretation, one that allows for the reworking of limitations of mobility placed on racialized cultures in the United States in a venue that is itself mobile. This essay examines the ways in which contemporary identity processes are becoming increasingly de-territorialized, especially in urban contexts, and advocates popular culture research as challenging

conventionally conceived cultural boundaries and their concomitant identities.

While Bakewell's essay depicts bourgeois notions of artesan creations as somehow "natural" and un-self-conscious, my own essay and that of Sanchez-Tranquilino stress that these conceptions are nowhere accurate. In working-class Chicano communities, artworks are influenced–although not determined–by the dual workings of powerful bureaucratic and disciplining institutions on the one hand, and, on the other hand, bourgeois culture systems. Sanchez-Tranquilino is critical of notions of muralism that place it as naturally or evolutionarily superior to graffiti, because such distinctions replicate class divisions and demonize racial difference. My analysis examines the way in which material culture can be refashioned as a pleasurable object, simultaneously critical of the aesthetics of mass production and the system of objects (and subjects) in which it is located.

What happens when native products are created for appreciation by both their producers and their consumers? The next two essays detail the difficult contexts of artistic production for Native American artists. Barbara Babcock's "Marketing Maria: The Tribal Artist in the Age of Mechanical Reproduction" critiques Anglo America's romanticized images of Indian women by focusing on Maria Martinez, the Pueblo potter, and the ways in which both the artist and her work have been produced and reproduced in a variety of discourses and institutions from postcards to books to videotapes and from world's fairs to museums to the White House.

Barbara Tedlock's "Aesthetics and Politics: Zuni War God Repatriation and Kachina Representation" details multiple contradictions for Zuni aesthetics depending upon contexts of display. She describes Zuni Pueblo as an art culture, in that the major source of individual income at Zuni consists of money earned from art production, and then details the difficulties created for controlling the display of Native American art due to the legacies of colonialism and tourism. The violence done by colonial legacies and high-culture interpretations is evidenced by the repatriated Kachina war god absent from the Museum of Modern Art's *"Primitivism"* show that was to be paired with Paul Klee's "Mask of Fear." But in New Mexico, the regional seat of the international Indian art market and ethnic tourism, the ability of Zunis to control the display of their art is compromised by governing practices of the All Pueblo Council, controlled by the Rio Grande

Pueblos, that avoid the display of any religious scenes to outside consumers and tourists.

Returning to the "high" art world once again, George Marcus's paper, "Middlebrow into Highbrow at the J. Paul Getty Trust," examines the on-going recreation of the "high" art category as a product of institutionalized petty-bourgeois conceptions. Here he considers the part played by intellectuals in this cultural production at one of the world's wealthiest operating art foundations. Not only is the Getty sited in the mass media capital of the United States, but the lives of intellectuals who work there are themselves thoroughly punctuated by mass society. Nevertheless, mass society only appears in this more "serious" world as entertainment or, negatively, as a degrading intrusion to be guarded against.

We conceive of this book as presenting two major challenges. First, it challenges conventional tendencies to analyze art. These essays compel one to examine the problems engendered by the institutional practices of valuation in reifying high culture. In reading about these genres together, a sense of identification with high art is ruptured and distanced. The second challenge was formulated by Renato Rosaldo. He said, "The sense of the 'other' dissolves, particularly if the 'other' happens to be in the room. If diversity exists in the room, the other becomes something like a rotating 'other,' rotating 'we,' so that people may think about difference. But they won't think about [the] 'Other' in the previous dehumanized terms."[6] This, we believe, is the constructive potential of critical cultural work.

NOTES

1. Similar examples were cited in a symposium on the role of the Latino artist held in conjunction with the *Hispanic Art in the United States* show at the Los Angeles County Museum in Spring 1989.

2. Gronk, Gamboa, and Herrón, together with Patssi Valdez, adopted the name Asco for their art-performance group in 1973.

3. The most noted characteristic of this system has been its bifurcated evaluation of objects as aesthetic or as anthropological—as "art" or as "culture." This bifurcation has been perpetuated institutionally as non-Western objects are displayed in either art museums and galleries or in ethnographic museums. As art, these objects are displayed to be appreciated for their formal and aesthetic properties, often without artistic attribution, cultural back-

ground, or acquisition information. As ethnographic objects, they are represented in a "cultural" context as belonging to a certain group and having certain use-functions and symbolism.

4. An important development in anthropological treatments is *Ethnic and Tourist Arts* (1976), edited by Nelson Graburn, which analyzes both ethnic art and tourist art and contends that the study of such arts must take into account more than one symbolic and aesthetic system. Graburn divides the art forms of the Fourth World—meaning those aboriginal or native peoples who are within the territorial boundaries and under the administration of countries of the First, Second, and Third Worlds—into primarily inwardly directed arts versus outwardly directed arts, depending upon the audience for the work.

Offering an important corrective in another direction is Bennetta Jules-Rosette's book *The Messages of Tourist Art*, about "tourist" art and "popular" art in three African contexts. Here she shows that the work of African artists is sold to urbanites, recent urban immigrants, and art collectors, as well as to tourists. This art is popular as well as tourist and plays an important multi-representational part in what she terms a "communicative system." Important in her treatment of popular art are the "circuits" of objects and their meanings. For more recent writings, see Taylor 1994.

5. "Institutions" is used here to refer to art museums, especially as they struggle to balance the demands of nationalism with internationalism.

6. Rosaldo made these comments when the essays were first presented at the 1990 Annual Meeting of the American Anthropological Association, where we were fortunate to have both Rosaldo and William O. Beeman as discussants.

REFERENCES

Anderson, Benedict
1991 *Imagined Communities: Reflections on the Origins and Spread of Nationalism.* London: Verso.
Appadurai, Arjun
1991a "Disjuncture and Difference in the Global Cultural Economy." *Public Culture* 2(2):1–23.
1991b "Global Ethnoscapes: Notes and Queries for a Transnational Anthropology." Pp. 191–210 in *Recapturing Anthropology: Working in the Present*, ed. Richard G. Fox. Santa Fe, N. M.: School of American Research Press.
Appadurai, Arjun, and Carol A. Breckenridge
1990 "Why Public Culture?" *Public Culture Bulletin* 1(1):5–9.
1992 "Museums Are Good to Think: Heritage on View in India." Pp. 34–55 in *Museums and Community: The Politics of Public Culture*, eds. Ivan Karp, C. M. Kreamer, and Steven D. Lavine. Washington and London: Smithsonian Institution Press.

16 Brenda Jo Bright

Bourdieu, Pierre
1984 *Distinction: A Social Critique of the Judgement of Taste.* Cambridge: Harvard University Press.
Carter, Holland
1992 "A Mulatto-Chinese Cuban With a Gift for Fusion." *New York Times*, September 25.
Clifford, James
1988 *The Predicament of Culture: Twentieth Century Ethnography, Literature, and Art.* Cambridge: Harvard University Press.
Clifford, James, and George Marcus, eds.
1986 *Writing Culture: The Poetics and Politics of Ethnography.* Berkeley: University of California Press.
Denning, Michael
1990 "The End of Mass Culture." *International Labor and Working-Class History* 37(Spring):4–18.
Dent, Gina, ed.
1992 *Black Popular Culture: A Project by Michele Wallace.* Seattle: Bay Press.
Domínguez, Virginia
1989 *People as Subject, People as Object: Selfhood and Peoplehood in Contemporary Israel.* Madison: University of Wisconsin Press.
Fox, Richard G., ed.
1991 *Recapturing Anthropology: Working in the Present.* Santa Fe, N. M.: School of American Research Press.
García-Canclini, Néstor
1993 *Transforming Modernity: Popular Culture in Mexico.* Austin: University of Texas Press.
Gilroy, Paul
1987 *"There Ain't No Black in the Union Jack": The Cultural Politics of Race and Nation.* Chicago: University of Chicago Press.
Gómez-Peña, Guillermo
1992 "The Other Vanguard." Pp. 65–75 in *Museums and Community: The Politics of Public Culture*, eds. Ivan Karp, C. M. Kreamer, and Steven D. Lavine. Washington and London: Smithsonian Institution Press.
Graburn, Nelson, ed.
1976 *Ethnic and Tourist Arts: Cultural Expressions from the Fourth World.* Berkeley: University of California Press.
Griswold del Castillo, Richard, Teresa McKenna, and Yvonne Yarbro-Bejarano, eds.
1991 *Chicano Art: Resistance and Affirmation, 1965–1985.* Tucson and London: University of Arizona Press.
Grossberg, Lawrence, Cary Nelson, and Paula Treichler, eds.
1992 *Cultural Studies.* New York: Routledge.
Hall, Stuart
1981 "Notes on Deconstructing 'the Popular.'" Pp. 234–39 in *People's History and Socialist Theory*, ed. Ralph Samuel. London and Boston: Routledge and Kegan Paul.

Handler, Richard
1988 *Nationalism and the Politics of Culture in Quebec.* Madison: University of Wisconsin Press.
Hanly, Elizabeth
1992 "The Cuban Museum Crisis, or Fear and Loathing in Miami." *Art in America* (February):31–37.
Herzberg, Julia P.
1990 "Wifredo Lam." *Latin American Art* 2(3):18–24.
Hobsbawm, Eric, and Terence Ranger, eds.
1983 *The Invention of Tradition.* Cambridge: Cambridge University Press.
Huyssen, Andreas
1986 *After the Great Divide: Modernism, Mass Culture, Postmodernism.* Bloomington: Indiana University Press.
Jameson, Fredric
1979 "Reification and Utopia in Mass Culture." *Social Text* 1 (Winter): 130–48.
Jasper, Pat, and Kay Turner
1991 *Art Among Us/Arte entre nosotros: Mexican-American Folk Art in San Antonio.* Denton: University of North Texas Press.
Jules Rosette, Bennetta
1984 *The Messages of Tourist Art: An African Semiotic System in Comparative Perspective.* New York: Plenum Press.
Karp, Ivan
1991 "High and Low Revisited." *American Art* (Summer):12–17.
Karp, Ivan, C. M. Kreamer, and Steven D. Lavine, eds.
1992 *Museums and Communities: The Politics of Public Culture.* Washington and London: Smithsonian Institution Press.
Karp, Ivan, and Steven D. Lavine, eds.
1991 *Exhibiting Culture: The Poetics and Politics of Museum Display.* Washington and London: Smithsonian Institution Press.
Lippard, Lucy
1989 "Captive Spirits." Pp. 3–18 in *Multiethnic Literature of the United States*, ed. C. Candelaria. Boulder: University of Colorado.
1990 *Mixed Blessings: New Art in Multicultural America.* New York: Pantheon Books.
Lipsitz, George
1990 *Time Passages: Collective Memory and American Popular Culture.* Minneapolis: University of Minnesota Press.
Lomas Garza, Carmen
1991 "Pedacito de mi corazón." Pp. 10–13 in *Carmen Lomas Garza: Pedacito de mi corazón* (catalog), curated by Peter Mears. Austin, Tex.: Laguna Gloria Art Museum.
Marcus, George, and Michael M. J. Fischer
1986 *Anthropology as Cultural Critique: An Experimental Moment in the Human Sciences.* Chicago: University of Chicago Press.
Ortiz, Ralph
1971 "Culture and the People." *Art in America* (May):27.

18 Brenda Jo Bright

Price, Sally
1989 *Primitive Art in Civilized Places.* Chicago: University of Chicago
 Press.
Radway, Janice
1984 *Reading the Romance: Women, Patriarchy, and Popular Literature.*
 Chapel Hill: University of North Carolina Press.
Rodriguez, Sylvia
1989 "Art, Tourism, and Race Relations in Taos." *Journal of Anthropologi-
 cal Research* 45(1):77–99.
Rosaldo, Renato
1989 *Culture and Truth: The Remaking of Social Analysis.* Boston: Beacon
 Press.
Rose, Tricia
1992 "Black Texts/Black Contexts." Pp. 223–27 in *Black Popular Culture,*
 ed. Gina Dent. Seattle: Bay Press.
1994 *Black Noise.* Middletown, Conn.: Wesleyan University Press.
Ross, Andrew
1989 *No Respect: Intellectuals and Popular Culture.* New York: Routledge.
Rowe, William, and Vivian Schelling
1991 *Memory and Modernity: Popular Culture in Latin America.* London:
 Verso.
Smith, Barbara Herrnstein
1988 *Contingencies of Value: Alternative Perspectives for Critical Theory.*
 Cambridge: Harvard University Press.
Tagg, John
1992 *Grounds of Dispute: Art History, Cultural Politics, and the Discursive
 Field.* Minneapolis: University of Minnesota Press.
Taylor, Lucien, ed.
1994 *Visualizing Theory.* New York: Routledge.
Ybarra-Frausto, Tomás
1977 "The Chicano Movement and the Emergence of a Chicano Poetic
 Consciousness." *New Scholar* 6: 81–109.

2 BELLAS ARTES AND ARTES POPULARES

THE IMPLICATIONS OF DIFFERENCE IN THE MEXICO CITY

ART WORLD

LIZA BAKEWELL

I t's *folklórico,*" Mexican contemporary artists say when de-
scribing artwork they consider characteristically Mexican.[1] As an ad-
jective, *folklórico* literally means folkloric, and it refers to the tradi-
tions of the so-called popular sector. One of those traditions, the most
tangible and transportable, is represented by Mexican folk art,
known in Spanish as *artesanías* or *artes populares.*[2] Woven sarapes,
netted hammocks, coiled ceramics, carved wooden figurines, painted
masks, lacquerware boxes, braided baskets, and bark-paper paintings
are only a few examples of the rich diversity of objects categorized by
Mexican elites as artesanías and artes populares. In contrast to them

stand the *bellas artes*, literally the beautiful arts. Western-oriented art forms, such as easel painting, orchestral music, staged theater, ballet, modern dance, and film, are all examples of bellas artes. Closely related to the distinctions drawn in Western art history and culture between "fine" art (beaux-arts) and "folk" art, the qualifications that compose the definitions of bellas artes and artes populares designate no absolute category of meaning; all that is absolute is that the actual objects to which they refer are, in a literal sense, hand-crafted human artifacts.

"Good" examples of Mexican folk art, from the perspective of an artist living in Mexico City today, epitomize Mexicanness or twentieth-century Mexican nationality in a way generally thought positive—not only well executed but *muy típico*, that is, typically Mexican in palette, shape, and sentiment, as in the state-financed Ballet Folklórico of Mexico City. Today contemporary artists, critics, dealers, and government officials often judge contemporary painting by how well it articulates the colors, materials, and motifs of Mexican artesanías. Cultural rootedness is highly valued in the Mexican art world. It is, perhaps, one of the Mexican Revolution's most enduring legacies. "For me," artist Janitzio Escalera (b. 1956) explained, "Mexican artesanías embody the real truthful culture, the authentic personality of America—all of Latin America, but especially Mexico. I learned about color from Mexican artesanías. All of it has a lot of color, texture, form. It is a special characteristic of Mexico."

When assuming office, Mexican presidents have regularly issued statements similar to the following proclamation by President López Portillo to a visiting group of Indians during his presidency, 1976–82: "Mexico is distinguished from the rest of the world by our ethnic groups [i.e., the popular, non-European-oriented sector]. What would Mexico be were it not for what you signify and represent? Almost nothing!" (Riding 1985:204). Intellectuals, too, have frequently proclaimed the importance of ethnically rooted art to the making of twentieth-century Mexican identity. As Nobel laureate Octavio Paz has observed many times, "The [Mexican] Revolution, by discovering popular art, originated modern Mexican painting, and by discovering the Mexican language it created a new poetry" (1985:34; also 1987:92). And, as Rowe and Schelling have noted, Mexican modernity and Euro-American modernities are not synonymous. "A major factor in its difference—probably the major factor," they argue,

"is the force of popular culture. It is a modernity which does not nec-
essarily entail the elimination of pre-modern traditions and memories
but has arisen through them, transforming them in the process"
(1991:3).

Yet despite the praise for the popular arts on the part of politicians
and artists in Mexico, a painting described as folklórico by critics is a
painting considered bad, too much inspired by Mexican crafts. While
cultural rootedness and nationalism are valued in the revolutionary
Mexican art world, provinciality is not; a painting described as folklór-
ico, arte popular, or artesanías is a painting considered provincial and
backward, placed outside the contemporary, Western, cosmopolitan
mainstream.

It was during the Mexican Revolution (1910–17) when insurgents
challenged the nature of cultural and political relations between Mex-
ico and Europe and criticized the Eurocentricity of the Mexican art
world—its paintings, sculptures, iconography, style, and pedagogy
(Charlot 1962). Recognizing the art world's non-Mexican ways, dissi-
dent art students and intellectuals attacked the academy—the neoco-
lonial institution—where, until the revolution, European-trained art-
ists taught courses in Western-oriented "fine" arts within brick-walled
studios protected from the popular sector. These dissidents rejected
the connoisseurship of earlier collectors and their decontextualized
sensibilities—their art-for-art's-sake attitude toward collecting. Like
the connoisseurs' Victorian counterparts, who piled Persian rugs
onto the cold floors of their English homes and lined their walls and
bookshelves with African sculptures, nineteenth-century, Spanish-
born Mexicans and their children interspersed Mexican "curios"
among the more-numerous examples of European imports that fur-
nished their abodes.

By the 1920s, Mexican revolutionaries claimed a political as well as
cultural victory. Ever since, the revolution, in its institutionalized form
and through its programs of cultural nationalism, has sought to valo-
rize the popular sector, especially the "indigenous" peoples and their
cultural products, constructing them as repositories of Mexican na-
tional identity and authenticity. To the revolutionary art world, the
popular sector—its people and its arts—was the starting point of a
new aesthetic. It is for these reasons that I would use with reservation
the adjective "Western oriented" to describe the bellas artes, for de-
spite their Western orientation, many contemporary Mexican bellas

artes draw upon indigenous traditions—so much so that a casual reading of them renders insufficient information to distinguish one from the other. In other words, Mexican art may seem as popular in its orientation as it is bourgeois, as locally situated as it is universally focused, and as Mexican as it is international.

To describe the Mexican art world is to describe two historically and culturally constructed, opposing world views. One is based on cultural nationalism, a program of the revolution rooted in a populist notion of the popular sector and in popular expressions of culture. The other grows out of European bourgeois constructions of culture, which the Mexican Revolution sought to overthrow—at least ideologically. Of the two world views, the latter provides the warp of the art world's cultural and ideological fabric. The revolutionary ideology and policies of cultural sovereignty are its weft, woven inextricably into its bourgeois warp.

Yet the effort on the part of cultural and political elites to weave the popular sector into the political and artistic arena of the revolution ultimately contributed to more elaborately defined distinctions between the two sectors and their productions and created a tension between the two that characterizes the twentieth-century Mexican art world, a tension that all twentieth-century artists have had in the past and continue to negotiate in producing their work.[3] In sum, therefore, what the terms "fine arts" and "folk arts" may mean in other art worlds is only partially compatible with the complicated network of distinctions that categorize works as bellas artes and artes populares in the twentieth-century art world of Mexico City.[4]

In this chapter I will focus on the problematic relationship of artistic representation and national identity within the Mexican art world. Rather than feature the presence of the monolithic colonial past (the central concern of most recent scholarship on twentieth-century art and identity in Latin America—see Bayón 1987; Cimet 1987a, 1987b; García Canclini 1993; Rowe and Schelling 1991), this study will scrutinize twentieth-century, Mexican-generated, postcolonial identity, which at times works to maintain, rather than shed, a colonialist position. Despite the ideology of the Mexican Revolution and the efforts of its practitioners, and because of them, the categories of fine and popular art or (in the Mexican context) bellas artes and artes populares classify objects along lines of difference that ultimately contribute to a wider context of social definitions of progressive and back-

ward, Western and non-Western, urbane and provincial, European and Indian, white and brown, rich and poor, and male and female, and thus participate at the ideological level in reproducing the hierarchy evident in prerevolutionary times between the sexes, races, and classes.[5] Tessie Liu calls this "racial thinking": thinking within a hierarchical framework that, while in its most pernicious form may produce discrimination, as she posits, and even genocide, in its less-overt forms can come "disturbingly close to many of the 'acceptable' ways that we conceptualize social relationships" (Liu 1991:159). Indeed, while, as Baddeley and Fraser note, "the persistent concern of Latin American |particularly Mexican| creative artists |has been| to give authentic expression to their own voices, to locate their own cultural identity" in their works (1989:2), apart from their repressive colonial past and the inequity of Western art history, at the same time, and overlooked in the literature, the Mexican art world maintains and usurps many of the oppressive measures it seeks to destroy. In sum, the categories of bellas artes and artes populares not only organize handwork into a hierarchy of objects in which one group of artifacts (bellas artes) is privileged over another (artes populares), but they organize people into a social hierarchy in which some persons (artists) are more privileged than others (artisans), as is characteristic of other systems of difference—those based explicitly on race, ethnicity, or gender, for example.

REVOLUTIONARY MANIFESTOS

The categories of difference and the social webs into which the fine arts and other arts are organized in Mexico's art world have their origins in the European academies of art, as they did before the revolution. It was in the European academy where the arts of painting, sculpture, and architecture emerged as "finer" than other cultural productions or productions from other cultures. Brought to Mexico in the eighteenth-century with the building of the Academia Real de San Carlos, the first New World art academy was a large, colonial building in downtown Mexico City, whose interior courtyard was lined with replicated Greco-Roman statues. It stood originally, as it stands today, as the bastion of European bourgeois taste and ideology, a place to find systematic training, both historical and practical, in the arts of "Western civilization."

For the art world, revolutionary nationalism initially translated into an attack on the teachings of the academy—its valorization of Western culture and the hierarchical privileging of the bellas artes. Revolutionaries recognized the academy as a European invention; its courses in classical drawing, sculpture, and architecture as colonial imports; and its elitism and European orientation as a hindrance to the reconstruction of Mexico's cultural sovereignty. Ever since the revolution, Mexico's foreign and domestic policy has exploited the conviction that foreigners, especially Westerners—their capital, politics, and cultures—have threatened Mexican sovereignty and have made the fissures that run through Mexican society and divide rich and poor, elites and nonelites, ruling and populace, and whites and Amerindians ever more pronounced.[6]

It was in the 1920s when Mexican revolutionary elites—ruling, intellectual, and artistic—began to systematically locate their legitimacy, sovereignty, and authenticity in their country's Indian heritage and traditions, especially its artes populares. Early in the 1920s, painters, musicians, poets, and later filmmakers drew heavily upon indigenous colors, design motifs, musical scales, linguistic tropes, and panoramic landscapes for inspiration. Magazines, books, and newspapers celebrating Mexican indigenous art appeared on the scene, disseminating the shapes, forms, and colors of various Mexican arts and crafts (e.g., Atl 1922). The deference awarded to Indianness throughout the century by artists and the government (the latter through its secretaries of public education and tourism) distinguishes the Mexican art world from other Western and Western-oriented art worlds, a contrast noted regularly by artists who come to Mexico City to live. "When I arrived in Mexico," Argentine painter and architect Luis Maubecín told me, "it was a totally unexpected surprise to find Mexico so influenced by Mexican crafts, perhaps because in Argentina we are closed off and European oriented. We [Argentines] have no knowledge of what is being made in Mexico. Here art is incredible; it is so Mexican." It is so locally oriented, in other words.

Responding to the government's commitment to a public arts program, painters and government officials in the early 1920s initiated what came to be known as the Mexican Mural Renaissance, a government-funded program founded on the principle of "art of the people." It was joined by other nationally oriented (if not fully nationally funded) projects such as the establishment of the Ballet Folklór-

ico, which integrated indigenous dance traditions into its Western-oriented choreography, and by the excavation and reconstruction of archeological sites. All these artistic ventures had two goals in common. First, they were sponsored by the secretary of public education because, it was believed, art ought to be a vehicle for information, a democratic means by which the Mexican people—all Mexican peoples, literate or not—could learn "their" own history and locate themselves within this extended national community. Second, they aimed to celebrate the ideology, sovereignty, and new nationalism of the Mexican revolutionary state, not only by painting the articles of the 1917 Constitution on public walls, but by popularizing pre-Columbian icons and fostering anti-foreign sentiment, especially an anti-United States one.

Generally speaking, the mural renaissance was a microcosm of the revolution's nationalist programs, which aimed to create a unified nation in order to bring together a country decimated by its war-ravaged economy, by its destabilized political structure, and by the loss of 10 percent of its citizens. According to the new constitutional government, the uneducated were to have access to free, public education and well-paid jobs; the land of large farmers and aristocrats was to be appropriated and divided equally among the peasantry; Mexican labor was to be empowered by unions and celebrated and privileged over foreign labor; and the otherwise private, exclusive art world was to be made accessible to all Mexicans.

In an effort to bring the country together, philosopher, politician, and architect of the mural renaissance José Vasconcelos, appointed in 1921 by President Alvaro Obregón to the powerful position of secretary of public education, spoke in terms of an exceptional nation, one constituted by a special people, a "cosmic race." Vasconcelos also described Mexico as a sovereign nation but one composed of a cosmic, racial mixture of both Caucasian and Amerindian peoples. The cosmic race was made up of the offspring of Spanish fathers and Indian mothers. "We [Mexicans] are Indian, blood and soul," he pronounced, "the language and civilization are Spanish" (Riding 1985:201). The concept of the "cosmic race" was a tentative racial and cultural solution to the young republic's many political and economic woes, aimed to incorporate the "people" into the national picture in a way the economy and education ministry had failed to do.

Among artists the ideology of Mexican nationalism began with the

formation of a Syndicate of Revolutionary Painters, Sculptors, and Engravers of Mexico, and, although short lived, its manifesto, issued in 1923, presciently captured—at least in emotion if not in actuality—what would become the overarching ideology of the twentieth-century art world in Mexico:

DECLARATION

Social, Political, and Aesthetic of The Syndicate of Technical Workers, Painters and Sculptors to the native races humiliated through centuries; to the soldiers made executioners by their chiefs; to the workmen and peasants flogged by the rich; to the intellectuals not fawners of the bourgeoisie . . .

. . . THE ART OF THE MEXICAN PEOPLE IS THE GREATEST AND MOST HEALTHY SPIRITUAL EXPRESSION IN THE WORLD [and its] tradition our greatest possession. It is great because, being of the people, it is collective, and that is why our fundamental aesthetic goal is to socialize artistic expression, and tend to obliterate totally, individualism, which is bourgeois.

We REPUDIATE the so-called easel painting and all the art of ultra-intellectual circles because it is aristocratic, and we glorify the expression of Monumental Art because it is a public possession.

We PROCLAIM that since this social moment is one of transition between a decrepit order and a new one, the creators of beauty must put forth their utmost efforts to make their production of ideological value to the people, and the ideal goal of art, which now is an expression of individualistic masturbation, should be one of beauty for all, of education and of battle. (Goldman 1981:3)

When muralist David Alfaro Siqueiros (1896–1974) drafted the manifesto for the syndicate of revolutionary artists he did so with Vasconcelos's program of cultural nationalism in mind, a program that over the years turned into an enormous government-sponsored public arts promotion that involved, along with painters, the sponsorship of musicians, filmmakers, writers, and other artists. Like the syndicate's manifesto, cultural nationalism was a child of the Mexican Revolution, and its nationalist orientation has provided political rhetoric and has directed state policy toward the arts throughout the century. The revolutionary intellectual Pedro Henríquez Ureña described it well. Cultural nationalism, he explained (paraphrased by Jean Franco), is "not to be understood . . . in the nineteenth-century

sense; 'Culture is conceived of as social, offered and really given to all and founded on work'" (Franco 1970:84–85). In other words, as Franco noted, there were two impulses behind cultural nationalism in Mexico: "First, there was the desire to bring all sections of the community into national life. Secondly, the elite now sought, in folk culture, in the indigenous peoples and the environment, the values they had previously accepted from Europe" (1970:84–85), an agenda typical to other postcolonial cultural programs worldwide.

REVOLUTIONARY PARADOXES

Nevertheless, it was at the height of Mexico's revolutionary nationalism in the 1930s and its celebration of the popular sector that the Mexican government institutionalized the separation of the artistic categories "bellas artes" and "artes populares" with the creation of two state organizations, the National Institute of Fine Arts (INBA) and the National Institute of Anthropology and History (INAH). Both institutes have administered the arts ever since. The numerous responsibilities of these two organizations include the housing and curating of Mexico's cultural patrimony, beginning with its prehistoric archeological sites and extending to its contemporary easel paintings and sculptures. Founded and operating today under the auspices of the Secretary of Public Education, both institutions are largely responsible for educating the Mexican people about Mexican culture, ethnic groups, art, and history. INAH and INBA are responsible for the functioning of several public educational facilities and programs, including schools and museums. They oversee numerous publications, and they have active public outreach programs consisting of lectures, film series, workshops, and exhibitions. Children in the public school system are regularly sent on their own or with their parents to INBA and INAH museums to study a broad range of topics—from pre-Columbian history to contemporary Mexican painting.

Under the domain of INBA are all the arts from the mid-eighteenth century to the present. In contrast, INAH is the curator of all the arts, except architecture, produced in Mexico before then: from pre-Columbian times through the colonial period. The Museum of Modern Art in Mexico City, for example, with its twentieth-century painting and sculpture, is an INBA-operated museum, and the National Museum of Anthropology, with all its pre-Columbian artifacts, is an

INAH-operated museum. There are few collections of contemporary arte popular exhibited and curated by museums in Mexico. Those examples, however, such as are found in the Museo Nacional de Artes e Industrias Populares (the National Museum of Popular Arts and Industries) in Mexico City, are managed, staffed, and curated by INAH personnel, despite the fact that, like contemporary painting, the artes populares curated are twentieth-century creations. The institutionalized difference and segregation found in the organization of INBA and INAH museums and programs is one of the most overt indicators of the revolution's involvement in not only challenging but simultaneously perpetuating the bourgeois distinctions made between fine and folk.

AMATE PAINTING

In 1985, in an effort to promote artesanías as art objects, a young, prominent private gallery of contemporary art in Mexico City hung the work of three *amate* painters (figure 2.1). Amate painting, or bark-paper painting, owes its existence largely to tourism (Stromberg 1984) and is usually sold in the marketplace or on the streets, but not in Mexico City art galleries. It is popular art. The gallery dealer collaborated with a neo-Mexicanist painter (Puerto Rican born) and an American anthropologist.

"We tried to make an exhibit which showed a type of Mexican popular art called amate," the young gallery dealer explained to me. "I had to go to an indigenous area in Guerrero [a state south of Mexico City] to pick these paintings up. . . . [My artist friend] and I picked out the work together."

He continued, "An American anthropologist wrote a text which was interesting because it spoke of the anthropological aspects of these painters' works. She wrote about the artists, their iconography, and all that. For me it was interesting, and because this is a gallery of contemporary art, the text helped to justify our interests in popular art. Generally this art is considered [by the rest of the art world] 'folk' or, perhaps better put, 'artesanías,' like 'crafts,'" he said, picking his synonyms from English. "At the last minute, however, we had a disagreement over her text. To me it was too anthropological. What I wanted to focus on was the aesthetic aspect of each painter," he stressed, as if to enact the 1920s reaction of the bourgeoisie to the

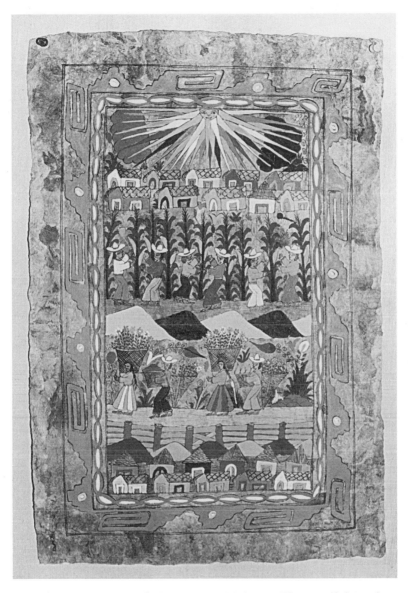

FIGURE 2.1 Simaco Hernández, *Labores del Campo*. Photograph by author.

Mexican policy of *indigenismo* promulgated by the founding father of Mexican anthropology, Manuel Gamio, along with his colleague, Vasconcelos.

"Each of the exhibitors had many followers in their hometowns, but [the ones we chose] represented the best examples of what was being done in amate painting at the moment. I wanted to emphasize that these painters were more than just painters of the popular art of amate painting but were each individual artists and had developed their own personal language.... [We sold them for] 100,000 pesos, about $100. Each was an original work. It was a gift." The dealer paused and added, "But we wanted to offer them at low prices because we didn't want to put them at the price of a Venegas [whose work dealers and artists often describe as "primitive"], because it is another thing. The amate paintings continue to be arte popular," he concluded. Despite the aesthetic aspects the gallery dealer and others attributed to them, the gallery setting did not make amate painting into bellas artes.

In conclusion, painting on canvas is, in most cases, "arte," while amate painting is, in most cases, arte popular—unless painted by an artist. If the amate painters were considered artists, the dealer may have shown their work along with other paintings by artists like Venegas, but mixing the two professions (except for didactic purposes) is rarely considered.[7] He understood the context in which he was operating; those in the art world, public and private, including many of his peers, draw the boundaries between bellas artes and artes populares by carefully maintaining the boundaries between artist and artisan.

Mexican artists and other cultural elites have a clear idea where the boundaries lie, and although these boundaries vary with generation, class, and geographical location—and therefore may not mirror INAH and INBA's criteria—they are always drawn, despite how blurred those boundaries may appear to an outsider. "When we [young Mexican artists] talk about folklorization," artist Adolfo Patiño (b. 1954) explained to me, "we mean to say that there are artisans who believe that they are artists ... and there are artists who work like artisans.... In my judgment, an artist who works like an artisan could be German Venegas, who gives his woodcarvings a popular art value. They are defined, clean, and well done. But his art work is not folklórico like artesanías; it is art."

INSTITUTIONALIZED REVOLUTIONARY "ART"

The government's nationalistic mandate and its public policies have both enhanced and haunted the twentieth-century Mexican art world. On the one hand, the mandate has been the art world's (and other elite's) greatest ally because it has financially and ideologically supported much art production. On the other hand, it has been the art world's relentless nemesis because it challenges its Western proclivities and sensibilities. The two overarching questions that characterize postrevolutionary art appreciation in Mexico City might be articulated as follows: How much of the indigenous culture can artists and dealers incorporate into their work without appearing folklórico? And, how much of the Euro-American avant-garde modernism and now "postmodernism" can artists include in their work without appearing to violate their national identities and cultural autonomy? The task, Pierre Bourdieu (1984:1) noted in another context, is "to establish the conditions in which the consumers of cultural goods, and their taste for them, are produced, and at the same time to describe the different ways of appropriating such of these objects as are regarded at a particular moment as works of art, and the social conditions of the constitution of the mode of appropriation that is considered legitimate." While few art-world elites—painters, dealers, or critics—fully endorse the propositions of cultural nationalism, fewer are able to ignore them because nationalism pervades the art world in many different ways. Like the gallery dealer intent on exhibiting amate painting as art—stating that the cultural products of non-European-oriented Mexicans are as good as those informed by Western sensibilities and training—Mexican artists, dealers, and critics have for the past seventy years formed their artistic identities within the tensions produced by the bourgeois-revolutionary fabric.

The art world is constructed with two opposing authenticities. The ideology of cultural nationalism locates (popular Mexican) authenticity in a common Indian past; the bourgeoisie locates (artistic) authenticity in the avant-garde and the unique. If Mexican artists are not visibly nationalistic, they are not honoring their country and themselves and may risk being labeled "anti-Mexican" or "foreign" by public or private consumers. Because nationalism composes such a significant part of one's identity in the Mexican art world, these are harsh accusations. Yet artists, to be players in the contemporary, in-

ternational art world, must address the principles on which that world is built—that "fine" art is more valued than "popular" craft and that artists are more valued than artisans. Ultimately, the appropriation to which Bourdieu referred is part of a larger political process of identity politics and group formation characteristic of revolutionary Mexico.

A PORTRAIT OF THREE ARTISTS

A brief portrait of three eminent artists—Diego Rivera, Rufino Tamayo, and Francisco Toledo—their modes of appropriation, and some of the discourses that surround their works will help to illustrate the politics and processes of identity politics involved in the production of "fine" art in Mexico (figures 2.2, 2.3, and 2.4). All three strategized their "national" identities differently, their strategies prominently occupying center stage in the Mexican art world at different periods during the century. All have been trumpeted, at one time or another, as the most important living Mexican artist. First, it was Diego Rivera (1887–1957) who broadly speaking for the first half of the century occupied this position. He was followed by Rufino Tamayo (1898–1991), who dominated most of the second half of the century, and now there is Francisco Toledo (b. 1940).[8]

DIEGO RIVERA

Diego Rivera, by far the most vocal and well known of the Mexican muralists, took it upon himself, throughout his career, to confront and deconstruct the bourgeois, neocolonial prejudices that isolated art from "the people" and from national identity. Due to Rivera's close friendship with Vasconcelos and his aggressive personality, he was considered by many to be *the* man responsible for creating the visual vocabulary of the revolutionary government. In his painting he both glorified Indians and gave them a place in history. While he depicted the Indians as acted-upon by others during the initial stages of European contact and throughout the colonial period, Rivera also painted Indians as actors (occasionally leaders) in his pre-Columbian scenes (as builders of temples and ceremonial centers, and as master craftspeople), in his colonial scenes (as literal forgers of Mexico's future history—as artisans, miners, laborers, and farmers), and in his twentieth-century scenes (as heroes of the revolution and builders of

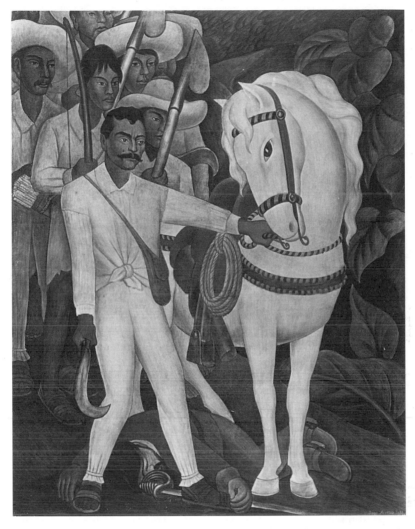

FIGURE 2.2 Diego Rivera, *Agrarian Leader Zapata*, 1931. Museum of Modern Art, New York.

the new republic). Fashioning himself as a wizard and his painting as sympathetic magic, Rivera intended his public works to have direct consequences for "the people," and that included the living descendants of pre-Columbian Indians. In contemplating his life's work, he wrote, "I sought to be . . . a transmitter, providing for the masses a synthesis of their wishes so as to serve them as an organizer of consciousness and aid their social organization" (Franco 1970:89). Rivera

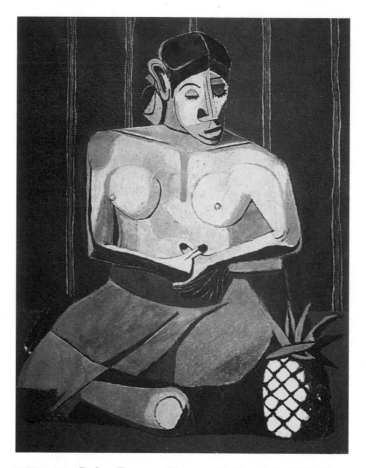

FIGURE 2.3 Rufino Tamayo, *Woman with Pineapple*, 1941. Museum of Modern Art, New York.

felt personally responsible for the valorization of the indigenous peoples (see Trotsky 1938).

For young artists today, Rivera seems hopelessly romantic and his paintings quintessentially folkloric. In his own time, however, Rivera's critics thought much worse things. They called his painted actors "Rivera's monkeys" (Herrera 1983:82). Even the revolutionary sensibilities of José Vasconcelos, architect of the Mexican mural renaissance, were challenged when Rivera assumed too much of a populist orientation. While Vasconcelos and other ruling elites sponsored the painting of such popular figures as Emiliano Zapata and Pancho Villa, both prominent revolutionary leaders, they in fact never placed their full

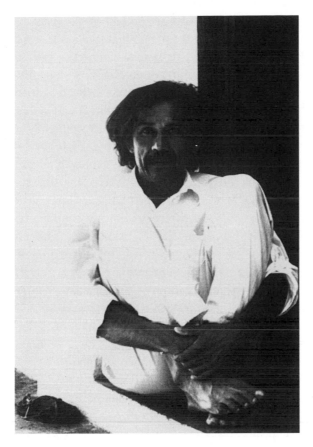

FIGURE 2.4 Francisco Toledo. Photo © Carole Patterson.

support behind either Zapata or Villa. Indeed, Vasconcelos hailed not from the populist side of the revolution but from the more intellectual side, as exemplified in the image of Mexico's first revolutionary president, who was not a rough, grassroots leader as was Zapata, but the Paris and Berkeley, California–educated Francisco Madero (Franco 1970:85).

It was Diego Rivera's insistence on depicting an antibourgeois aesthetic that included not only painted examples of artesanías but artisans themselves that helped earn him and other muralists the reputation as a painter of "monkeys." Muralist José Clemente Orozco (1883–1949) did not support Rivera's style or the attention Rivera and others paid to the Indian in their painting. Rejecting it, Orozco said of

such depictions, "they led me to eschew once and for all the painting of Indian sandals and dirty clothes. . . . I do wish that those who wear them would . . . get civilized. But to glorify them would be like glorifying illiteracy, drunkenness, or the mounds of garbage that 'beautify' our streets, and that I refuse to do" (Charlot 1962:226–27; Franco 1970:90–91). Orozco had a modernist, bourgeois orientation, one that located art and artists above artisans and artesanías. He compared it to the universal, which to him stood diametrically opposed to the local; it was a sensibility that prevailed (and continues to prevail) alongside the national rhetoric of Mexicanness. It was also one that reflected a deep ambivalence toward the Revolution's agenda to incorporate local arts and people into its revolutionary community, albeit imagined, as Benedict Anderson (1983) would note. Orozco surmised, "The essential difference between painting at its noblest and painting as a minor folk art is this: the former is rooted in universal permanent traditions from which it cannot be torn apart, no matter what the pretext, the place, or the time, while folk arts have strictly local traditions that vary according to the customs, changes, agitations and convulsions suffered by each country, each race, each nationality, each class" (Charlot 1962:226–27; Franco 1970:90–91). Orozco was not alone in his thoughts.

In retrospect the muralist program could be shown to have appropriated folk arts and people but not elevated them, to have spoken for them but not with them, in short, that it was art *of* the people, as advertised in the syndicate's manifesto, but not *by* the people. Despite their overt differences, Rivera and Orozco, alas, shared a fundamental assumption: the indigenous peoples, as either glorified (by Rivera) or denounced (by Orozco), are not producers of cultural meaning. Either they are too unorganized, or they are too uncivilized; either someone must order them and speak for them as Rivera claimed was his goal, or they must shed their plight and "get civilized" as Orozco wished. In either case creation is the prerogative of the artist—the civilized, urbanized (white) male.

RUFINO TAMAYO

Rufino Tamayo, born only twelve years after Rivera, was never comfortable with the muralist's didactic program and eventually fled the Mexican art world to live for almost twenty years in New York and

Paris, where he became a successful painter of canvases as well as murals. It was not until the 1950s (and from then on only sporadically until the 1970s) that the government recognized Tamayo's work as exemplary of Mexicanness, but a postmuralist Mexicanness, which suited the image the government began to hold of itself as the head of a modern, cosmopolitan nation/state. Ironically, perhaps, this recognition first came in the form of a mural commission for the Palacio de Bellas Artes, although it followed on the heels of a retrospective of Tamayo's work at the Palacio held in 1948. With his years of European and U.S. experience, Tamayo's iconographically Mexican work was arguably stylistically located in the epicenter of the bourgeois, international, modernist movement. The paintings of Rivera and Tamayo stand for two different versions of painted Mexicanness. Throughout his long life, Tamayo focused on incorporating native peoples and traditions into his canvases in an effort to represent a Mexicanness that was neither ideologically focused nor folklórico. Tamayo is famous not for his socialist realism but for his renderings of a metaphysical, indigenous reality—a *"realismo mágico,"* as some contemporary artists categorize it.

To many Mexican artists, old and young alike, Tamayo more than any other artist is thought to have established in his paintings a personalized, noncentrist sense of place. The fact that Tamayo is from Oaxaca is important to note: not only because Oaxaca is known for its living Mexican traditions and, more than any other Mexican state, has offered a gold mine of icons of Mexican identity, but also because Tamayo speaks from the position of a *oaxaqueño*, as does Francisco Toledo. In this sense his Mexicanness is experiential and participatory, painting in the first-person singular, as opposed to the third-person narration of the muralists. Most significantly, however, Tamayo's paintings derive more from his use of pre-Columbian sculpture and contemporary Mexican crafts or artes populares than from any overt reference to actual, living peoples. Despite his focus on Mexican indigenous traditions, Tamayo rooted his images as much in European modernism as in Mexico's past. It is not surprising that the official acceptance of Tamayo in the 1970s and 1980s came at a time when the government had openly reestablished its links to the modern world, a link that began in the 1940s and 1950s as politically and economically more conservative and capitalistic administrations periodically came to power.

The break from the Mexican School was a political event in every way. When in the 1950s and 1960s a small but vocal group of artists, following the lead of Tamayo, began to challenge the hegemony of the government-sponsored mural program with less didactic and more painterly art works, nationalist critics accused these painters of being "anti-Mexican." Rather than proselytize the revolution's ideology with "drum and bugle aesthetics" (Paz 1993:260), Tamayo, according to Paz, had a "relationship to art [that] was more authentic than the Muralists" (259). "[P]opular plastic inventions . . . do not appear in [Tamayo's] painting because of wildly excessive nationalist or populist zeal. Their significance lies elsewhere. . . . Their value is affective and existential" (230). One can make an interesting comparison between Tamayo's paintings and the built forms of Tamayo's contemporary, Mexican architect Luis Barragán (1902–88), the father of the Mexican School of Architecture. Barragán is one of Mexico's most famous twentieth-century architects, known for the private homes he built for wealthy Mexicans (figure 2.5). He and Tamayo have been the most instrumental in bringing an awareness of the aesthetic dimension of Mexican crafts to their upper-class patrons. When Paz proclaimed the importance of artesanías to the art of the revolution, he probably had Tamayo in mind. Tamayo's paintings, like Barragán's structures, bring together large, flat surfaces of *rosa mexicana* (Mexican pink, an unofficial national color), brilliant yellow, and vibrant blue in a way that reminds one of a Mexican marketplace. Tamayo's paintings are firmly associated with the shapes of pre-Columbian sculpture and contemporary crafts, much as Barragán's houses are rooted in pre-Hispanic architectonic structures and contemporary artesanías. The work of both, however, reflects Western influence: Tamayo's painted forms are mixed with a European modernist palette and style, and Barragán's houses also draw heavily upon modernism.

One of the key representational strategies of Tamayo and Barragán is how these two artists conspire to render the artesanías referents (the actual objects of inspiration) placeless. That is, they are identifiably Mexican, sometimes identifiably Oaxacan, but they are of no particular place within Oaxaca (e.g., the marketplace). In a Tamayo painting or a Barragán house neither time nor place interferes with the aura of Mexicanness that surrounds them. The method of each is abstraction, and that is the method of modernism. The magical

FIGURE 2.5 View of a courtyard at Casa Prieto López with pulque pots, a "signature" of Barragán architecture. Photograph by Tim Street-Porter.

realism of Tamayo, therefore, straddles a Mexican regionalism, on the one hand, since it is evocative of Mexico, and, on the other hand, a non-Mexican modernism, since it draws upon the European avant-garde (Cardoza y Aragon 1986; Torres Michúa 1988/89).

In a 1989 interview Rufino Tamayo described how he found his life history spun into a web of half-truths promulgated by critics, dealers, and the government, in which his youth was characterized as *more* Mexican, *more* Indian, and *more* poor than it actually was, as if to counterbalance the strong influences of modernism found in his work. An interviewer asked him, "It is commonly believed that you experienced deprivation during your early days in Mexico City. We have been told that you were a poor Zapotec lad whose aunt sold fruit from a stall in the market. What was your adolescence in the capital like?" Tamayo replied, "Actually, I'm not Zapotec. I'm not Mayan or Aztec either; I am Mexican, a thousand percent. And, I wasn't poor. Of course, I had to work, but these are myths they write about me. My aunt was a wholesaler with a large fruit business. I helped her, of course, and so I was surrounded by tropical fruits," but this was not in the Indian marketplace (Esser and Nieto 1989:40). The practitioners of the antibourgeois, revolutionary rhetoric continue to seek their heroes in the popular sector of Mexican society, regardless of whether or not they were or are actually there, while their counterparts, the modernists, continue to extricate them from it. "Modern aesthetics," Paz wrote of Tamayo, "opened [Tamayo's] eyes and made him see the modernity of pre-Hispanic sculpture. Later . . . he appropriated those forms and transformed them . . . [an] impulse [without which Tamayo's work] would have dissipated or degenerated into mere folklore and decoration" (Paz 1993:234). A balance must be struck to mediate the tension that is produced from an agenda that is informed by other-than-revolutionary sources and programs.

FRANCISCO TOLEDO

Francisco Toledo shares much in common with Tamayo. Like Tamayo, Toledo was born in Oaxaca; his mode of appropriation is focused on the indigenous traditions, rather than the people, of Oaxaca; and his canvases have a strong modernist patina. In terms of his art, Toledo paints and sculpts the stories and myths he heard from his Zapotec-speaking grandfather. To him they are living traditions, not

just museum artifacts. However, despite their similarities Toledo's work stands in contrast to Tamayo's in significant ways: the most noticeable is Toledo's earthy palette and mythological iconography. Although in Toledo's canvases, prints, and frescoes there are no etherealized pre-Columbian sculptures or exaggerated market-place colors, it is not how and what Toledo paints that sets him apart. Instead it is Toledo himself—who he is and how he stands relative to indigenous peoples on actual as well as painted terms. Toledo adorns himself as a Mexican peasant and appears in Paris, New York, and Mexico City as a *campesino* in his *huaraches* or on occasion even barefoot, with his head shaded by the brim of a *sombrero*, out of which his thick, uncut black hair hangs long (figure 2.4). Toledo is from Juchitán, where he grew up speaking Zapotec and listening to his grandfather recite the legends of the Zapotec Indians (Peden 1991). His work is, in a sense, even more in the first person than Tamayo's. He really is Indian, but unlike the artesanías of other Indians, his work is considered "art" by the establishment, even while it draws heavily upon the world of artisans and even the materials of artesanías. As Mexican artist Adolfo Patiño put it, "We could say that the ceramics of Francisco Toledo are 'fine artesanías,' but it isn't true. It is art, no? Why? Because simply you are seeing that there is a creative definition which the popular artisans do not achieve, even though Don Francisco comes out of the Oaxacan popular art tradition; and he includes them, hints at them, and develops them in such a magnificent way. You can call it art. It is a pre-Columbian tradition because if you look through the ethnographic rooms or the archeological rooms at the Anthropology Museum [in Mexico City], you realize the rich imaginations those creators had, but you know that there were thousands of each figure there. You can see it. In Toledo's case there are not a thousand pieces. There is one."

Toledo's Indian persona and his bourgeois notions of "authorship," however, only partly describe the "artist." "The other thing, which is sort of odd but original," Oaxacan artist Emilio Sánchez pointed out to me in a 1987 conversation, "is the fact that Toledo has gone away from Mexico. The majority of his life he has spent outside of Mexico. He doesn't even live here, and nevertheless his childhood, his family, the Oaxacan ambiance have a lot to do with his development as an artist." Indeed, Toledo used to spend almost as much time in Paris and New York as he did in Mexico, although that has changed some-

what with his return to Mexico in the late 1980s. But to the people of Juchitán, which is home to the opposition political party COCEI (the Student-Worker-Peasant Coalition of the Isthmus of Tehuantepec) and place where both Rivera and Tamayo found many sources for their revolutionary iconization of Mexicanness, Toledo is a Robin Hood, spending much of the profits earned from the sale of his paintings (which average around $30,000) and prints on enhancing the cultural and the political activities there. Taking what he has earned from the rich and distributing it among the people, he has become, as Cynthia Steele put it, a "cultural decentralizer" (1992:150). In the contemporary context, where the struggle to incorporate the low into the high continues to preoccupy the Mexican artist's vision, Toledo contributes a variation on the theme quite distinct from his predecessors—one, I think, compatible with the postrevolutionary, postnational agenda the Mexican government's posture is most likely to assume in the twenty-first century.

BELLAS ARTES AND ARTES POPULARES REVISITED

To write about twentieth-century Mexico is to write about a country that struggles to balance the demands of nationalism with the demands of internationalism. Toledo presents himself as a barefooted Mexican Indian, but is careful to spend time at his studio in Paris; Tamayo "modernized" the voice of the other, while the government and critics kept his Indianness intact; Orozco denounced the indigenous peoples as "uncultured and monkey-like," while Rivera sang their praises before and after he wined and dined with the Rockefellers and the Fords. Both the adulation that native traditions receive from Mexican artistic, intellectual, and ruling elites, as well as the qualms elites have toward those traditions, dovetail with the politics of Mexico's postrevolutionary racial identity. "Today in strictly ethnic terms," Alan Riding reports, "90 percent of Mexicans are *mestizos* . . . but they cannot accept their *mestizaje*" (1985:3). Octavio Paz, in his essay on the Mexican character written over forty years ago, described the consequences of rhetorically embracing what in practice is rejected:

> When we [Mexicans] shout [in Independence Day celebrations] "!Viva México, hijos de la chingada!" [Long live Mexico, children

of the raped woman] we express our desire to live closed off from
. . . the past. In this shout we condemn our origins and deny our
hybridism. The strange permanence of Cortés [the Spanish father]
and La Malinche [the Indian mother, and Cortés's mistress] in the
Mexican's imagination and sensibilities reveals that they are some-
thing more than historical figures: they are symbols of a secret
conflict that we have still not resolved. When he repudiates La Mal-
inche—the Mexican Eve, as she was represented by José Cle-
mente Orozco in his murals in the National Preparatory School
[figure 2.6]—the Mexican breaks his ties with the past, renounces
his origins and lives in isolation and solitude. (Paz 1985:87)

In essence the mestizo lacks a "pure past," and this places Mexican
identity and authenticity in a state of constant emergence. The di-
lemma is the same as the artist's: how much a visible role should
the Indian and her/his artifacts play in Mexico's society, history, and
biology, and how much a role should the West play?

 To many in the upper and upper middle classes—not only artists—
blurring the boundaries between Indianness and one's Western,
bourgeois lifestyle might jeopardize a career; in the political world, it
can lead to an elite's success or failure. A notable example of the latter
is the presidency of Luis Echeverría. When President Echeverría
took office in 1970, he immediately talked in revolutionary terms of
Mexico's prehispanic origins, but that was what many of his predeces-
sors had done at each of their own inaugurations. It is the expected
rhetoric. However, when he removed all the Chinese vases and Per-
sian carpets from Los Pinos, the presidential residence, and ordered
them replaced with the weavings, paintings, and pottery of Mexican
artesanos, and, in addition, requested that all women attending state
dinners wear traditional Indian attire, the urban upper class was out-
raged (see Bakewell 1993).

 President Echeverría, according to Lomnitz and Pérez-Lizaur's
study of the Gomezes, an elite family in Mexico City, is remembered
as "the bad guy" who "served 'jamaica' water [an indigenous drink
made with hibiscus flowers] to Queen Elizabeth . . . [and] insisted on
foisting his lower class, *pelado* customs on the rest of Mexico" (Lom-
nitz and Pérez-Lizaur 1987:201). The Gomezes have never forgiven
him; it "was a mistake and an unforgivable offense," they cried, when
the President's wife not only donned native attire—an old theme, the

FIGURE 2.6 José Clemente Orozco, *Cortés and La Malinche*, National Preparatory School, Mexico City, Mexico. Archives from the Audio-Visual Unit, Art Museum of the Americas, OAS, Washington, D.C.

feminization of the other—to greet the Shah of Iran, but along with her husband "threw out all the *beautiful French* furniture and china and replaced them with *coarse Mexican* handicrafts" (210, my emphasis). "Pelado," according to the Gomez family, refers to a person "eating only tortillas, chile, and beans; having an uncultured form of speech; being lazy; and 'leading a promiscuous life'" (195)—a derogatory synonym for "Indian," in other words.

Linked by the government to the glories of the past, living Indians and artisans are often perceived as the debris left over from the Conquest, descendants of a violated and vanquished people, and derivative, rather than exemplary, of a once-glorious past. They are treated quite differently from the official promises of the revolution, protected as well as patronized but not exactly embraced by the government (cf. Cook 1983; Hewitt de Alcántara 1984; Lauer 1982; Rodríguez Prampolini 1982). It is a posture that García Canclini (1993) argues the government fosters because of the conflicts a traditional economy creates for capitalism. But this posture is engulfed in a complex cultural matrix. In a recent interview, Mexican textile artist Pedro Preux described the artisan's dilemma: "The artisan is overvalued [in the rhetoric] and given little support in real life; it is said that he is the glory of the fatherland, but he is given nothing with which to go on living. . . . Politics here [in Mexico] towards artesanías seem to me to be misguided" (García Bergua 1989:17). Echeverría's actions were those of a "pelado" because he integrated or mixed the culture of the indigenous peoples into his life too much—not a manly thing to do. Worse, it was for "all the world to see" (Lomnitz and Pérez-Lizaur 1987:201). This is not the image the bourgeoisie wants to project to the world. Echeverría defined Mexico's identity such that it appeared too Mexican, almost quaint, and too mixed up with the indigenous culture for the Gomezes' comfort.

THE BOURGEOIS WORLD ORDER

Despite the efforts of revolutionary governments in Mexico, the Mexican art world's eighteenth-century bourgeois roots run deep, as do its world view and constructions of difference. As anthropologist Michael Jackson noted, it was during the rise of the bourgeoisie in the late eighteenth century that activities considered intellectual, aesthetic, and moral in origin were separated out from activities consid-

ered manual and sensual in origin (Jackson 1989). One was culture, "in the normative sense," as Pierre Bourdieu put it (1984:1), the other nature. To the bourgeoisie, Jackson wrote, "Culture almost invariably designated the refined mental and spiritual faculties which members of the European bourgeoisie imagined set them apart from the allegedly brutish worlds of manual workers, peasants, and savages" (1989:120). The activities of the latter belonged not to culture and the fine arts but nature. It was in the "repudiation of the low," according to Stallybrass and White (1986:ix), that the European bourgeoisie was able to produce its "status and identity." The dichotomy between bellas artes and artes populares is rooted in the culture/nature dichotomy Jackson described, an essentially Western and bourgeois categorization.

When Pedro Preux, the young, urban (non-Indian) textile "artist" quoted above, was asked in a 1989 interview to comment on the relationship of artesanías to art for a left-of-center, Mexico City magazine, he stated confidently, "People forget that the traditional artisan is a product of rural labor who turns into an artisan between sowing and harvesting the fields. During that time, the artisan makes fabric because he needs clothing, makes ceramics because he needs cooking pots" (García Bergua 1989:16). In keeping with this, amate painters are artisans because they are rural peoples—campesinos—and paintings by campesinos are not art, but artesanías. Indeed, amate paintings are documents of country life. Like an illuminated book of days, they keep time with the actualities of a farmer's life. Within them people till the land, plant the seed, harvest the fruits, weave the baskets, go to church, and attend village weddings, fiestas, and funerals.

The consequence of the culture/nature dichotomy, Jackson argued, was the formation of a social order based on a culture/nature sociopolitical hierarchy, in which cultural products and activities associated with the intellect and morals were more privileged than the activities of nature associated with the senses, the hands, and the body. Indeed, the latter was not and is not of culture or, rather, Culture with a capital C. Within the bourgeois art world the artist is fashioned as a *cultured* individual, a man of the intellect, inspired by the spirit, and a kind of disembodied creator, while the artisan is conceived of as earthbound, of nature, a *campesino*, and body-bound, since he or she is considered a *hand*-laborer or manual worker. By implication,

the labor of farmers—if we explore the bourgeois model to its logical conclusions—is unintelligent and an-aesthetic. "One idealizes that the artisan is as great as the artist," Mexican artist Adolfo Patiño explained to me, "but it is not so. I am aware that simply what happens is that artisans arrive at creations unconsciously and nevertheless something curious happens. You become aware that they are accidents. When they discover one [successful accident], they make forty the same. Nothing more than with variations. The point is that there is no intention to transcend the simple fact of presenting the painted element, the utilitarian element, the clay vessel."

As Jackson concluded for the workings of culture, so we might conclude for the workings of bellas artes: "Culture has thus served as a token to demarcate, separate, exclude, and deny, and although at different epochs the excluded 'natural' category shifts about among peasants, barbarians, workers, primitive people, women, children, animals, and material artifacts, a persistent theme is the denial of the somatic [the body] . . . where our sense of separateness and distinction is most readily blurred" (1989:121). Moreover, Jackson noted, "Exclusion of the body from discourse went along with the exclusion of the masses from political life" (120), including exclusion from the art world. If the indigenous people's expressive culture, their arte popular and so on, are categorized as part of the archeological and historical record (INAH) and not as one of the "beautiful arts" or bellas artes, it is because contemporary Indians are linked more to the past than to the present in the minds of policy makers, artists, and others in the art world. Indigenous peoples, in other words, are thought to form a "human bridge" to the past, as Scott Cook noted (1983:59). As a bridge to the past, or as part of the archeological record, they are in essence people without a history they can call their own, separated from the contemporary art world in which the bellas artes mark (art) historical moments.[9]

It is this bourgeois world view that Jackson described, exacerbated by a prevailing revolutionary program that partly informs the distress of the director of a state-owned, fine arts museum, who in 1988 said to me, "I am opposed personally to the joining together into one place producers of artesanías and producers of arte." Her galleries, however, were located on the second floor of the National Auditorium, a complex in which weekly scheduled activities on the ground floor

attracted hundreds of thousands of visitors. Our interview followed on the heels of one of the National Auditorium's ground-floor shows, which featured that particular week handcrafted objects, food, and music of Oaxaca, the state most famous in Mexico for its artesanías and indigenous populations. "I think that there should not have been any relationship between the two," she continued. "I was against putting together Oaxacan food, artesanías, and art—all three important sources of Oaxacan culture. But I think that each one ought to have its own forum. Painting, in this environment, passes for artesanías, and artesanías could be confused with the arts and so on." In sum, the Oaxacan show was a festive, loud, sonorous, and odoriferous occasion with its song, food, and dance, where the persistent theme was the celebration, not the denial, of the somatic. To have mixed the two art forms would have been to have mixed intellect with body, culture with nature, high with low. Given the nationalistic agenda, it was not coincidental that the Mexican government scheduled the two events simultaneously. Nor was it coincidental, given the bourgeois foundation of that nationalistic agenda, that the paintings were hung in the galleries upstairs, elevated from the events downstairs.

DIMENSIONS OF DIFFERENCE

Today there is little discussion of Vasconcelos's cosmic race except in historical terms, and the collective fervor of the manifesto issued by the Syndicate of Revolutionary Painters was short lived. Mexico's "cosmic race" is a term that described an ideal but never an actual ethnic and racial reality. Indeed, its failure to resolve or even to characterize national identity is evidenced by the number of arguments that are battled out regularly in the daily newspapers even at present. When Vasconcelos proclaimed, "We are Indian, blood and soul," he did not say *body* and soul. The Gómez family, Lomnitz and Pérez-Lizaur point out, "recognizes its *mestizo* origins yet defines itself as Spanish, white, and typically blue-eyed" (1987:196), despite the fact that few have blue eyes. Today an average upper-class or upper-middle-class Mexican family has little contact with people of the popular classes, "except, of course, with their domestic servants," as one Mexican political scientist ironically put it in private conversation.

"Mestizo" may literally mean "mixed," but as constructed in upper-

class, bourgeois Mexican society—the society to which the Mexico City artist aspires—it can connote skin color, class, and level of "cultural" sophistication, a series of associations underscored by a porcelain figurine that Banamex, a government-owned bank until recently, was selling in 1988. Advertised in color in the major Mexico City newspapers and labeled MESTIZO, the figurine was cast as a dark-skinned, wandering laborer. Indeed, if you did not know that mestizo meant mixed race, you might conclude from a visual reading of the porcelain figure that mestizo meant dark, poor, and homeless.

The (Indian) artisan and his/her artifacts, while implicated in the artist's nationalist/bourgeois dynamic, serve as the other against whom the artist and, for that matter, intellectual and political elites differentiate themselves, structure their social worlds, and create their representations of national identity. While the Ministry of Tourism markets the artesanías of indigenous peoples as exemplary of Mexico's otherness (the best of the Third World), the Ministry of Foreign Affairs markets the "art" of its "artists" as testimony to Mexico's cosmopolitanism and internationalism. Interpretive authority over Mexicanness rests in the hands of a few privileged elites, not in the popular sector. With this in mind we might read something more into Orozco's mural than Paz suggested; not only do La Malinche and Cortés stand for a problematic inheritance, but, perhaps more significantly, La Malinche is silenced behind the strong arm of Cortés, which runs diagonally across her naked body as if to warn of some prohibition: "You are no longer our interpreter." When Vasconcelos made his famous pronouncement, "We are Indian, blood and soul. . . . The language and civilization are Spanish," he left the Indian speechless—silenced, like pre-Columbian sculpture.

In sum, to return to Liu's argument to which I alluded in the introduction, she poignantly states, "The metaphors and reasoning behind race and racial thinking provide a generalized model for building all sorts of communities, including those defined by different criteria of affiliation such as culture, ethnicity, or nationality" (1991:158). Indeed, the reconstruction of postcolonial nations has often included a process of building a single, all-inclusive ethnic authenticity somewhere outside or within an exclusive bourgeois hierarchy. Its constructed unity and distance are essential to the nationalist imagination. "When difference [among ethnicities] disappears in this way,"

Rowe and Schelling write, "the popular is made to appear as a single thing rather than a multiplicity," and therefore, I would argue, facilitates the controlled positioning of its relationship to elite culture. "This notion that there is one popular culture is a mark of populism: the long-lasting appeal of folklore in Mexico ... needs to be understood, therefore, in connection with the persistence of populism as a force" (1991:6), generated as much, if not more, by revolutionary rhetoric as by actual state policy. And, as they conclude, "The study of popular culture is incompatible with ascribing to the state a fictitiously neutral function, since what states have actually done is to seek to homogenize culture in order to consolidate the power of ruling groups" (10).

While Mexican artists do not necessarily seek to homogenize cultural difference in the way states do, the temporal, spatial, and symbolic shifts that occur in their works through processes of artistic production and appropriation, as briefly described above for the works of Rivera, Tamayo, and Toledo, have nonetheless contributed to the consolidation of ruling elite power. The investigation of popular culture in the context of Mexican nationalism "requires taking the cultural sphere as neither merely derivative from the socioeconomic, as a merely ideological phenomenon, nor as in some metaphysical sense preceding it. Rather, it is the decisive area where social conflicts are experienced and evaluated" (Rowe and Schelling 1991:12). Understanding the contingencies of value on which the terms "bellas artes" and "artes populares" rest, therefore, and the processes of inclusion and exclusion that support them is key to understanding constructions of revolutionary and now postrevolutionary Mexican identity and the dimensions of difference named in one of the most problematic ideological contexts within which the Mexican artist and artisan produce and shape—indeed, craft—their objects.

ACKNOWLEDGMENTS

I would like to thank Ken Newman, who at a critical time offered many wonderful and unique insights and crucial comments on the thesis advanced here. I would also like to thank the several artists quoted above, who have always responded graciously over the years to my probing questions. In addition many thanks go to Drs. William O. Beeman, Louise Lamphere, Shepard Krech III, and Barbara Ted-

lock, who made valuable comments and inquiries on earlier drafts. Mary-Anne Martin at Mary-Anne Martin/Fine Arts in New York was very helpful in locating artists and photographic reproductions of their works. The research was funded by a Fulbright Grant, a National Science Foundation Dissertation Research Grant, and a Thomas J. Watson, Jr., Institute for International Studies fellowship.

NOTES

1. This research is based upon fieldwork I conducted in Mexico City, Oaxaca, New York City, and Los Angeles between 1987 and 1993. Quotes from artists without references are taken directly from fieldwork interview transcriptions.

2. Some aficionados distinguish between the two; the former is more craft than the latter, so a basket may be arte popular if woven in a particularly fine way.

3. Compare with the French Revolution as theorized by Michelle Perrot and Lynn Hunt (Perrot 1990:1).

4. I am presenting here a different picture than that described by Rowe and Schelling, who state: "The problem of appropriate terms arises from the fact that 'popular art' (*arte popular*) and 'folk art' (*artes folklóricos*) presume an integration of different worlds which may be wishful thinking. *Artesanía*, in Spanish, has no such pretension, and is now the preferred term" (1991: 68). I have found that what is the "preferred term" depends entirely on the person with whom you speak. Often in conversation with Mexican cultural elites, as noted in note 2 above, "artesanías" incorporates tourist art and is more anonymous than "arte popular," which is a kind of "arte," albeit "popular."

5. See Griselda Pollock on hierarchies in the art world, especially gendered ones (Pollock 1988).

6. Foreign policy has changed dramatically since President Carlos Salinas de Gortari took office in 1988.

7. Indeed, those who do consider it are generally U.S. or European curators of Mexican art exhibits.

8. I have left Frida Kahlo out of this discussion because she was never touted during her lifetime as the quintessential Mexican artist by Mexicans. Indeed, she still is not by the government. It is very much an (upper class) male privilege. For the place of Frida Kahlo in this picture, see my forthcoming book (Bakewell 1996).

9. I am alluding to Eric Wolf's *Europe and the People Without History* (1982).

REFERENCES

Anderson, Benedict
1983 *Imagined Communities: Reflections on the Origin and Spread of Nationalism.* London: Verso.
Atl, Dr.
1922 *Artes populares en México.* México, D.F.: Editorial Cultura México.
Baddeley, Oriana, and Valerie Fraser
1989 *Drawing the Line: Art and Cultural Identity in Contemporary Latin America.* London: Verso.
Bakewell, Liza
1993 "Frida Kahlo: A Contemporary Feminist Reading." *Frontiers: A Journal of Women Studies* 14(3):139–51, 165–90.
1996 *Remembrances of Open Wounds: Betrayal, Nationalism, and the Legacy of Frida Kahlo.* Forthcoming.
Bayón, Damián
1987 *América latina en sus artes.* Paris: Unesco.
Beezley, William H.
1987 *Judas at the Jockey Club and Other Episodes of Porfirian Mexico.* Lincoln: University of Nebraska Press.
Bourdieu, Pierre
1984 *Distinction: A Social Critique of the Judgement of Taste.* Translated by Richard Nice. Cambridge: Harvard University Press.
Cardoza y Aragón, Luis
1986 "Toledo, tal vez." *México en el Arte* 13:49–53.
Charlot, Jean
1962 *Mexican Art and the Academy of San Carlos, 1785–1915.* Austin: University of Texas Press.
Cimet, Esther, et al.
1987a *Cultura y sociedad en México y América Latina: Antología de textos.* Colección Artes Plásticas, Serie Investigación y Documentación de las Artes. México, D.F.: Centro Nacional de Investigación, Documentación e Información de Artes Plásticas.
1987b *El público como propuesta: Cuatro estudios sociológicos en museos de arte.* Colección Artes Plásticas, Serie Investigación y Documentación de las Artes. México, D.F.: Centro Nacional de Investigación, Documentación e Información de Artes Plásticas.
Cook, Scott
1983 "Crafts, Capitalist Development, and Cultural Property in Oaxaca, Mexico." *Inter-American Economic Affairs* 25(3):53–69.
Corredor-Matheos, José
1987 *Tamayo.* New York: Rizzoli International Publications.
Debroise, Olivier
1983 *Figuras en el trópico: Plástica mexicana, 1920–1940.* Barcelona: Ediciones Océano-Éxito, S.A.
Esser, Janet Brody, and Margarita Nieto
1989 "Interview: Rufino Tamayo." *Latin America Art* 1(2):39–44.

Flores, Toni
1989 "The Center at the Edge: The Formation of Gender Identity, the Or-
 dinary Woman, and the Goddess." Paper presented at the American
 Anthropological Association 88th Annual Meeting, Washington,
 D.C., November.
Franco, Jean
1970 *The Modern Culture of Latin America: Society and the Artist.* Rev. ed.
 Harmondsworth, England: Penguin Books.
García-Bergua, Alicia
1989 "El tejido de la experiencia: Entrevista con Pedro Preux." *La Jornada
 Semanal: Nueva Epoca* 17 (October 8):15–17.
García Canclini, Néstor
1993 *Transforming Modernity: Popular Culture in Mexico.* Translated by
 Lidia Lozano. Austin: University of Texas Press.
Goldman, Shifra
1981 *Contemporary Mexican Painting in a Time of Change.* Austin: Univer-
 sity of Texas Press.
1985 "Elite Artists and Popular Audiences: Can They Mix? The Mexican
 Front of Cultural Workers." *Studies in Latin American Popular Cul-
 ture* 4:139–54.
Goldwater, Robert
1947 *Rufino Tamayo.* New York: Quadrangle Press.
Herrera, Hayden
1983 *Frida: A Biography of Frida Kahlo.* New York: Harper and Row.
Hewitt de Alcántara, Cynthia
1984 *Anthropological Perspectives on Rural Mexico.* London: Routledge and
 Kegan Paul.
Jackson, Michael
1989 *Paths Toward a Clearing: Radical Empiricism and Ethnographic In-
 quiry.* Bloomington: University of Indiana Press.
Lauer, Mirko
1982 "Identidad, indígenas, indigenismo (tres tristes trampas)." *Artes Vi-
 suales e Identidad en América Latina.* México, D.F.: Foro de Arte
 Contemporáneo.
Liu, Tessie
1991 "Race and Gender in the Politics of Group Formation: A Comment
 on Notions of Multiculturalism." *Frontiers: A Journal of Women Stud-
 ies* 12(2):155–65.
Lomnitz, Larissa Adler, and Marisol Pérez-Lizaur
1987 *A Mexican Elite Family 1820–1980.* Princeton, N.J.: Princeton Uni-
 versity Press.
Paz, Octavio
1985 *The Labyrinth of Solitude and The Other Mexico, Return to the Laby-
 rinth of Solitude, Mexico and the United States, The Philanthropic Ogro.*
 New York: Grove Press.
1987 "Tamayo en la pintura mexicana." *Rufino Tamayo: 70 años de crea-
 ción.* México, D.F.: Instituto Nacional de Bellas Artes, Museo de Arte

Contemporáneo Internacional Rufino Tamayo, y Museo del Palacio de Bellas Artes.

1993 *Essays on Mexican Art*. Orlando, Fla.: Harcourt, Brace, and Co.

Peden, Margaret Sayres

1991 *Out of the Volcano: Portraits of Contemporary Mexican Artists*. Washington and London: Smithsonian Institution Press.

Perrot, Michelle

1990 "Introduction." Pp. 1–5 in *A History of Private Life: From the Fires of Revolution to the Great War*, ed. Philippe Ariés and Georges Duby. Cambridge: Harvard University Press.

Pollock, Griselda

1988 *Vision and Difference: Femininity, Feminisms, and the Histories of Art*. London: Routledge.

Riding, Alan

1985 *Distant Neighbors: A Portrait of the Mexicans*. New York: Alfred A. Knopf.

Rodríguez Prampolini, Ida

1982 "Comentario de identidad, indígenas, indigenismo (tres tristes trampas)." *Artes Visuales e Identidad en América Latina*. México, D.F.: Foro de Arte Contemporáneo.

Rowe, William, and Schelling, Vivian

1991 *Memory and Modernity: Popular Culture in Latin America*. London: Verso.

Stallybrass, Peter, and Allon White

1986 *The Politics and Poetics of Transgression*. Ithaca, N.Y.: Cornell University Press.

Steele, Cynthia

1992 *Politics, Gender, and the Mexican Novel, 1968–88*. Austin: University of Texas Press.

Stromberg de Pellizzi, Gobi

1984 *El universo del amate*. México, D.F.: Museo Nacional de Culturas Populares, Secretaria de Educación Pública.

Torres Michúa, Armando

1988/89"En el homenaje a Tamayo." *Artes Plasticas: Revista de la Escuela Nacional de Universidad Nacional Autónoma de México* 2(December–February):67–75.

Trotsky, Leon

1938 "Art and Politics: A Letter to the Editors of Partisan Review." *Partisan Review* 5(3):3–10.

Wolf, Eric

1982 *Europe and the People Without History*. Berkeley: University of California Press.

3 SPACE, POWER, AND YOUTH CULTURE

MEXICAN AMERICAN GRAFFITI AND CHICANO MURALS IN EAST LOS ANGELES,

1972–1978

MARCOS SANCHEZ-TRANQUILINO

Visual environments orchestrate signification, deploy and stage relations of power, and construct and embody ideologies through the establishment of frameworks of legibility. Such frameworks incorporate and fabricate cues as to how they are to be reckoned with by individual subjects and groups.
—Donald Preziosi, *Rethinking Art History: Meditations on a Coy Science*

In print as well as in person, I often use the quotation "A Chicano is a Mexican American who does not have an Anglo image of himself" as a basic working definition for politicized Mexican Americans, that is, "Chicanos."[1] This citation, excised from an important article by

Rúben Salazar, signifies the dividing line between politically conscious Chicanos and other Mexican Americans who follow a less politically resistant and more culturally conformist "American" identity, or who otherwise prefer not to be identified with the particular goals of *Chicanismo*, the political ideology of the Chicano civil rights movement of the 1960s and 1970s (Salazar 1970).[2] While I find the Salazar quote most useful, I use it with caution so as not to disregard the political activity by earlier generations of Mexican Americans or, especially here, to lose sight of those Mexican Americans in the process of *becoming* politically aware.[3] Indeed, the following case study involving the painting of murals on walls previously marked by the very same persons with graffiti is at the core of the relationship between "Chicano" murals and "Mexican American" graffiti. It involves understanding what is personally and communally at stake when one undertakes to survive simultaneously as a part of two communities: the established Mexican American youth gang culture and the emergent Chicano culture of the early 1970s. My analysis of this cultural discourse is dependent on mapping out the differences between these two communities, whose identities—the former established, the latter emergent—at times conflate so as to appear as one under certain cultural circumstances.

In order to follow the discourse between nonpoliticized gang youth practices/Chicano community politics and Mexican American graffiti/politicized Chicano murals, I focused on this interaction as it was taking place at a large, government-subsidized housing project and other poor and working-class areas of predominantly Mexican American residents in East Los Angeles. While I will be relating information that concerns the behavior and beliefs of Mexican American gang youth, I do so not to glorify or condemn them but rather to shed light on one aspect of negotiating Chicano cultural survival, not only through the politics of what constitutes "art" but also through an examination of how identity is constructed as part of the process of making artistic form and content "readable" in a particular context.

Given the profound lack of understanding of Mexican American and Chicano culture and history in this country, I, as a "minority" art historian and cultural analyst, undertook to reveal (for myself if for no one else) the connections between "art" and "graffiti" as they existed in my own backyard. My goal for doing so was twofold. As a product of the Chicano Movement, I wanted to participate in uncov-

ering whatever cultural contributions the Chicano *barrio* had to make to *itself*. That is, in my case, to clarify the contributions of so-called graffiti as seen throughout East Los Angeles in terms that were understandable within its own developmental and functional contexts and not dependent on legitimizing structures of dominant Anglo society for its value. Indeed, by that measure Mexican American graffiti could only be continued to be assessed as vandalism. Simultaneously, my objective was to understand the machinations for creating and perpetuating stereotypes in order that I might participate in their dismantling.

It is crucial that the reader be reminded that the persons about whom I am speaking in the following essay constitute one example of the myriad of cultures that presently make up the diverse U.S. urban youth populations.[4] All of the Chicano artists and Mexican American gang youth referred to in this paper speak English, and while some are bilingual in different ways, they all consider themselves "Americans." Throughout the following discussion, as a way to signal the dialectical relationship between Mexican Americans and Chicanos, I will continue to use the term "Mexican American" to indicate a political identity that is *prior* to that of "Chicano."

MI CASA NO ES SU CASA

As part of this country's 1976 bicentennial celebration, the predominantly Mexican American residents of the Estrada Courts in East Los Angeles were honored by having their government-subsidized housing project included as one of 200 locations in the national "Horizons on Display" program.[5] They were enlisted into the official celebration because the Estrada Courts mural program had met the selection criteria. In a letter to the Courts' mural program director, Charles W. "Cat" Felix, President Gerald R. Ford commended the Estrada community for exemplifying the principle that "America was founded on the conviction that individuals can join together in common purpose to resolve their differences and build a life of freedom, opportunity and achievement" (Pinke 1984:104).[6] The irony of this situation was lost on President Ford as a representative of dominant culture. For while his statement was true of the Courts' artistic achievements, the fact that they came about was due more to dissent and resistance to the "American" paradigm. In this paradigm, conquered ethnic

peoples and the immigrant poor, as exemplified by many of the Courts' residents,[7] are typically positioned as voiceless by the dominant Anglo society in this country.[8] Nevertheless, the residents' achievement deserved the praise, for the murals at Estrada Courts have become a record of a community determined to succeed, to a large extent, on its own terms.

The common purpose referred to in the letter from the White House was the monumental achievement of the Residentes Unidos (United Residents) of the Courts, who transformed their drab, graffiti-littered housing project into what they perceived as a unified residential community.[9] The many walls of the project, previously marked for years by barrio calligraphy or Mexican American graffiti, had been, since 1973, painted with highly acclaimed Chicano murals.[10] Through the painting of Chicano murals, the Estrada Courts' residents had managed to (ostensibly) suppress the writing of graffiti on their project's walls, which popular social conventions held as signalling vandalism and a lack of residential pride.

Between 1973 and 1978, except for the few invited, nonresident Chicano artists, the eighty-two murals at Estrada Courts were produced by the artistically untrained, supervised youth (males and females) of the housing project, who included many members of the resident youth gang known as Varrio Nuevo Estrada, or simply, the VNE.[11] The transformation of their environment was publicly perceived as a relatively straightforward effort involving the displacement of Mexican American graffiti by Chicano murals.[12] This paper, however, questions the accuracy of that public perception. Furthermore, because the very same youngsters who painted many of the murals at Estrada Courts had previously marked the area's walls with their *placas* (see below), it is also my belief that the murals' form and content were both influenced and informed by the earlier practice of barrio calligraphy as well as the overall social characteristics of youth gang culture.

It is my contention that *placas* or *plaqueasos*, the name given to the unique form of graffiti insignias developed by Mexican American barrio calligraphers over several generations (figure 3.1), is not vandalism at all but rather a visual system developed by Mexican American graffiti writers themselves to keep a public check on the abuse of power in the streets.[13] While vandalism tends to appear randomly without regard to the normative function of the surface on which it occurs, placas systematically occupy specific surfaces relevant to the

FIGURE 3.1 VNE placas (1973), Olympic Boulevard, Estrada Courts Housing Project, East Los Angeles. Photograph by Kazuo Higa.

Chicano youth street culture. Close observation of the public place-
ment of placas reveals that they are consciously written or spray-
painted on surfaces pertaining to buildings located on the periphery
of youth gang territories. The content of these inscriptions also fol-
lows an established system for conveying information.

Following barrio-developed conventions for encoding information
that is visible to everyone but "readable" by only a few, the placa's
emblematic design provides timely and vital details in a quick visual
format to the inquiring street reader.[14] Included among the "street
intelligence" decipherable from Mexican American graffiti by a youth
gang associate or "homeboy"[15] is the name of the youth gang that
monitors the immediate area where the placas are visible, its territo-
rial size, and its fighting strength. The inscription is always written
by an individual who places him- or herself in a hierarchical context
indicating his or her relationship to the youth gang. When the name
of the individual writer is included, it is usually in the form of a *nom
de guerre* or street name and invokes either a physical or behavioral
characteristic, such as *El Gato* (The Cat), *El Oso* (The Bear), *La Mou-
sie* (The Mousie), and *La Loca* (The Crazy One). The size and
strength of the youth gang is conveyed through clusters or lists of

names as part of an insignia as well as through encoded references to its cliques or age-ranked cohorts, for example, "VNE Ds" (the Dukes cohort of the Varrio Nuevo Estrada youth gang or barrio) and "VNE Sharks" (the Sharks cohort of the Varrio Nuevo Estrada youth gang). A *cris de guerre*, motto, or "power phrase" not only affirms the youth gang's territorial claims but also underscores the ferocity of the youth gang's fighting strength first alluded to by individuals' street names and cohort names such as "bear," "cobra," "sharks," or "crazy." Coded mottoes such as "R" or *Rifan* (Rule or Excel) and "C/S" or *Con/Safos* are two of the oldest still in use.[16]

An understanding of the relationship between Mexican American graffiti and Chicano murals is accessible only through an appreciation of what the encoded graffiti component brings to bear upon the apparently more easily interpreted figurative mural component. In my attempt to bring the two divergent visual components of graffiti and murals into an analytic model for understanding their interdependence at Estrada Courts, a basic lesson in reading placas is required. Following is a generalized interpretation of the placas at Estrada Courts as represented in figure 3.1; the awkwardness of the reading is due to my brokering of the translation of these insignias, which are simultaneously informed by English and Spanish, as well as the *Caló* or *Pachuco* and *Cholo* patois. An absolutely necessary but unspoken relationship implied in the writing and reading of placas is that their encodings are specifically directed at other members of the youth gang culture and not at all to the general public, who are considered to be "civilians" in their world of barrio warriors. The act of decoding positions the reader as a homeboy or a homegirl.

The overall meaning, stated and implied, of the VNE graffiti in figure 3.1 is: "Be warned, you are now approaching the home of the Varrio Nuevo Estrada youth gang territory. *Rifamos* (We rule it); the ubiquitous placement of our placas at this location is an indication of our unquestioned authority here. These placas, written in the appropriate established form and containing all of the necessary references of street visibility and authority, delineate the size of our territory and are clearly placed on its periphery so as to avoid any confusion. As you know, if you are considering entering you must do so through the appropriate sponsorship of any one of our active members listed before you, or through a *veterano* of this barrio. Should you be considering an attack upon one of our members, be assured that it will be

considered an attack upon all of us. In our placa name lists and clusters you are welcome to count how many members are currently associated with us and then make your final decision; as you know, our placas are both a clear message and challenge to you from all of us, including all of our *Cortes' klikas* (Courts' cliques), but especially from the toughest members of the highest ranks of the VNE, namely, the Dukes, the Cobras, and the Sharks. Our individual reputations are in allegiance to the VNE. We don't want any hassles from you, but we are ready if need be; we are the best defenders of our barrio—number one—and we can back it up."[17]

ART HISTORY QUE?

Through the use of a methodology primarily consisting of historically rooted semiological analysis, my objective was to understand how the murals were able to *displace* the graffiti at Estrada Courts, from the perspective of reading muralism and graffiti as contending systems of meaning or signification.[18] That is, my objective is to examine graffiti and muralism not as already given categories of an external and imposed *discourse* on art into which one assigns particular cultural practices—in this case, public writing and public art, respectively—but to interpret them as languages, systems that produce specific meanings in and through "intersecting systems of historical constraints" (Tagg 1988:3).[19]

Approaching the analysis of the interdependent relationships between Mexican American graffiti and Chicano murals from the perspective of contending cultural practices permits one to evaluate certain *effects* produced by the traceable intersections of each system across a complex array of possible historical strategies and negotiations. The outcome of such an approach is an understanding of the historical discourse between Mexican American graffiti and Chicano muralism produced in and through the development of the Estrada Courts murals. I contend that a photograph that depicts a mural surrounded by graffiti such as "The Black and White/Moratorium Mural" (figure 3.2) painted by Gronk and Willie Herrón at Estrada Courts *does not* represent a simple affirmation or evidence of a "graffiti problem" in this community, but rather visually demonstrates the very real contention between placas and murals for physical space and cultural representation.[20] The following discussion reveals that

FIGURE 3.2 Willie Herrón and Gronk, "The Black and White/Moratorium Mural," 1974–78, Estrada Courts Housing Project, East Los Angeles. Photograph by author.

similar occurrences of this contention where Mexican American graffiti and Chicano muralism were going through parallel negotiations were evident in other areas of East Los Angeles.

Prior to the present study, the relationship between graffiti and murals in Chicano barrios received a lot of attention, but little serious analysis. In particular, there has not been any discussion of what being "Mexican American" or "Chicano" means in this cultural context. Past conclusions on the function of graffiti or its relationship to murals have offered what amounts to a formulaic application of earlier models created by authors studying only graffiti.[21] Furthermore, approaching the interrelation between Mexican American graffiti and Chicano murals with methodologies that were developed for analyzing non–Mexican American graffiti tends to support conclusions about the relationship between these two practices that position graffiti as culturally inferior to the making of murals. Often, a positivist concept of evolution from lesser to better forms lies just beneath the surface of many of these approaches; thus, cultural and historical links between murals and graffiti are reduced to the expressive falla-

cies of the conditions of existence of their makers. In 1975, Kahn surmised that relationship between the two forms in East Los Angeles, the largest area of concentration of Mexican American residents in Los Angeles: "For the individual, his name means he exists. For the gang member who writes his name in coded script on a wall, he not only owns that part of the wall, his 'soul' is there. This need to have a visible identity is the very essence and reason for the Chicano mural, an art that depicts the destructive elements and bitter frustrations of existence in the barrio" (Kahn 1975:118). Unable to acknowledge a blurring of the interests of contending signs between muralism and graffiti, Kahn's commentary is unwilling to concede to the complicity of the speaker's preconditioning to culturally inflect what is "perceived." Thus, his conclusions are based on a negation of the required understanding of the complexity of the contextual specificity necessary for the interpretation of *process* or for an appreciation of the interdependence of one system of representation and another. In 1976, Goldman echoed Kahn's perception of the discourse between graffiti and murals as the transparent expression of social class: "From making *'placas'* (the solitary public expression of a voiceless, powerless adolescence) to participation in the organized awareness of a mural is an educative step of no mean proportions. It is the difference between fratricidal gang warfare—the internalization of oppressive social conditions—and externalized political struggle against the sources of oppression. Both the *'placa'* and the mural are forms of communication and affirmation of existence: one is individual and aimlessly aggressive; the other collective and directional" (Goldman 1976:75).

Neither of these analytical perspectives addresses the *political* differences between placa writers, who are relatively "unpoliticized" Mexican Americans, and Chicano muralists, who through their community-based work are following, constructing, and developing incipient Chicano liberation ideologies to varying degrees.[22] Implicit in these analyses is the assumption that both graffiti writers and graffiti writers-turned-muralists are somehow able to unproblematically exchange one identity for the other. As previously mentioned, how a switching of apparently disparate identities by gang youth took place without apparent compromise is at the very heart of the questions raised by this study. Indeed, as discussed below, even trained Chicano artists were unable to escape the politics of compromise and

identity and were fundamentally impacted both individually and communally.

The mural/graffiti debate divided artists in the Chicano community into two major camps. At the time, Judith Baca represented the view that placas were an evolutionary step in the development of graffiti into murals: "I think that the murals were a very natural extension of that graffiti because what happened is, I think, the graffiti made one kind of statement—'I am who I am' and 'This place, this is my neighborhood, I own this wall.' And I think the murals make a statement that is more complicated and can say many more things and it's a business [matter] of pride."[23] Barnett follows Baca's observational insights and contextualizes the relationship of Chicano murals to Mexican American graffiti as an art *ism*, that is, as logical extensions of art of protest coupled with an ability to signify a fixed and constitutive subject or identity. Barnett states, "Both are not only protests; they are also affirmations of the identity of a people" (1984:38). Romantic notions about the role of graffiti in society are similarly extended by Barnett to murals: "Graffiti and murals are types of struggle art by which people seek to survive as humans in an increasingly dehumanized world" (38).

As an artist, Willie Herrón represented the opposing camp, which felt that placas were a viable and original cultural form developed by barrio youth to interact effectively with one another. When he painted his memorable "The Wall That Cracked Open" mural in 1972, he integrated the local placas into the mural (figure 3.3).[24] He believed that this was the least he could do since his mural was, as he saw it, appropriating the space that belonged by custom to placas. While Barnett and others see murals as a nonproblematic development from graffiti ("Graffiti, like the murals that often follow them" [Barnett 1984:40]), Herrón's comments on first approaching walls to paint murals indicate a more complex social and cultural process that echoes Baca's characterization of a barrio calligrapher's "owning" a wall. Herrón's sensitivity to the tradition of placas had provided him with an understanding of the important prerequisite process necessary for creating graffiti or murals: wall appropriation. Without his having participated in the appropriation of barrio walls for writing graffiti as a Mexican American youngster prior to painting his first mural as a Chicano artist, he would not have had "the courage to approach a wall to paint in the first place" (Herrón, interview with author, Los Angeles, Decem-

ber 29, 1987).[25] Appropriately, Herrón's first two murals were painted in an alley in City Terrace, East Los Angeles, where normally one expected to find placas and *not* murals.

Returning our attention to Estrada Courts, I reiterate that in order to continue to understand how murals displaced graffiti there (or anywhere else), one cannot resort to "revealing" the expression of the historical conditions of a proud but defiant people, specifically "the solitary public expression of a voiceless, powerless adolescence," or to a mystifying appeal that art is inherently superior to graffiti by insisting that "one [the placa] is individual and aimlessly aggressive; the other [the mural] collective and directional" (Goldman 1976:75). The implicit basis for the general perception that one cultural practice (and, indeed, one culturally differentiated group of people) is superior to another is an uncritical, often unconscious, internalizing of notions in use by the dominant culture to support its various hierarchies of social value.[26] Writing of graffiti as improper social behavior becomes a way of discrediting barrio calligraphy because it is read in this context as public vandalism, while muralism is, conversely, read as a legitimate art form.[27] The position of muralism versus graffiti as analogous to art versus vandalism cannot be used to bring closure to a complex discourse. Rather, it should be taken as an indication of a debate, not between two given categories but between two signifying systems in which social value is produced in and through their constructed meanings as an integral part of the process of developing the painter's/viewer's subjectivity or identity. Tagg is clear on the acknowledgment of the social relations necessary for the construction of meaning in any system of signification: "To function as means of communication and exchange, systems of meaning must already contain social relations. Without shared conventions, patterns of usage and a community of speakers, we would not say we were dealing with a language at all" (1988:1). To *not* develop an analysis of graffiti and murals as signifying systems would reduce this analysis to a comparison between socially imposed categorical privileges to mark class difference, wherein art (murals) represents the values of dominant society and graffiti (barrio calligraphy) exemplifies the "subdominant" social values. Through commitment to a nontraditional art-historical analysis, it is then possible to understand that the *perception* of the "displacement" of graffiti by art at Estrada Courts was a cultural intervention deployed by the housing project's resident youths. The

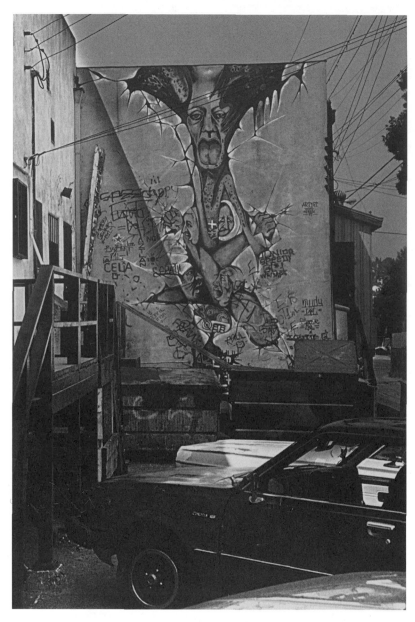

FIGURE 3.3 Willie Herrón, "The Wall that Cracked Open," 1972, alley in City Terrace, East Los Angeles. Photograph by author.

perception was not intended, however, to deliberately mislead the community or other viewers of the murals. Rather, because the youths' interests intersected with the interests other people had for the same walls, the result was a *blurring* of the signs of each contending system by the young Estrada Courts painters.[28]

The mural known as "The Sacrifice Wall" serves as an excellent example of a mural that can be shown to blur the signs between contending mural and graffiti practices as they were informed by the youth gang context. This design (figure 3.4) was based on a pre-Columbian ballcourt relief panel at El Tajín, Mexico, as depicted in a black-and-white photograph on a postcard provided by the mural program director, Charles "Cat" Felix. According to Felix, the Cobras, the older VNE *cliqa* ([or *klika*] clique or age cohort), had asked him for a design to which they could relate as a group and that could represent their contribution to the Estrada Courts' mural program. These older youths had been motivated by the responses of the invited nonresident artists to the mural program, who had been given their choice of the most visible wall locations along Olympic Boulevard for their murals. Alex Maya recalled that the VNE homeboys saw this as something of an invasion of *their* territory: "Artists from San Diego, San Francisco, the long-hairs from City Terrace who made those weird murals [Gronk and Willie Herrón]. . . . So a lot of the guys started saying, 'Yeah, yeah, let's do our own murals, we can't let all these guys have all these good walls.' And a lot of guys *did* make their own ideas. . . . And little by little some of the guys started taking more control of the situation—'Hey, we want this wall, we're gonna paint here!' Whatever, but mostly we were open to ideas. Sure! If somebody had an idea, fine, let'm go for it!" (Maya, interview with author, July 24, 1985).[29]

Through control of the content, the mural "The Sacrifice Wall" demonstrates Felix's desire for a suitable pre-Columbian subject sanctioned by prevailing Chicano cultural politics that was also capable of making a social comment against violence. Equally important to consider, for Felix, was the Cobras' need to relate to the figures as warriors. Felix realized that the warrior connection was crucial if his intervention on their behalf was to succeed. He was effectively able to bring these two interests together because he was a veterano, that is, a veteran of the Mexican American youth gang culture, who had learned the lesson of survival through the redefinition of postadoles-

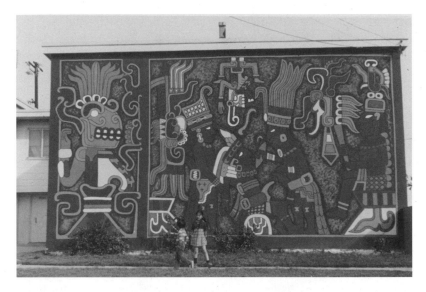

FIGURE 3.4 Charles W. Felix and VNE Cobras, "The Sacrifice Wall," 1974, Estrada Courts Housing Project, East Los Angeles. Photograph by Kazuo Higa.

cent personal goals.[30] He had purposely chosen the image in order to have the youths produce a visual interpretation of the biblical dictum, "Those who live by the sword, shall perish by it." In other words, Felix had the toughest members of the VNE paint a composition in which they would see themselves as warriors and, in seeing themselves in this way, would have to confront the fullest implications of their choice: death.[31] Interestingly, Felix's personal interests also included world mythologies, and many of his other nonmural works involved the representation of war gods and heroes from Greek and other classical mythological narratives. When asked why he chose the pre-Columbian panel from El Tajín instead of a scene from the life of Odin (the Norse god of war), he responded, in a deliberately coy manner typical of veteranos, which always masks that which is of real importance to them: "It could have been something else, it just happened to have been that." He added: "I did [choose it] because it was a pre-Columbian piece and it was warriors, and these youngsters were warriors. So, it was something pertaining to that—you know—

not necessarily that they want to be warriors, but there was also the other side of death. That it's going to catch you. You know it, if you're out there. You're gonna die if you keep messing with it. That was the thing" (Feliz, interview with author, October 17, 1984).

The appropriation of the pre-Columbian genre was a major tool of cultural reclamation sanctioned by the political tenets of early Chicano Movement ideology, and references to the pre-Columbian past abounded throughout the emergent Chicano visual, performing, and literary arts. "The Sacrifice Wall" at Estrada Courts reflected what was at the time considered an appropriate subject—one that visually demonstrated the cultural roots that politically conscious Chicanos shared with their Mexican antecedents and contemporaries. To some the mural may have represented a direct borrowing or copying from a "real" culture by a group of confused or uncritical Mexican American artists.[32] However, the manner in which this mural came into being at Estrada Courts reveals that the search for its legitimacy need not go further than the intersection of Olympic Boulevard and Lorena Street. This mural is integrally involved as a component of identity construction for Mexican American gang youth impacted and/or responding to the demands of Chicano liberation. The following discussion describes its role as a site for the negotiation between muralism and graffiti for both physical space and cultural representation.

The overall readability of this mural not only as "art" but also as a placa by writers and readers of Mexican American graffiti rested on the interdependent positioning of the writer and reader, through the mural's form and content, as a homeboy or homegirl. In terms of composition, the forms involved in the original ballcourt panel were attractive to these youths because, like those of graffiti insignia, these were also relatively flat and the spacing between them was absolutely balanced. The choice of subject matter was crucial in that the pre-Columbian figures, like the youths themselves who followed the fashion and behavior of the youth gang culture, were males dressed in ritual clothing and acting according to ritual behavior.[33] Signs of rank and power are evident in the figure performing the sacrifice in the modern mural; he is centrally visible, he wields the knife, and he is accorded special recognition by the inclusion of more feathers on his headgear than appear on the original pre-Columbian panel on which this design is based. Except for the two standing figures, most of the

major iconographical elements are springing forth from, standing on, or sitting on decorative bases, a common compositional element of Mexican American barrio calligraphy (Romotsky and Romotsky 1976:26). The skeletal figure on the far left also plays a compositional role similar to that of the "power phrase" or "C/S" symbol in plaqueasos, emphasizing the theme of power and danger, which was usually included beneath the central placa message.[34]

Whether the young men read Felix's message or their own, the mural demanded their attention because, like barrio calligraphy, it had been produced by them and depicted the strength or cunning of one group of "warriors" (youth gang) over the member "warrior" of another (youth gang) group. As demonstrated in the discussion of the meaning and purpose of the VNE placas in figure 3.1, graffiti is often encoded in stylized barrio calligraphy and therefore one message is clear to the Mexican American gang youths, while a different one is read by outsiders (i.e., non-gang youth) and other "civilians." Other murals painted by the resident youth at Estrada Courts can be similarly understood to represent a conflation of Mexican American graffiti and Chicano mural forms and contents. Smaller walkway-wall murals surrounding the periphery of the housing project also used imagery that included pre-Columbian iconography primarily to carry on the function previously served by placas: namely, that of displaying the youth gang's collective identity, cohorts, fighting strength, and ferocity, and of symbolically guarding the youth gang's territory. The members of the VNE youth gang could continue to be openly supportive of the "displacement" of their placas because, in fact, *they* did continue to be visible through encodings in the murals. This was possible because they were already familiar with methods for encoding vital street information in their graffiti insignias. However, the encoded visibility of the VNE youth gang culture was at stake when other murals were proposed that threatened to deconstruct their narratives of apparent personal transformation and graffiti displacement. One such mural proposed by Judith Baca, in particular, that sought to confront the negative aspects of youth gangs with its content was not approved by Felix, the mural program director, and it was never painted.

ENCOUNTERING ART

The rejection of her mural had the effect of proving once again to Baca what she had learned to be suspicious of: that the Chicano Movement, and Chicano art in particular, was directed predominantly by men who were unwilling to recognize the opportunity to open supposedly revolutionary social structures to greater participation by women. According to Baca, her proposed mural was turned down because it was interpreted as being "too negative." There is no doubt that Baca's mural design represented a critical assessment of the Mexican American youth gang culture at a time when the youth gang veteranos and other mural supporters were attempting to put forth a "positive" image of the Mexican American community. To them, that meant not promoting images of the gang youth culture that could be seen as an uncritical celebration of it by outsiders. Conversely, to the VNE members and their supporters, it also meant not allowing imagery that represented the defensive and offensive territorial strategies of Mexican American youth gang culture as nothing but destructive social behavior.

Both by conscious choice and unconscious effect, Baca's design reflected an unwillingness to blur the signs between youth gang–informed graffiti and Chicano art. Baca's personal background did not include immersion into the youth gang culture from a participant's perspective, as did that of Felix and the other Estrada Courts mural program managers. Although Chicana, her expertise in this discourse came through experience as a sympathetic "civilian" committed to working with youths from competing youth gangs. Her goals were more informed by a need to effect communication *across* territories, not to enhance or affirm youth gang turfs and their boundaries as unique or nondependent on each other for survival in a larger social context. In this particular instance, Baca's way of redirecting gang youth was at odds with how the Estrada Courts's veteranos had decided to proceed. At a time when merchants, police, and elected government representatives were being sold by the veteranos on the virtues of having organized, marginalized Mexican American youth paint murals, they felt the need to closely monitor the youths' public image. This meant that all of the murals at Estrada Courts, in contrast to Baca's proposed mural, must avoid overtly controversial political themes and traditional gang iconography.

It had been Baca's desire to paint her mural on the wall on busy Olympic Boulevard that now features "We Are Not a Minority," the 1978 mural painted by Mario Torero and his assistants.[35] Baca's finished drawing for the proposed Estrada Courts untitled mural focused on the pain and suffering of women as they have been historically impacted by different forms of male militarism (figure 3.5). She portrayed women as the ones ultimately responsible for putting a stop to the cycle of death initiated and maintained by male-directed acts of violence, including war. Her mural design begins by depicting a landscape inflected with female attributes. The mountain range in the background is symbolized by a woman whose outwardly stretched arms represent the terrain that encompasses a row of the Estrada Courts housing project buildings, which mimic the cemetery rows of the dead that lie at their doorsteps. A Mexican midwife assists a Mother Earth figure who is giving birth to men directly from her very veins. As the men grow, they group together and start a cyclic march of combatants that begins with Mexican revolutionaries, followed by Mexican regulars (such as those that fought at the Alamo), followed by Mexican American and Chicano troops of the World Wars, the Korean Conflict, and the Vietnam War. The march ends with armed homeboy youth gang warriors detained from proceeding further by a young mother's outstretched arm. This *madre joven* holds a male baby that cries in protest against the destructive aspects of this march of male violence. Like his mother, he also holds out his arm to halt the cycle. Other female figures, including *adelitas* from the Mexican Revolution, mothers, and female workers, are depicted with sorrowful facial expressions or hunched over crying for their dead boys and men.

According to Baca, her design had been inspired by a dream, which she interpreted to mean that she saw herself regarding her young male mural assistants as "underprivileged" in the sociological sense: as an outside observer might label them as victims of their marginalization by the larger society, and, in particular, by the Mexican American youth gang culture. Because she was unwilling to continue to see them as victims, she came to understand that their victimization was a symptom of a larger offense against women. Baca recalls: "I realized that I was treating the [gang] kids as victims and could only perpetuate their victimization unless I changed *my* approach to them. I became much more demanding after that. . . . [In the proposed mural]

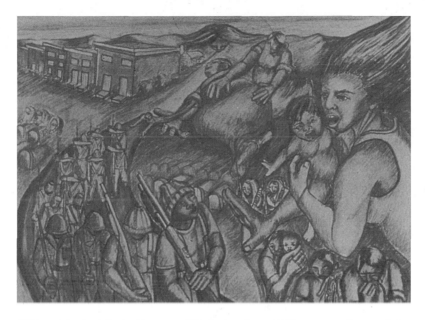

FIGURE 3.5 Judith F. Baca, untitled drawing, 1974, proposed mural for Estrada Courts Housing Project. Courtesy of Judith F. Baca.

I saw all the women in the projects victimized by the victim. The producer [the mother, the women] says that's enough. It called for active participation from mothers. *They* also needed to give the kids different treatment" (interview with author, July 10, 1986).

UNO, DOS; ONE, TWO, TRES, CUATRO!

The success of the Estrada Courts mural program was due to several factors, not the least of which was the context of community self-help inherent in El Movimiento (the Chicano civil rights movement), as well as the experimental context of the early stages of Chicano muralism in which the Estrada Courts' youth participated. The young painters were able to incorporate signs and themes into the new murals that would produce similar meanings for them as barrio calligraphy previously had done. However, what took place at Estrada Courts was more than a transparent incorporation of Mexican American graffiti into the murals' form. Ultimately, therefore, an evaluation of the murals' displacement of graffiti at Estrada Courts cannot be based solely on the disappearance of the recognizable graffiti. It must be

understood that because each signifying system is simultaneously one of representation, for the displacing system to be successful it had to meet the following criterion: to be able to continue to function as a means of representation for the graffiti writers as well as, or better than, the system it displaced. The following discussion of a periphery mural demonstrates the importance of self-representation for graffiti writers caught in the groundswell of the emergent Chicano mural movement.

The original walkway murals located in front of "Give Me Life" (figure 3.6), the first mural painted at Estrada Courts in 1973, points to their seminal role in the process of determining the formal and contextual cross-influences between Mexican American graffiti and Chicano muralism. Looking carefully at the repetitive abstract design painted on the left (by the Estrada Courts "kids," directed by Charles "Cat" Felix), it becomes apparent that it can also be read as a placa. What at first appears to be an abstract colorful design is actually the repetition of the initials of the Varrio Nuevo Estrada youth gang: VNE. Recalling the monogramatic techniques so often used in barrio calligraphy, the black "V" and the red "N" were made up of geometric elements, superimposed and connected so as not to stand out as the youth gang's initials, while the "E"'s three horizontal bars were attached to a white perpendicular post, with the center bar ending with a white "arrowhead." This repetitious pattern also resembles the pre-Columbian flat and roller stamp designs, which were used in other walkway murals throughout the periphery of Estrada Courts. This walkway mural was, in effect, a very long (approximately sixty feet) and ingenious placa or youth gang graffiti logo. This, of course, would have been apparent to the VNE as well as to youths from rival gangs. Thus, through innovation, the VNE youth gang was able to participate in the new "mural" practice and contribute to their barrio, while still achieving their goal of a visible collective territorial presence.[36]

It is crucial to understand that what has been discussed here is a process that, if it had been executed less subtly by the young Estrada Courts painters, would have produced another example of a Mexican American "graffiti mural" such as exemplified in the Ken's Market mural painted by Mexican American youth gang members supervised by Bill Butler, a non-Chicano artist (figure 3.7).[37] That mural included the placas of the young assistants as part of the composition

FIGURE 3.6 *a*, Los Niños del Mundo and Charles W. Felix, "Give Me Life," 1973, Estrada Courts Housing Project. Photograph by Kazuo Higa. *b*, Schematic drawing by author of left side of walkway mural. Note camouflage configuration of repeating VNE placa (logo) designed to appear as a "pre-Columbian" style design.

without employing the camouflage techniques at Estrada Courts. Had the same method been used at Estrada Courts, each of the eighty-two murals there would have included youth gang members' names, and the perception of murals having displaced graffiti would have never been possible.

What took place at Estrada Courts constituted a cultural integration of a greater scope, due in large part not only to the fact that the murals themselves were painted by gang youth conversant with barrio calligraphy, but more importantly that they were supervised by older, former members of Mexican American youth gangs. The young adults who provided leadership at Estrada Courts had survived the destructive youth gang lifestyle and were intent upon redirecting the lives of active youth gang members in more positive directions through Mexican American and Chicano *carnalismo* (neighborhood or group brotherhood) (Moore et al. 1978:77). These young men,

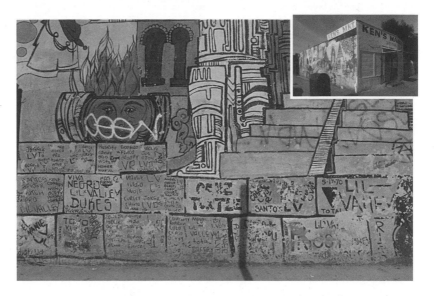

FIGURE 3.7 Detail of placas from untitled mural (1972), Bill Butler and Li'l Valley Youth Association. Inset, mural on Ken's Market, East Los Angeles; detail from left bottom of wall. Photograph by author.

such as "Cat" Felix, were emeritus members of the Mexican American youth gang culture and as such were respected as "veteranos."

STREETS THAT CANNOT DIVIDE

Barrio calligraphers wrote on public walls out of necessity. Their placas appropriated marginalized areas, such as fences, alleys, side walls of stores, and housing projects, which for dominant society held little apparent value. Homeboys appropriated these "valueless" spaces, not to vandalize them for the sake of destruction of private property, but to use them for their own needs. They wanted to assert publicly their corporate identities in a way that was meaningful to those participating in the same youth gang lifestyle.[38] The space available to Mexican American youth in the barrios (and housing projects in particular) for recreation and social interaction was severely restricted due to the carving up of these working-class neighborhoods by manufacturers and developers.[39] Placas represented a system developed by Mexican American youths by which they could divide what little space (territory) was left. Space as a limited resource was the territorial economy upon which their street culture was based.

Operating on that level, placas were designed by them to serve as a public check of the abuse of power in the streets.[40] Barrio calligraphy became an innovation developed by the Mexican American street youth culture to signal and monitor visually the social dynamics of power through coded symbology in the economy of restricted public space. To understand the socialization process of Mexican American street culture is to understand the institution of *street social control*, imposed not by traditional authority but rather by the youth who found it necessary to participate in it. Vigil's findings are elemental in this regard: "The streets and older street youths became the major socialization and enculturation agents, with the gang representing a type of street social control institution by becoming in turn a partial substitute for *family* (providing emotional and social support networks), *school* (giving instructions on how to think and act), and *police* (authority and sanctions to enforce adherence to gang norms)" (1988:12; emphasis Vigil's). Therefore, one youth gang's graffiti inscribed inside a contending youth gang's territory would constitute a public notice to everyone concerned that an attempt was in the offing to appropriate more territory by the placa-attacking group. Theoretically, this allowed enough time for the group considered for attack to increase its strength or vigilance and, contrary to popular belief, *avoid* a fight.[41] Mexican American youth gangs have been characterized as fighting gangs. However, this can only describe the process that is most easily discerned by past sociological studies as well as the general public. Prior to a street fight ever breaking out, the Mexican American youth gang culture has intervened in many forms to avoid this taking place. In global politics, this is called détente.

ART IS SOMETIMES NOT ART

The assertions made in this paper reflect my attempt to understand the opposite of what is usually held to be true of murals: that is, the possibility of reading murals not as art at all, but as graffiti; not as the displacement of vandalism, but as the condensation of a deeply charged barrio cultural tradition.[42] Within this context, it is possible to begin to discern the personal and collective investment in the construction of identity necessary for the survival of Mexican American youth gang culture through appropriation, adaptation, and innovation understood within the scope of Chicano liberation.

Group cohesion in the youth gang culture, supported by a strong identity with one's barrio or territory, was part of what Charles "Cat" Felix, as mural program director at Estrada Courts, was willing to support and invest himself in. As a veterano, even though not originally of Estrada Courts, Felix developed, after only a short time, indelible ties of identification with the VNE youth. Responding casually to my question about his assessment of the more than twenty-five murals at the nearby Ramona Gardens housing project situated just five miles north of Estrada Courts, Felix admitted that he had never been there. This answer, to a question that presumed that murals as "art" were to be appreciated *anywhere* they might be painted, seemed inconceivable. Just as the Chicano murals of the VNE clearly signified the defensive challenges of the Mexican American placas they ambiguated, Felix and other VNE homeboys were able to read the murals of Ramona Gardens as re-presenting the warnings and challenges of the "displaced" Hazard Grande youth gang graffiti. Felix's candid admission provides one of the keys to the fundamental realization that, to those living the youth gang lifestyle, the murals were far more than "art": they had become, like graffiti, an integral part of their particularized systems of cultural and territorial signification.

While bicentennial visitors and other outsiders (specifically, non–youth gang members) perceived the Estrada Courts' Chicano murals *solely* as art, the project youth, in the throes of a changing political context for the entire Mexican American community, would continue for years to read many of the signs of Mexican American graffiti and its youth gang signifieds in the Chicano mural compositions. Estrada Courts is the best defended youth gang territory—and the *murals* there tell you so.

NOTES

An earlier version of this paper was presented at the 89th Annual Meeting of the American Anthropological Association, New Orleans, La., December 1, 1990, as part of the panel, "Looking High and Low: Art and Problems of Cultural Identity," Brenda Jo Bright and Elizabeth Bakewell, session organizers. This paper and the earlier version are based on the research and analysis done for my Master's thesis at UCLA (1991).

1. The term "Mexican American" is written without a hyphen as per Chicano usage.

2. Salazar, an unwilling martyr of the Chicano civil rights movement, was killed by a Los Angeles sheriff's tear gas projectile while he sat at the bar of the Silver Dollar Cafe. He had run into this establishment along with other members of the Spanish-speaking media in order to wait out the altercation that broke out between police and anti-war demonstrators on Whittier Boulevard in East Los Angeles. Two other Chicanos were also killed. The date of this dual event, August 29, 1970, marks an important turning point for the Chicano Movimiento.

3. The reader should note that the term "Chicano" may be applied, in connection with graffiti, to indicate the larger historical discourse of Chicano art and culture that dates back to 1848 and, in some cases, before. See Mario T. García 1989 for an in-depth study of political action by Mexican Americans prior to the Chicano movement.

4. I disagree with the use of the term "subculture" as representative of the culture of Chicanos or Chicano gang youth. Not only is my disagreement a resistance to subordination, it is also a questioning of the accuracy of such a categorical reference.

5. Estrada Courts was originally constructed in 1941 (*Southwest Builder* 1942). In 1953, an additional 200 housing units were added, which are known as the Extension. The Estrada Courts murals are all located within the Extension.

6. The term "community" is used throughout as a metaphor for organized action in the political and cultural arenas by persons or groups acting on behalf of themselves with a collective voice. It is not intended to connote that Chicanos are necessarily a cohesive, monolithic entity working on group interests, agendas, or goals. This paper is predicated on the understanding that Chicanos who paint murals are not all the same—some are trained artists, while others are untrained; some are male, others are female; some are young, others are old; some are youth gang members, others are not—and it is not always easy to differentiate among any of them without deeper analysis. Even then we should ask, Why is it important to know who is who? And who is asking?

7. See Hasson and Aroni 1979:25 for an economic profile of the Estrada Courts residents. Acuña provides the following summary gleaned from 1970 census information on East Los Angeles and Boyle Heights, the larger community within which the Estrada Courts housing project is located: "The area . . . was predominantly Chicano, since approximately 95 percent of the Spanish-surname population belonged to that ethnic group. There were other trends. The population was young and only one-fourth had a high school education, in contrast to two-thirds of Los Angeles residents. . . . Boyle Heights residents earned approximately 56 percent and East Los Angeles residents 69 percent of what other Angelenos earned. The households were markedly larger, lowering the per capita income" (1984:184).

8. The term "Anglo society" is used throughout, in part as a partial metaphor for the negative historic forces that have contributed to shaping an iden-

tifiable Chicano experience as an emergent underclass in the United States. See Griswold del Castillo 1979:103–38 for an introduction to the dynamic interplay of U.S. history and Chicano culture as well as for sociological theories on the creation of ethnic groups that have been applied to Chicanos by various authors.

9. A board made up of concerned Estrada Courts residents created Residentes Unidos as the legal copyright holder of all of the Estrada Courts murals. This step represented an effort to control the proliferation of the Estrada imagery by insensitive outsiders who used it commercially in books, films, television, and slides without compensating the original artists. The board is no longer extant (Daniel Martinez, telephone interview with author, May 11, 1988).

10. "Barrio calligraphy" is the term developed by Jerry and Sally Romotsky in their 1976 analysis of the unique style of graffiti developed and used by Chicanos in Los Angeles and its immediate environs (Romotsky and Romotsky 1976). The present study uses this term for the graffiti style employed by Mexican Americans for the period 1972–78 at Estrada Courts. The terms "Mexican American graffiti," "graffiti," "barrio calligraphy," and "placas" are used interchangeably in this paper for the sake of particular emphases. The term "Chicano graffiti" is used to signal the connections of this practice within the larger field of Chicano history.

Barrio calligraphy tends to be seen as vandalism and as a sign of a lack of residential pride by many different groups of society. Not all Mexican Americans (especially those aspiring to the middle class) appreciate graffiti by other Mexican Americans or Chicanos. Many immigrants from Mexico do not like Mexican American or Chicano graffiti because it is similar to vandalism in their own country. It is probably most appreciated by graffiti writers, for whom it fulfills several needs, including urban aesthetics (see Sanchez-Tranquilino 1991:20–23).

11. See Vigil 1988:70–75 for a brief cultural profile of the Estrada Courts Housing project and the Varrio Nuevo Estrada youth gang.

12. In the *Eastside Sun*, January 1, 1976, Los Angeles Mayor Tom Bradley spoke about the necessity of wiping out all graffiti, and about the beauty of the Estrada Courts murals that had succeeded in accomplishing their task of replacing the vandalism.

13. The concept of vandalism as it is understood in this paper is that it does not exist as an a priori entity. It does not exist except as a metaphor to describe a relation of power in which the expression of one subject is condemned by another. While it is generally applied to public inscriptions, theoretically it cannot be restricted to this practice. In other words, "vandalism" is a term applied to expression when it is deemed to be outside of acceptable behavior, or when such expression is outlawed. In this sense, "vandalism" is used as a mode of restriction or censorship similar to the way other categorical terms such as "pornography," "bad taste," and "dirty language" are applied as part of social control. Susan Stewart (1987) analyzed the structural

scope of the discourse of graffiti in a postmodern, consumerist context, which, though both qualitatively and quantitatively different from that involving the graffiti practices of Chicano gang youth, nevertheless provides connections necessary for a fuller understanding of the axiological relationship into which Chicano graffiti is ultimately pulled as a result of being categorized as either "art" or "vandalism." I am grateful to Brenda J. Bright for making Stewart's article available to me.

14. The placa insignias have much in common in both form and content with European heraldic coats-of-arms and, particularly, the heraldic device. As I noted in an earlier study (1991:47–57), placas are heavily influenced by European coats-of-arms and, as such, carry many of their residual forms and symbolic references.

15. The term "homeboy" serves as a unifying designation that identifies the relationship in which one participates as a barrio *carnal* (a barrio "brother") in the familial network, whether one is in the barrio itself or in prison, where an extension of this relationship functions as an important resource of cultural support (Moore et al. 1978:99).

16. See Romotsky and Romotsky 1976:12. It is not possible to pinpoint the beginning of this practice. In 1976, a sixty-year-old plumber reported to the Romotskys that placas were in full bloom when he began the practice as a youngster in Los Angeles.

"C/S" signals its affinity to Caló language while resisting a literal reading even in Spanish. See Vigil 1988:177. According to Vigil, Caló originated with Spanish Gypsies and was diffused by Spanish bullfighters to Mexico. This motto is the only one known that is said to confer the meaning, "Any disparaging remark written upon this placa also applies to the offending writer"; thus, "C/S" has been used as a charm or hex that symbolically imbues the inscription with the capacity to transcend all attacks upon it.

17. My ability to read public placa texts is due to my familiarity with the subject as research, and not because I practice the art of placas. So far, I am able to write only in the most rudimentary Cholo style, but I continue to practice.

18. See Coward and Ellis 1977:25–44 for a discussion of semiology as applied in this study.

19. For further reading on discourse theory and discursive formations as they apply to the analysis of culture, see Michel Foucault 1972:31–39.

20. For years, Willie Herrón's and Gronk's names and telephone numbers as the mural's artists appeared along with the graffiti.

21. For further inquiry into graffiti, see Abel and Buckley 1977 and Reisner and Wechsler 1980. Studies on graffiti in general indicate that it serves a variety of communicative purposes. Therefore, the association of it as vandalism takes place only after graffiti, as a form of unsanctioned representation, transcends socially imposed restrictions, whether spoken or written, public or private. See also Kohl 1974 and Romotsky and Romotsky 1974a:10–15 and 1975:12–14, 35, for an introduction to graffiti as a viable social and historical

form, and for discussions that begin to address links among graffiti, murals, and education.

22. This is not to say that Mexican American graffiti writers are not politicized, but rather that they are deemed as such because no comparison of the political beliefs is offered by Kahn, Goldman, and others within the specific (and explicit) Chicano ideological context.

23. Excerpt from *Through Walls*, a contextual video written and directed by Carlos Avila in conjunction with the exhibition *Chicano Art: Resistance and Affirmation, 1965–1985*, UCLA Wight Art Gallery. Judith Baca was originally filmed saying this in *Murals of East Los Angeles* (1977), directed by Heather Howell and produced by Humberto Rivera. See also Baca 1985, where she subsequently clarifies that while she felt it was necessary that murals displace placas in order to bring about cohesion among her young mural team members, her mural work with them was complex and "clearly *not* [only] graffiti abatement."

24. The mural depicts the severe beating Herrón's older brother received at the hands of rival youth gang members. The attack occurred late one evening on the stairway at the bottom of the wall where Herrón began to paint his mural immediately upon returning from taking his brother to the hospital. Herrón intended his composition to be read by Chicano youth gang members who claimed the alley as part of their territory. The grieving grandmother in the mural points to the related pain created in families when youth gang altercations claim victims. Herrón wanted to demonstrate visually to those participating in this culture that they, as well as their victims and families, were caught in an unforgiving wall of self-destruction. The pre-Columbian life and death mask from Tlatilco, Mexico, underscores the human investment in this situation.

25. Herrón's signature on "The Wall That Cracked Open" appears on the upper right side, toward the edge of the wall. Interestingly, the lettering style and form of the signature, "Willie Herrón—Artist—1972," are influenced by barrio calligraphy. Not only can Herrón's signature be seen as his placa, but the entire mural itself follows many compositional conventions of barrio calligraphy.

26. See Raymond Williams 1981:36–38, 217–18. The "notions" referred to in this paper are those manifested by all sectors of society, including (one must suppose) Chicanos living in or outside of housing projects. However, it is the dominant sector that benefits most from the internalizing of these ideas/values by all sectors.

27. Although muralism is classified by art historians as a legitimate form of artistic expression, it has, at least in the twentieth century, been categorized as having a lower status than easel painting, and its study has not been included in standard art history survey books such as Jansen's *The History of Art*, or Gardner's *Art Through the Ages*.

28. See Donald Preziosi 1989:168–79 for an eloquent example of the *blurring* of signs as they construct meaning in the subject relative to visual environments of fifth century B.C. Greek civic architecture.

29. The positive response from the invited nonresident artists also prompted demands from the VNE cliques to paint "In Memory of a Home Boy." Although located on a side street not usually visited by the general public, it is a mural that openly commemorates the life and death struggle of youth gang members. According to a former resident of Estrada Courts, because the idea at the Courts was to paint only "positive" themes without overt references to the VNE, there had been resistance by the mural managers to permit a mural dedicated solely to the resident youth gang. However, the VNE cliques prevailed by pointing out to the managing group the increasing number of walls being painted (appropriated) by nonresidents (Azua, interview with author, May 1, 1987). Whether the invited nonresident artists were active youth gang members or not, the areas from which they came made them suspect to the VNE cliques. For instance, Herrón and Callejo may say that they were from City Terrace, but the cliques understood that as "Gerharty Loma" youth gang territory; and although Judith Baca lived in Venice, because many of her East Los Angeles mural team members belonged to the "White Fence" youth gang she was seen not so much as a neutral "professional mural director" but more as a potent invested liaison to the youth gang.

30. "Cat" or "Gato" Felix was a veterano of the Hoyo Mara youth gang in the nearby Maravilla Projects neighborhood. This identity is somewhat similar to the academic emeritus position that continues to confer rights and privileges to retired professors long after their active teaching and research careers have peaked. Many veteranos who are disposed or able serve in leadership capacities to many barrio youth (gang and nongang members), especially through government-sponsored social programs. This role is a logical extension of their years of preparation for leadership as they come up through the ranks of the Chicano youth gang. Joan Moore et al. (1978) provide excellent insights into this development of the veterano; see also Vigil 1988.

31. Current academic accounts identify the figures as priests or ritual ballplayer/heroes, not as warriors as "Cat" Felix and others understood them. The mural was based on a close adaptation of a central panel from one of the ancient ballcourts of postclassic El Tajín in Veracruz, Mexico. According to art historian George Kubler, the ballcourt panel depicts the ritual heart sacrifice of a ballplayer by others also wearing pre-Columbian ballplayer paraphernalia (Kubler 1984:146). See also Wilkerson 1983:101–2.

32. See Goldman 1982:129. The complexity of what constitutes a Chicano mural, especially one containing pre-Columbian imagery, should not be relegated to the reduced analysis of uncritical appropriation without regard to historical and geographical particularities, as offered by Goldman:

Two Chicano murals, one from Los Angeles and the other from Denver, are taken directly from pre-Columbian sources; they are copied *uncritically* without concern for historical context. Charles Felix recreates in color a

sacrifice scene from a ballcourt relief sculpture at El Tajín, Veracruz. San-chez [in Denver] reproduces the single figure of the Goddess Tlazolteotl—the same used as a central figure by [Diego] Rivera in his *Hospital de la Raza* mural [in Mexico] on ancient and modern medicine. Rivera related pre-Columbian to modern medicine as a continuum, the patients being In-dians of the past and present. The murals by Felix and Sanchez are essen-tially decorative and unselective about content—surely Felix did not intend to glorify human sacrifice. (1982:129, emphasis mine)

33. See Vigil 1988:82, 109–24, for important descriptions and insight into the significance of ritualized behavior for Chicano gang youth.

34. The original framing bands of the El Tajín ballcourt relief were not transferred to the Estrada wall, in order to accommodate as much of the central narrative as possible. Other smaller details were also left out in order not to clutter the modern mural, because an important influence of barrio calligraphy was the desire to keep the placas' emblematic messages clear. Except for the copy of the deity from Tomb 104 and the mistitled *Aztec Deity* mural (really a *Jade Tlaloc* fresco from Teotihuacan, which has been given lower limbs by the extension of the central radiating panels), the color on all of the pre-Columbian-based designs throughout the Courts was invented by Felix and the Estrada youth. It is evident through careful comparison that the pre-Columbian figures here (as well as many throughout the Courts) were taken directly from Covarrubias's *Indian Art of Mexico and Central America* (1957).

35. Torero was assisted by Mano Pina, Tomas "Coyote" Castañeda, and "Balazo," known collectively as the Congreso de Artistas Chicanos en Aztlán, or C.A.C.A. The wall remained unpainted for five years until Torero and his San Diego crew were given permission to paint on it.

36. The success of the incorporation of the VNE placa or logo into an ac-ceptable (albeit short-lasting) public design may be attributable both to trans-formational techniques long in use in Caló (sometimes known as Chicano Spanish) as practiced by many of the Mexican American lower class and fa-vored by *pachucos* (Katz 1974:40–41), as well as to subsequent generations of Chicano gang youth and their use of barrio calligraphy and its apparent influence from European heraldry. The constraints of this study do not permit a closer comparison between Chicano visual forms and those produced in language through particular regional variations on Chicano bilingualism. However, it is important to keep in mind that the bilingualism of the South-west has constructed a historical context for the tendency of many cultural practices and art forms to employ techniques similar to transformational techniques of bilingualism. These include code-switching, "melange" or lan-guage mixing, and language alternation. See also Bowen and Orenstein 1976 for further reading.

37. See Cockcroft et al. 1977 for discussion of the "Ken's Market" mural. This "graffiti-mural" exemplifies a variation on the position held by Herrón.

Completed before the beginning of the Estrada Courts murals, it was painted in East Los Angeles by the Little (Li'l) Valley youth gang (youth association). The mural celebrates the organized mural efforts of the youth gang by incorporating their placas in the composition.

38. Within the exigencies of that experience, the attainment of personal and corporate or collective status was a primary concern, informing the many cultural forms developed by marginalized Chicano youth. Such practices included the wearing of the flamboyant original 1940s zootsuit and its present-day derivations, the speaking of Caló (the Pachuco argot), the adherence to a code of ethics based on the responsible soldier, and the emblazoning of barrio calligraphy based on status-laden Old English script and public heraldic display.

39. "One of the striking characteristics of public housing projects in Los Angeles is their proximity to noxious land uses" (Hasson and Aroni 1979:16). This meant airports, chemical plants, freeways, milling plants, harbor facilities, and so on. See also Brenda Bright 1994 for vignettes from residents of three different Los Angeles barrios that demonstrate adjustments by youths to space increasingly restricted by commerce and development.

40. See Vigil 1988:131, for casual testimony on how school territory is divided in a similar manner. A seventeen-year-old male from one youth gang who was transferred to a high school located in a different barrio explained: "They came up to me, so we started talking about territory and shit, that they should have this territory and we should have another territory. That way everyone would have their place and no *pedo* [fights] would start."

41. In this regard, Vigil's view of placas is different from mine in that he sees placas "thrown" in rival territory as a way of maintaining territorial dominance and "as a form of boasting much like Plains Indians' 'counting coup'" or as gaining attention from the general (non-gang) public (Vigil 1988:115). While I agree with his theory of territorial dominance, I tend to see (and describe) this process as a dialectic. See Castleman 1982 for development of "New York" style tagging and graffiti art. Admittedly, in recent years a type of Chicano graffiti has been influenced by New York–style "tagging" (although it began in New York in the early 1970s), where the objective is to get one's name in as many places as possible.

42. Similar structures of material and territorial display occur in the larger art world. While major metropolitan museums can be read as "placas" of the socially privileged, the current crop of "boutique" museums put up to house the private appropriations of wealthy collectors indicates a new dialectical component of who *rifas* (rules) in this division of world art sources. Interestingly, like placas, museums employ all of the signs of legitimacy and status (including "fancy" lettering on exterior signage, letterhead, and invitations) to partially rationalize their assertions of high culture.

REFERENCES

Abel, Ernest L., and Barbara E. Buckley
1977 *The Handwriting on the Wall: Toward a Sociology and Psychology of Graffiti*. Westport, Conn.: Greenwood Press.
Acuña, Rodolfo F.
1981 *Occupied America, A History of Chicanos*. 2d ed. New York: Harper and Row.
1984 *A Community Under Siege: A Chronicle of Chicanos East of the Los Angeles River, 1945–1975*. Chicano Studies Research Center Publications, Monograph no. 11. Los Angeles: University of California.
Baca, Judith Francisca
1985 "Our People Are the Internal Exiles." Interview with Diane Neumaier. Pp. 62–70 in *Cultures in Contention*, ed. Douglas Kahn and Diane Neumaier. Seattle: Real Comet Press.
Barnett, Alan W.
1984 *Community Murals: The People's Art*. Philadelpha: Art Alliance Press.
Bowen, J. Donald, and Jacob Orenstein, eds.
1976 *Studies in Southwest Spanish*. Rowley, Mass.: Newbury House Publishers.
Bright, Brenda Jo
1994 Mexican American Lowriders: An Anthropological Approach to Popular Culture. Ph.D. diss., Rice University.
Castleman, Craig
1982 *Getting Up: Subway Graffiti in New York*. Cambridge: MIT Press.
Cesaretti, Gusmano
1975 *Street Writers, A Guided Tour of Chicano Graffiti*. Los Angeles: Acrobat Books.
Clifford, James
1988 *The Predicament of Culture: Twentieth-Century Ethnography, Literature, and Art*. Cambridge and London: Harvard University Press.
Cockcroft, Eva, John Weber, and James Cockcroft
1977 *Towards a People's Art: The Contemporary Mural Movement*. New York: E. P. Dutton.
Covarrubias, Miguel
1957 *Indian Art of Mexico and Central America*. New York: Alfred A. Knopf.
Coward, Rosalind, and John Ellis
1977 *Language and Materialism: Developments in Semiology and the Theory of the Subject*. London: Routledge and Kegan Paul.
Foucault, Michel
1972 *The Archaeology of Knowledge and the Discourse on Language*. Translated by A. M. Sheridan Smith. New York: Pantheon Books.
1980 *Power/Knowledge: Selected Interviews and Other Writings*. Edited by Colin Gordon. Translated by Colin Gordon, Leo Marshall, John Mepham, and Kate Soper. New York: Pantheon Books.
García, Mario T.
1989 *Mexican Americans: Leadership, Identity, and Ideology, 1930–1960*. New Haven, Conn.: Yale University Press.

Goldman, Shifra M.
1976 "Affirmations of Existence; Barrio Murals of Los Angeles." *Revista Chicano-Riqueña* 4(4):73–76.
1982 "Mexican Muralism: Its Social-Educative Roles in Latin America and the United States." *Aztlan: International Journal of Chicano Studies Research* 13(1,2):111–33.
Grider, Sylvia Ann
1975 "Con Safos: Mexican-Americans, Names and Graffiti." *Journal of American Folklore* 13:132–42.
Griswold del Castillo, Richard
1979 *The Los Angeles Barrio 1840–1890: A Social History.* Los Angeles and Berkeley: University of California Press.
Hasson, Schlomo, and Samuel Aroni
1979 Public Housing in Los Angeles—A Social Study. School of Architecture, University of California, Los Angeles. Photocopy.
Jones, Gareth Stedman
1983 *Languages of Class: Studies in English Working Class History, 1832–1982.* Cambridge: Cambridge University Press.
Kahn, David
1975 Chicano Street Murals: People's Art in the East Los Angeles Barrio." *Aztlan: International Journal of Chicano Studies Research* 6(1):117–21.
Katz, Linda Fine
1974 The Evaluation of the Pachuco Language and Culture. Master's thesis, University of California, Los Angeles.
Kohl, Herbert
1974 "The Writing's on the Wall—Use It." *Learning* (Chicago) (May–June):10–15.
Kubler, George
1984 *The Art and Architecture of Ancient America.* The Pelican History of Art. Harmondsworth, England: Penguin Books, Ltd.
Moore, Joan, with Robert García, Carlos García, Luis Cerda, and Frank Valencia
1978 *Homeboys: Gangs, Drugs, and Prison in the Barrios of Los Angeles.* Philadelphia: Temple University Press.
Pinke, Dieter
1984 Wandbilder der Chicanos in Los Angeles. Baccalaureate thesis (university not identified), Kassel, Germany.
Preziosi, Donald
1989 *Rethinking Art History: Meditations on a Coy Science.* New Haven: Yale University Press.
Reisner, Robert, and Lorraine Wechsler
1980 *Encyclopedia of Graffiti.* New York: Galahad Books.
Rendon, Armando
1971 *Chicano Manifesto.* New York: Macmillan.
Romotsky, Jerry, and Sally R. Romotsky
1974a "Barrio School Murals: A Decorative Alternative." *Children Today* (September–October):16–19.

1974b "California Street Scene: Wall Writing in L.A." *Print* (May–June) 28(3):1–11.

1974c "Placas and Murals." *Art in Society* (Summer–Fall) 2(11):1–10.

1975 "Graffiti to Learn by." *Children Today* (September–October):12–14, 35.

1976 *Los Angeles Barrio Calligraphy.* Los Angeles: Dawson's Book Shop.

Salazar, Cora

1972 "Painting walls at Estrada Courts." *Eastside Sun*, June 8.

Salazar, Rubén

1970 "Who Is a Chicano? And What Is It the Chicanos Want?" *Los Angeles Times.* Reprinted in *Chicano Art History: A Book of Selected Readings*, ed. Jacinto Quirarte, p. 5. San Antonio: Research Center for the Arts and Humanities, University of Texas, 1984.

Sanchez-Tranquilino, Marcos

1991 Mi Casa No Es Su Casa: Chicano Murals and Barrio Calligraphy as Systems of Signification at Estrada Courts, 1972–1978. Master's thesis, University of California, Los Angeles.

Southwest Builder and Contractor

1942 "Estrada Courts Dedicated to Housing Man Behind Production Line." July 7, 12–15.

Stewart, Susan

1987 "Ceci Tuera Cela: Graffiti as Crime and Art." Pp. 161–80 in *Life After Postmodernism: Essays on Value and Culture*, ed. John Fekete. New York: St. Martin's.

Tagg, John

1988 *The Burden of Representation: Essays on Photographies and Histories.* Communications and Culture Series. London: MacMillan Education.

Vigil, James Diego

1988 *Barrio Gangs: Street Life and Identity in Southern California.* The Center for Mexican American Studies Mexican American Monographs, no. 12. Austin: University of Texas.

White, Hayden

1973 *Metahistory: The Historical Imagination in Nineteenth-Century Europe.* Baltimore: Johns Hopkins University Press.

Wilkerson, S. Jeffrey

1983 "In Search of the Mountain of Foam: Human Sacrifice in Central Mesoamerica." Pp. 101–32 in Ritual Human Sacrifice in Mesocamerica. A Conference at Dumbarton Oaks, October 13–14, 1979, organized by Elizabeth P. Benson, ed. Elizabeth H. Boone. Washington, D.C.: Dumbarton Oaks.

Williams, Raymond

1981 *Culture.* London: Fontana Paperbacks.

4 REMAPPINGS

LOS ANGELES LOW RIDERS

BRENDA JO BRIGHT

With a teenage life, there are so many roads you can take, and I chose this one [car customizing]. It brought me closer with my family and my dad in building the car. —Dukes Car Club member

If I hadn't been into cars, I probably would have ended up in a gang. —Lifestyles Car Club member

In Los Angeles, Mexican American car customizers often map the possible paths of their lives as having been decided in an adolescent choice between gangs or cars. What is, for many, a long personal involvement with cars is narrated to the ethnographer as a "choice,"

one road of possiblity taken instead of another that would have been more limiting. The road of gang membership involves one in a locally based community, where neighborhood, cohort, and identity converge and must be protected. The other, low riding, involves one with others from all over the city in both cooperative and competitive networks.

In the male-dominated popular culture of low riding, not only is the development of skills important, but so is the participation in a variety of social networks for manipulating commodities and creating symbolic circuits. Low rider car club members describe the art of customizing and the organization of the club as giving one mobility and providing options for employment, camaraderie, leisure, public display and cultural pride, and ultimately pleasure. These car customizers contrast their organizations to gangs, narrating gang membership as a dead end, as limiting at best in terms of social affiliations and at worst as a road to incarceration.

Quite often the conditions conducive to youth gang involvement are concentrated in the early teenage years, especially in junior high or middle school, when social cliques are developing but before driving or working become real alternatives. To be sure, gang membership and car customizing are not exclusive activities. In working-class and poor neighborhoods, adolescent males engage in both, but extensive modifications to cars are discouraged both because of cost and because such cars frequently become targets in gang conflicts. After high school, the intensity of gang participation can abate. Often then, contrary to popular impressions of car-based activities as part of teenage youth culture, the car becomes an increasingly important locus for symbolic and social activity (Bright 1991; Vigil 1988; Trillin 1978). The opening quotes are representative of narratives told by car club members ranging from twenty to thirty-five years of age.

CARS, MOBILITY, AND TERRITORY

Having a car does not necessarily give a man the mobility he desires. On a Saturday night soon after the airing of the Rodney King tape in March 1991, many Chicanos out on Hollywood Boulevard admitted to also having been harrassed by the police or having witnessed a severe beating similar to the one King received at the hands of the Los Angeles Police Department. A lesson many learned prior to the publicized beating of Rodney King is that a man of color driving a car

is not necessarily free to move about the city as he pleases. Latinos and Blacks have long been subject to strict surveillance and delimited mobility. As policeman Bruce Jackson set out to prove in Long Beach, California, in 1989, a Black man driving an old car through a predominantly Anglo middle- or upper-middle-class neighborhood is likely to be stopped and harrassed, as Jackson was by the Long Beach Police Department.

This essay addresses the relationship between territory, mobility, and self-representation as configured in car customizing in Los Angeles. For low riders, the automobile is the center of a constellation of cultural practices, a mobile canvas for cultural representation and critique. In this essay, I will examine how low rider car culture has created an alternate cultural space for performance, participation, and interpretation. The presence of such a cultural alternative allows for the reworking of the limitations of mobility placed on racialized cultures in the United States, especially in a city such as Los Angeles with a legacy of surveillance and conflicts between racial minorities and the police. Following Jules Rosette (1985), I suggest that "deterritorialized" culture is often symbolically remapped in people's uses of material forms. This work is done symbolically through performance in the world of commodities, social networks, and popular culture.

Underpinning the restrictions on the spatial mobility of racially marked men are notions of class mobility in United States culture. Sherry Ortner (1991) argues that given the lack of explicit discourse on class in the United States, concerns about class are often displaced onto race, ethnicity, and gender. She reveals that there is a great deal of talk about mobility in which class is coded into these other terms. Continuing anxieties about class, which are coded in terms of race and culture in the United States, serve to reinforce de facto segregation. Operating in conjunction with cultural codes are three major factors contributing to the segregation of neighborhoods according to members of the same ethnicity/race and class: patterns of industrialization, deindustrialization, and reindustrialization; residential settlement patterns originally controlled through legalized racial segregation and later by Anglo out-migration or "white flight"; and continuing police enforcement of racial boundaries as criminal boundaries.[1]

The reproduction of segregation can be seen in United States ethnographies. Ortner contends that generally anthropologists have ethnicized populations within the United States, their accounts tending

to exoticize and isolate spatially and culturally those they study. While granting communities a certain amount of authenticity on their own grounds, such studies tend not to problematize cultural separations or the conditions of inequality under which they are produced. Instead, the studies replicate segregation, with the result that cultural separations appear natural.

Los Angeles is a site of central importance for low riding, which is increasingly a translocal as well as transnational popular culture. Los Angeles is the home of the largest concentration of people of Mexican descent outside of Mexico City. Importantly here, it has *the* largest concentration of low riders. The offices of *Low Rider Magazine* are located in Orange County, just south of Los Angeles, and half of its magazines are distributed in the Los Angeles area.This essay, a study of Los Angeles low riders, is part of a larger comparative research project on Mexican American low riders in three sites in the Southwest. The project is twofold, examining the local cultures of low riders, and examining low riding as a translocal phenomenon whose popularity is facilitated in part by print and visual media and in part by migrations of people. It is an inquiry into the links between the imagination, media, and social life among Mexican American low riders. This essay is based upon dissertation fieldwork in Los Angeles in 1988–89.[2]

Given my research topic, from the start it was impossible for me to spatially and culturally isolate my subject. In fact, in the beginning of my Los Angeles field research, it was even difficult for me to locate low riders. On the first day of apartment hunting in Montebello, I saw a customized 1957 Chevrolet. It was the last low rider I was to see for a while. I spent the first few weeks or so on the phone, trying to locate networks and setting up interviews before I ever talked to someone involved in low riding. Eventually I made connections that proved fruitful and met a wide range of people with important knowledge about the low riding scene, about *Low Rider Magazine*, about the history of low riding, and about gang participation in Los Angeles. Car shows proved to be the easiest place to meet low riders.[3] For a while, cruising was popular on Whittier Boulevard, a half block from our apartment. When the Montebello police began blockading the street, the low riders, mini-trucks, and motorbikes were rerouted up our street. Eventually they went somewhere else.

In contrast to my previous research in Houston, fieldwork in Los

Angeles was difficult. While in Houston, some key people decided to trust me and cultivate my understanding of their lives and activities. In Los Angeles, Chicano experiences of surveillance by the dominant Anglo society made people suspicious of my motives and protective of their privacy. Surveillance combined with racial segregation served to make my interest in Los Angeles low riders somewhat anomolous. Some people wondered if I were an undercover policewoman. Many treated me as they would a magazine reporter, telling me their stories in a somewhat guarded manner. Others, of course, were quite open and gracious with their ideas and their time. My experience of being a white woman in Los Angeles working on the Chicano male–dominated car culture was that of working a highly contested zone.

Through the research process, the central question that emerged was, What is the relationship of the process of segregation and surveillance to art and cultural identity? How do we account for these processes in the United States? In academic literature, representations of popular culture categorized as "folk art" and "ethnic art" are often interpreted as mere "reflections" of cultural values, rather than productions of people acting in complex political and economic circumstances. In order to counter these limitations, it is important to explore the relationship of cultural representations to social geographies as part of the historical material conditions under which they are produced.

In east and central Los Angeles, gangs have historically attempted to control their areas, streets, borders, and resources in a hostile, racially divided environment. In contrast, cars and car clubs have provided a means for young men to transgress and transcend limited territories. With increased urban migrations after World War II, greater ethnic mixing occurred. As car ownership increased in this era, car clubs developed among all groups and began to participate in youth culture, especially music and dances. Many early car clubs took their names from popular bands and lyrics. In Los Angeles, I learned that cars constituted an important cultural object for the examination of territory, mobility, and self-representation.

Car-based experiences among Chicano and Black men serve to create the car as a site of resistance. They understand the police actions taken against them as indicating assumptions about race, behavior, and buying power. For Mexican Americans, the displacing and the "othering" experience of surveillance converges with a working-class

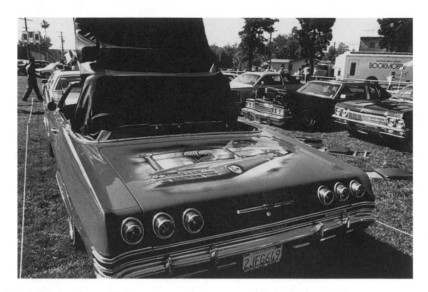

FIGURE 4.1 1965 Chevrolet "Ragtop" (convertible). Photograph by author.

socioeconomic position that quite often necessitates buying second-hand cars, and with cultural traditions that emphasize craft skills and tinkering on objects in order to make them pleasurable. In commercial advertising, the new automobile has "always already" been located within a narrative economy that promises its owner the potential pleasures of expression, experience, and travel based upon aesthetic choice and buying power. These locations of selves and objects are taken up and contested in the imagery of many low rider cars. The cars then become the place where the symbolic field is entered and pleasurable scenarios are imagined and created.

An example of this can be seen in figure 4.1. Frozen in a field of red, the mural painted on a Chicano's low rider displays an image of itself, a classy '65 Chevrolet Caprice convertible, parked in front of a fashionable, upscale restaurant. The top is down, and the car is empty. Behind it, a policeman stands next to his police car, eyeing this beautifully customized automobile. The owner is inside enjoying the cuisine while the policeman is outside at work. What occurs on the trunk of this car is a significant transformation, an inversion. The image creates a moment in which the car arrests, seduces, and transforms the surveillant gaze of the law enforcer. The look of the law is symbolically transformed by the owner's creation at the moment of his recreation.

The car in this image has been lowered, restored, and customized. In the mural, the owner stages his own interpretation of the meaning of the car, that the "crafted" revival of the automobile is an act of culturally distinctive labor that produces the pleasures of sociality. As the objects of narratives, these cars enact the meanings of a man's working-class life, which is for the most part oriented around highly gendered realms of activity, sociality, and authority (Willis 1977). The cars are most often second-hand and customized to be luxurious, while retaining their "outsider" distinctions by modifying both customizing fads and market definitions of automobile aesthetics.

On the '66 Chevrolet described, there are important traces of the multiple confrontations that engage Chicano low riders in the making of their pleasure places. In the introduction to *Homeboys: Gangs, Drugs and Prisons in the Barrios of Los Angeles* (Moore et al. 1978), cars are identified as an important source of conflict in the lives of barrio families. The family car is second-hand, often breaks down, and cannot be repaired immediately. The police get involved with the family through traffic warrants. Barrio residents are regularly stopped and given citations for minor violations, or simply stopped so that a warrant search can be done on their vehicle. Hence law enforcement and education are major sites of conflict with the larger Anglo society, but frictions are also apparent in deportations and urban uprisings. In the mural, conflict is depicted in the image of police surveillance, notorious in Los Angeles for its racial bias. The racial distribution of the Los Angeles Police Department inverts that of the population of the city and county. The mural suggests the most obvious and easily representable experience of racially experienced institutional control and repression, but one that is related in important ways to the marginalizing of Latino and African American men by demonizing and criminalizing as well as exoticizing them in institutions and the media. The rhetoric of criminalization in Los Angeles has been historically and cynically localized in the bodies of men of color in central and East Los Angeles. As described by Mike Davis, 1950s Los Angeles Police Chief Parker "invoked racialized crime scares to justify his tireless accumulation of power. . . . [He] constantly and self-servingly projected the specter of a vast criminal reservoir in Southcentral L.A. . . . held in check by an outnumbered but heroically staunch 'Blue line'" (Davis 1990:295).

In figure 4.1, the owner transforms the fact of being under surveil-

lance into the pleasure of being watched. He transforms himself pictorially from being the despised object of social control into an envied subject acting out his own desires. Here the desire is to control not only social assets and the exercise of pleasure, but their staging as well. This is the affective redundancy of the mural—first, the car's customizing relocates it within the symbolic material system of cars. The mural then serves as a performance of its meaning. In the mural, the car is located within a material luxury economy of pleasure (a convertible car, a luxury restaurant, and a beautiful date) and all within a dialogue on social power. In the image, at least, "the gaze" directed at the car owner is one of envy and desire, not scorn and discipline.

The mural provides perhaps the most succinct manifestation of "simulation." As defined by Celeste Olalquiaga, simulation is "the establishment of a situation through intertextuality instead of indexicality. In other words, rather than pointing to first-degree references (objects, events), simulation looks at representations of them (images, texts) for verisimilitude" (1992:6). Car murals locate truth not in actual objects or events, but in the retelling or simulation of these objects and events. The red car alters the surveillant moment so pervasive in relations with the police and in media coverage of minorities. It places in its stead a moment of consumptive pleasure.

In the wide range of low rider self-images, this mural succinctly expresses the important transformative experiences that low rider cars are seen as enabling. In Los Angeles, they are both "objects of" and "objects for" social pleasure. They are snapshots that stage performances of self-imagined identity enacted against an inverted background of cultural stereotypes and racially marked experiences. The automobile, an object that traditionally makes Chicanos the objects of surveillance and subjects them to the power of bureaucratic tyranny (Moore et al. 1978; Stone 1990), can be transformed through the skills of symbolic manipulation, money, hard work, and creativity into a vehicle of possibility, pleasure, and resistance.

Car customizing exhibits complex interrelations between consumer culture, surveillance, gendered race and class positions, and craft skills. Focusing on the interplay between class, territory, and consumer culture, in this essay I examine the ways in which the automobile is made the object of subjectivity. As a form of popular culture, low riding provides an important example of how cultural forms

emerge out of contradiction and interrelated cultural arenas. As will be shown, the car is a locus for playing out the contradictions of consumer culture. The form is drawn from the cultural arenas of generational relationships, industry and craft skills, youth culture, and institutional relationships. The hallmark of popular culture, as Andrew Ross notes, is its dialectical appeal to both self-respect and cultural authority. This is accomplished through complicity as well as decentering strategies (Ybarra-Frausto 1991). In this, style becomes a means to control symbolically the contradictions between Chicano experience (e.g., confrontations with the law and bureaucracies, and stereotyping by the press) and dominant culture roles generally denied them. What emerges from this examination of automobile culture is a picture of the difficulties of breaking out of neighborhood, ethnicity, and class. Popular culture serves as a means to do this. It is a forum for cultural participation. The pleasures depicted in the scenes of low rider popular culture are a great deal more than epiphenomenal, superficial adornments of an impoverished life.

THE PLACES OF PLEASURE

Los Angeles is known worldwide for its wealthy film and television industries, its stars, and its conspicuous consumption. "For many," as Edward Soja (1989) contends, "industrial Los Angeles nevertheless remains a contradiction in terms." The television coverage of the insurrection in the wake of the King verdict in May 1992 created a shocking reminder that Los Angeles is also an industrial city, subject to all of the class and racialized struggles that typify capitalist industry. As Mike Davis (1990) so aptly put it, "The ultimate world-historical significance—and oddity—of Los Angeles is that it has come to play the double role of utopia and dystopia for advanced capitalism."

As an industrial city, Los Angeles exhibits the characteristic geographies of two urban revolutions. First, like other industrial cities, Los Angeles concentrated residents and factories, and capital and labor within it. Second, Los Angeles also experienced a "postindustrial revolution," which diffused production and population. The second process, as described by Mollenkopf, "has dismantled the mosaic of blue collar ethnic segmentation which developed within the occupational and residential order of older industrial cities. This mosaic has largely

given way to a new central-city mosiac dominated by more recent, lower-status minority groups, particularly Blacks and Hispanics" (1983:13). The major effects of deindustrialization are the loss of blue-collar manufacturing jobs and an increase in nonunionized, minimum-wage employment that often favors illegal immigrants.[4] This "new central city" in Los Angeles is noticeably absent from popular positive representations of the city and eludes the understanding of most non-residents as well (Moore et al. 1978:20; Wilkerson 1992). Instead, following deindustrialization the area composed of the old central manu-facturing district, and the working-class and poor neighborhoods that surround and permeate it, is most often featured in the press as a site producing racialized poverty, desperation, and criminality—only occasionally as one of aspiration and assimilation.[5]

Mexican American settlement in Los Angeles results from two pat-terns. The initial segregation of Anglos, Blacks, and Chicanos in the early 1900s confined Blacks to the south-central area, while limiting Chicanos to downtown East Side neighborhoods. The subsequent evacuation of whites from central and eastern Los Angeles has meant a greater intermixing of Blacks and Latinos in south-central, whereas the Eastside and the suburban cities to the east are primarily Mexican American and Latin American (Lipsitz 1990; Griswold del Castillo 1991; McWilliams 1946; Collins 1980). Currently third- and fourth-generation Mexican American populations are found throughout Los Angeles County, especially in the San Fernando Valley to the north-east; Glendale, Pasadena, and South Pasadena (El Cereno) to the north; East Los Angeles, Boyle Heights, and Lincoln Heights at the center; Montebello, Pico Rivera, El Monte, Baldwin Park, La Puente, and La Habra to the east; South Gate, Watts, and Compton to the south; and Pomona, San Bernadino, and Riverside to the far east.

"Cruising" in one's best car on a favorite boulevard takes place in many of these areas. Each has its own local "loop," or route, for meet-ing people and being seen. There are also a few cruising strips fa-mous thoughout the city. Until 1979, Whittier Boulevard in East Los Angeles was the premier cruising strip for Chicanos. Especially in the 1960s and 1970s, they came from a five-county area—Los Angeles, San Bernadino, Riverside, Orange, and San Diego—to cruise Whit-tier Boulevard where it cuts through the heart of the largest Chicano barrio, East Los Angeles (figure 4.2). As the Chicano part of town, it was a "safe" place for them to cruise and congregate without the wor-

ries of conflicts and infractions from Anglos and Blacks. Whittier Boulevard was once the most important place—where La Raza, the people, came together to have a good time in cars that showed that they "had it together," and where those who were able competed with each other's cars to have the nicest ride. At the height of its popularity, thousands of people would come on Friday and Saturday nights to cruise bumper to bumper until early in the morning. As described by R. Rodriguez, "cruising was a tradition . . . it was a Chicano alternative to Disneyland. It brought Raza together from all parts of Southern California. It was unequalled entertainment for a minimal price. It wouldn't be an exaggeration to say that love and romance flourished on the Boulevard" (1984:23).

Ostensibly worried about the violent impact *Boulevard Nights*, a movie released in 1979 about cruising and street violence, would have on the cruising scene, the L.A. County sheriffs brutally closed down the Boulevard over the weekend of March 23–25, 1979, by cordoning it off and sending in armed police. There were over 100 police and at least 400 arrests, more than four times the arrests of a normal weekend. Whittier Boulevard was never reopened to cruising. With the closing of Whittier, the only major cruising strip in a Chicano-dominated area was abolished one night and with it the chance for Chicanos to cruise in a place that felt like it was theirs. Now, on Friday and Saturday nights, they are among the young men and women who come from all areas to cruise Hollywood and Sunset Boulevards. On Hollywood and Sunset, the cruising scene, made up of a broad mix of youths from all races and all areas of town and with all varieties of cars, dates back several generations. In this well-known part of town, local police and sheriffs monitor the traffic but have never peremptorily closed off these streets.

THE PASTS OF PLEASURE

OLD MAPS: CARS, NEIGHBORHOODS, AND YOUTH CULTURE IN 1950s LOS ANGELES

In a 1979 *Low Rider Magazine* article, Manuel Cruz lists some of the places where "la gente" liked to recreate in Los Angeles after World War II. They were mostly public places, like Lincoln Park, Olvera Street, and Old Chinatown. Families would travel out of their neigh-

borhoods in Los Angeles to Rancho Daniel, to the rivers, and to the beaches. By contrast, the scenes they left behind within the barrios were often more conflicted, for at this time Los Angeles was legally racially segregated.

"La Vida Loca": Cars, Gangs, and Neighborhoods

Max Rodriguez grew up as a member of the 38th Street Gang, in the 38th Street area of central Los Angeles in the 1950s. This gang was dramatically depicted as the defendant in the Sleepy Lagoon trial in Luis Valdez's play (1978) and movie (1980) *Zoot Suit*. Their area was a couple of blocks wide, and many more deep. They were separated from Blacks to the east by a commuter rail line running down Long Beach. To the west a freight line running down Alameda separated them from White Huntington Park, a town they were allowed to enter only on Friday nights and Saturday afternoons to use the movie theater. In Rodriguez's words, "We had the tracks, the dump and a park, which because it was too small for three neighborhoods, we divided up between ourselves."

In this restricted territory and in the gang, Rodriguez learned to protect his turf and his reputation, which rested on the embodied values of manhood and responsibility. In the 38th Street area, as in many other *barrios*, territory functioned as a cultural resource that corresponded to familial and cohort loyalties and had to be protected by barrio youth. Territory and identity overlapped with reputation as the index of one's ability to secure boundaries.

Rodriguez's family had moved to Los Angeles from the mines around Bisbee in southern Arizona. His family settled near other members of his father's family. His primary responsibilities as a youth were earning his own money and making the area safe for his family and sisters. He often worked several jobs. At one time, he worked for a local grocery, swept out the school, and on his way home stole beer to sell to his father's friends when they came over at night to play craps.

To get to school, the kids in his area had to walk through areas that were designated as "belonging" to others. The boys had to fight their way to school, then they fought their way back home. They built valuable reputations based on their willingness to defend themselves and their families, especially their sisters. "There are a lot of girls

alive today because we were there. . . . Other than ranching, it was the best way to grow up. That way, you grew up as a man, not giving any shit, but not taking any either." Protecting the neighborhood was central to male identity. In this setting a boy's male cohorts—usually neighbors and relatives—constituted an important source of friendship and allies in securing the neighborhood. This reinforced the notion of manhood as one of male bonding and responsibility to one's family, one's neighborhood, and one's cohort group. The privileges associated with mastering this gendered identity of earning and protecting were substantial—autonomy in one's behavior and authority over the neighborhood and the women in it.

In Rodriguez's youth, cars were an important part of barrio life. Barrio boys could distinguish residents' cars from outsiders. For the boys, they were more than just transportation, they were markers of identity. Neighbors often hired them to watch the cars when there were parties. They were identified with their owner, and by extension, with both his "home" turf and his cohort. But they were also a source of adventure—forays into other areas, cruising, searching for girls, drag racing, and when necessary, quick getaways. Rodriguez bought his first low rider, a '49 black Ford, in 1955. He was sixteen. He spent the next eleven months customizing it, marking it as his, and making it into a low rider. First he C-framed it, then he inverted the springs, removed the shocks, reversed the rims, louvered the hood and added lights, had the engine bored out and replaced with a full cam race engine, and added side pipes to mellow the tones of the engine's roar. The interior had roll and tuck upholstery, rabbit fur, and white pearl on the dashboard. He installed wheels on the bumper so he could race down Alameda and scrape (drag the bumper on the pavement) at the same time, without ruining the bumper.

As a teenage member of the 38th Street Gang, Rodriguez was considered a *"vato loco."* In his generation, this meant he was "a very serious person, respectable person, [but] very dangerous, very dangerous. A vato loco could be a judge, could be a lawyer. . . . [Most of all, he was] very dangerous and very respectable" (Leo Cordova, interview with author, February 1989). After Rodriguez's father left his mother, young Rodriguez had to drive her over to his sister's house in Florence, an area south of the 38th Street area. At that time, a gang from Clover barrio was "pulling a raid" on a gang from Florence, putting Florence on the lookout for outsider cars. They stopped

Rodriguez in his '46 Oldsmobile, called "the big brown dog," and asked him where he was from. "38th" was the reply. "Prove it," he was told. "By tomorrow you'll be dead," he responded ominously. The point was that 38th's word, "*la palabra*," was good, and to question it was to force them to prove it, often with serious consequences.

Rodriguez's story is typical, one where a vato loco (a crazy guy) is respected and feared as he negotiates life on the streets, "*la vida loca*" (the crazy life). But it is a story that holds little in common with bourgeois rationality. In his story, there is no mirroring of the bourgeois relationships between work and reward, where the work itself is rewarding emotionally and/or monetarily. Instead, it is a life on the streets, dangerous with few financial rewards. One is encouraged to gamble, to operate on a model not based on bourgeois rationality where hard work pays off, as a means of legitimating your own imagination and desire.

Landscapes of Memory:
Clothing, Gangs, and Neighborhoods

There are other stories of growing up in Los Angeles that emphasize different aspects of the crazy life. North of 38th, up in the barrio of Lopez Maravilla, the situation was similar. In the fifties, before the freeways were built, Lopez was bounded by hills on one side and a dump on another. The local boys contolled the dump, which they saw as a resource. As L. Cordova told me,

> We were raised with the dump. We used to get clothing from there; we used to get food, like fruit half rotten, cut the bad part off, eat the rest; shoes; empty jars for glasses; broken furniture that we would patch up. Just about every family around here would go up. And guys, we used to charge guys to go up there. Or when they would come down, we used to see what they got, you know, take some of their stuff. We used to cross the hill to Monterrey Park. Sometimes we would score, because it was nothing but white [people] everywhere. So we used to go through the rivers and then go into the community and get the clothing from the clothes lines, and we had pretty good clothes. Or else we'd find this big camp of boy scouts. We used to raid them, take their shoes off and everything, and we'd have brand new shoes, boots, and tennies. (Interview with author, February 1989)

But in 1971, some twenty years later, these same men continued to exhibit a strong connection to their neighborhood. Contained in the landscape of memory is the struggle of poverty and imposed racial boundaries, all creating a landscape of identity in which the contours of identity are metonymically recalled, through houses, streets, ruins, and the absences created by the freeways.

In Cordova's telling, the contours of identity are created not only by the boundaries of territory, but by markers of conflicts as well. Born in 1938, Cordova thought he was lucky: "I was lucky that some of my uncles were *pachucos*. . . . And, one of my uncles used to take me with him and I was able to see when they were getting beat up by the sailors. I remember when, once when they used to beat up the Ku Klux Klan. The Ku Klux Klan used to meet over at Arnold's Hair. . . . The pachucos used to go over there with bats and all kinds of stuff, chase them out of town. So I was lucky to be able to see that, that part. My generation was the last one to dress sort of like the pachucos. After that the baggies came in" (February 1989).[6] In this landscape, generations of clothing also become the territory of memory "vested" with signs of conflict, resistance, and necessary manhood. First, pachucos and zoot suits. Then vato locos and baggies (high pants with pleats). Now low riders and *cholos* wear zoot suits and baggies. In this way, clothing has become another terrain of tradition kept by subsequent generations. And yet, landscapes of memory vary for each generation. At each remove from immigrant experience, ethnic and familial enclave, and historical conflicts, technology and media present new memories and possibilities.

OVERLAYS: CAR CLUBS, CRUISING, AND
CUSTOMIZING IN 1960s AND 1970s LOS ANGELES

Youth (A)venues

In fifties Los Angeles, teenage groups were critically aware of the "others" around them. Susie Turner, then an "Okie" teenager, contended that her group worked hard to distinguish themselves from Chicanos and Blacks via cars, dress, and language, and suggested that this was a response, in part, to the low status that Okies had in Los Angeles.[7] Yet in this period among youth, there was racial mixing as well as boundary maintenance. As Lipsitz demonstrates in his ar-

ticle on Los Angeles minorities and rock and roll, the mass migrations caused by the postwar industrial boom in Los Angeles had the effect of producing unprecedented interethnic mixing. They also brought "radically new social formations that encouraged the development of alternative forms of cultural expression" (Lipsitz 1989:269). Crucial connections were made during this period between teens' cultural productions and the craft expertise of their parents. Aero-industry workers influenced surfboard construction, as auto-industry workers influenced and perpetuated car customizing, and a combination of the two influenced car racing.[8] From this nexus of industry and youth culture in Los Angeles emerged the rod and custom car magazines, such as *Motor Trend*, *Rod and Custom*, and now *Low Rider Magazine*, which support and encourage car customizers inside and outside the United States. Simultaneously, as Lipsitz details, rock and roll mobilized youth across racial, class, and ethnic lines. This mobilization occurred through popular culture, especially music and dance. Important sites included integrated performance venues, clubs in working-class parts of town, and the cruising strips and diners found in all parts of Los Angeles. In this milieu, cars became integral to youth culture activities.

Car Clubs

The tremendous growth of car ownership in the fifties meant the development of an alternate form of group membership—that presented by car clubs. To give one example, in 1954 some teenagers from the barrio of Tortilla Flats in East Los Angeles did not want to belong to the local gang. They approached Mike Duran, a local ex-gang member then working as a counselor for Juvenile Hall, and they asked him to sponsor them as a social club. "'Why me?' [I asked.] They said, 'You started college, you're smart, and besides that, you're tough enough to face up to my brothers. So if you told them to lay off of us, they probably would. We want to start a club.' So they started a club called the 'Honeydrippers' and for that time, it was the best organized club in L.A. . . . They considered themselves a car club, except in those days, not everybody had a car. So how can you be a car club if not everybody's got a car? . . . Of the whole group [of 25], maybe ten people had a car. They were all working to raise money to buy their cars and so in between, . . . they would have can good drives

and give out baskets to the needy and this kind of stuff" (Mike Duran, interview with author, January 31, 1989). In this discussion, "getting it together" involved one in new relationships to money, saving, craft, and group cooperation. Activities that simultaneously focused on individual ownership, community benefit, and sponsorship thus created the possibility of a new context for "social" activity. The development of youth car culture enabled the active invention of, and participation in, an alternate landscape of socializing, rock and roll, and dances.

In the fifties, in part because car clubs were breaking out of being territory based, members began to forge ties with other clubbers. As Mike Duran said, "One thing about the car clubs too, once they became social in nature, they started saying, 'We ought to break up this crap about being prejudiced towards other races.' The guys from East Los Angeles would go to Whittier and talk with the guys, talk it out with them and say, 'Why can't we get together and be friends instead of enemies, just because we're white and we're brown. We both love cars as a common thing'" (interview with author, January 31, 1989). Clubs and cruisers shared a common interest in cars. Both used them to transcend territorial identities. The Dukes Car Club, begun in the late 1950s, officially started in 1962 by the Ruelas brothers and a handful of close friends from the 38th Street Neighborhood. By 1965, they had 100 members, mostly Mexican American, from different parts of Los Angeles—the south side, the west side, the north, and the east. The Dukes were one of the few Latino car clubs to attend the early car shows thrown by the white R. G. Canning and the Tridents Car Club in the late fifties and early sixties. Car shows have become one arena where different racial groups participate together.[9]

CRUISING AND CUSTOMIZING

The low rider name "tag" was introduced in the sixties. It signified both the customizers and their rides. While the cars retained the low custom looks of the fifties, this was made problematic by a California State Vehicle code that stated that no part of the chassis or car body could be below the bottom of the wheel rim. Low riders began installing hydraulics pumps on their cars that could raise or lower the chassis with the simple flip of a toggle switch. Originally an aircraft tech-

nology used to power wing flaps, and also used to power the tailgates of bobtail trucks (West 1976), hydraulics were first engineered for cars in the early sixties. One version of the story of their adaptation has it that they were adapted to cars when Joe Baline, a prominent local customizer, put them on a '59 Corvette in the early 1960s. After that, they grew in popularity. Not only did they enable lowered cars to travel at legal heights, but they were soon seen to have enormous performative and competitive potential.

On Whittier Boulevard, the cruising strip, a common sight was two cars heading opposite directions, hopping for each other in an automobile version of the dozens. Perhaps due to more sophisticated customizing and the flexibility of hydraulically powered movement, the popularity of low riding grew. This growth is most evident in the increase in car club numbers from two or three in the early sixties, to fifteen or so by 1970. The Boulevard generated its own forms of cultural expression, according to Ralph Perez:

> I guess when you want a low rider, you want to be number one. You want to go down the street and say out of 500 cars out there low riding, you want to be number one out there, which these other guys out there just want to be the same.... So the next thing you know, we were having contests who could jump the highest straight up and down, sideways, who could outlast somebody. And you know, it would just progress as you went on. And then they got into paint. Who had the best paint? People would spend $3,000 on a paint job, $4,000 on the interior, and another $5,000 on chroming everything. So after a while, you spend a lot of money fixing up a car. Which you had your different categories. Guys who were working could afford it. Guys who weren't were just rims and tires and hydraulic suspensions and that was it. (Interview with author, February 1989)

The cars were customized to Mexican American standards that challenged and minimized their status as mass-produced objects and created them anew in the vision of their owners as unique objects of desire.[10] Techniques such as removing all manufacturing labels, chopping and channeling, cutting and welding side panels to bodies of different-year models, or interchanging accessories and details— such as putting '57 Cadillac tail lamps on a '62 Chevy Impala—were employed to make each car the unique creation of its owner.

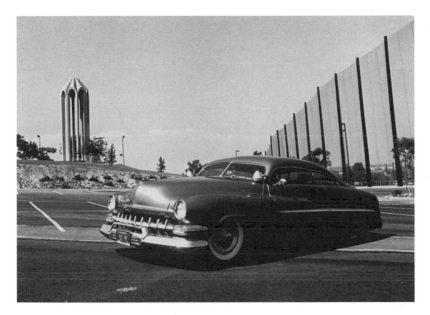

FIGURE 4.2 1950 Mercury. Photograph by author.

Steve Gonzales joined the Dukes Car Club in 1979, the year of the
first annual *Low Rider Magazine* car show. His car, a chopped '50 Mer-
cury with '52 rear quarter panels (figure 4.2), is a telling example of
the technical sources, memories, and cultural inspirations that low
riders draw on. It is the combination of these that constitute the subtle
moves that low riders use to subvert customizing categories as they
inscribe personal visions and memories onto their vehicles.

Gonzales's family moved to Montebello, the first municipality east
of unincorporated East Los Angeles, in 1971 from the White Fence
area of East Los Angeles (detailed in Moore et al. 1978). In 1973,
when Steve was twelve, he briefly joined a local gang, but quickly got
out. He traces his interest in cars to that same time: "1972, 1973 was
when I got started with this interest. Now that's a young age, a really
young age. With a teenage life there are so many roads you can take,
and I chose this one. It brought me closer with my family and my dad
in building the car" (interview with author, April 27, 1989). In 1975,
his father bought him his car, then in bad shape, from a used car lot
(figure 4.2). They bought parts and accessories from area junk yards.
They traded other parts with friends. They worked on it together for
the next three years while Steve attended high school. The '50 Mer-

cury has family meaning because Gonzales's father had owned a '51 Mercury in the early days of his marriage. Home movies show the young couple and their car in a family caravan driving out to a nearby lake. Steve evokes his own "memory" as a suburban kid through the image of James Dean's car in the film *Rebel Without a Cause*, which was also a '50 Mercury. In these two referents, Gonzales invokes both his father's experiences as a young man as well as his own. Steve traces his rapport with the Dukes Car Club to the fact that his mom and dad grew up in the same area as the Dukes, the 38th Street area represented in the film *Zoot Suit*.

Few of the older low rider clubs still cruise, largely because of the harrassment they receive from the police. Currently most car clubber activities revolve around car shows, meetings, and benefits. These have provided two related features important to low riders. First, they are generally safe ground for groups getting together, in that the cars are safe from defacement and their owners from harrassment. Second, they provide an arena for competitive performances. In this way, cars represent the atomization and fragmentation of territory and identity. Even as vehicles are designed to "allow" transit for their occupants, low riders became a kind of "territory" in motion, designed not only for movement but, in their visual elaboration, for "stasis" and performance as well. They are designed to make a place of themselves.

PICTURES OF PLEASURE:
CONTESTED IMAGES AND SAFE GROUND

In low riding, the car emerges as a site of the imaginary, marking the coincidence of place and travel, of the self and the social, and of affect and performance. The "places" and the "pasts" of low riding trace the integration of the car into the imaginary of the neighborhood and city as a social site (Vigil 1988). If, as Rob Shields suggests (1991:29), "[o]ften, elements of imaginary geographies are used interchangeably as metaphors for more abstract distinctions. Sites become symbols (of good, evil, or nationalistic events), and in tandem with other sites can be taken up in metaphors to express (gendered) states of mind, of affairs and different value positions," the question that follows is, How is the imaginary integrated onto the car via murals? Can we understand imaginary geographies as presented in mural images

to be mapping the male subject onto the "object" as such and thereby locating him in and creating an alternative map of identity by way of the city?

For low riders, the car is a "cultural vehicle," much as it is represented by Chicano artist Gilbert Lujan in his series entitled "Cultural Vehicles." In these drawings, he depicts Chicano families in cars "on the road" in Aztlán, traversing landscapes constructed of Aztec monuments, Southwestern visages, and city fragments. In his usage, the cars are both vehicles and metaphor for cultural travel. The drawings depict an adaptive strategy for "moving on" in a way that includes one's past, one's traditions, and one's family and friends. They show the necessity of re-inventing culture as one goes along. The important effect of these drawings, and of low rider cars as well, is that they create a new kind of home for Chicanos in a landscape of symbols containing histories of the present. Refigured in these symbolic landscapes are the terms of identity formation. As Flores and Yúdice insist, "Latino affirmation is first of all a fending off of schizophrenia, of that pathological duality born of contending cultural worlds, and perhaps more significantly, of the conflicting pressures toward both exclusion and forced incorporation" (1990:60). Affirmation figures into the images of popular culture not only in the portrayal of realms of pleasure but, as George Lipsitz points out, "the desire to connect to history, the impulse to pose present problems in historical terms, and the assertion of a temporal and spatial reality beyond one's immediate experience pervade popular culture in significant ways" (1990:36). In Lujan's images of Aztlán, the landscape enjoins iconic and ironic features of the "lost land" with the contemporary skyline, there for specular pleasures of the family outing. Low riders' own "landscapes" appear in murals painted on the trunks and hoods of cars that feature scenes of urban pleasure, scenic nature, cultural warriors (Aztec Indians), and scenes from popular culture. Increasingly, mural characters are drawn from popular culture's nightmares, and outlaws are used to depict the metropolis as a site of contestation. Ultimately, they depict metropolitan processes as responsible for alienated cultural states.

The *Los Angeles Times* has a long history of portraying Chicanos as associated with drug, gang, and criminal activity (Davis 1990; McWilliams 1946). In this, the paper is positioned as part of the metropolitan power bloc, along with city and state governments and the

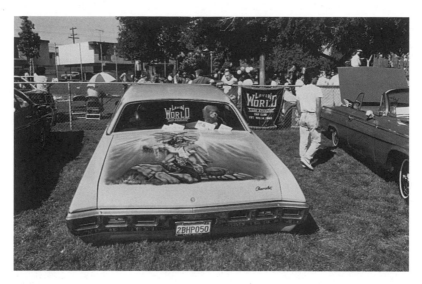

FIGURE 4.3 "Latin World." Photograph by author.

police. The traces of these portrayals and interactions on low riders' self-promotion are varied. Some claim their group histories and use their cars as evidence of their good behavior, noting that the time, money, and effort required to make a low rider makes them less likely to be engaged in gang or criminal activity. Others no longer claim the low rider label. While still having low rider cars, they ask to be known simply as "guys with customized cars." One place where media portrayals are taken up and visually contested is on murals that appear on the cars. Just as the landscapes of memory detailed earlier were registered in clothing styles, so also are discourses of identity manifest in customizing aesthetics, especially murals. During the 1970s, many murals incorporated themes of the Chicano movement through the use of images of the Virgin of Guadalupe, Aztec mythology, and Mexican Catholicism (figure 4.3). Today, these figures compete with others that depict metropolitan conflicts through the use of popular media figures.

In many murals, the car functions as a stand-in for the hopes and desires of the owner. In the mural image of one South Central car, the owner appears as a character in a scene invoking both religious and civic themes. In a manner similar to the first car discussed (figure 4.1), the mural features the car itself, a beautiful Oldsmobile, parked in a liquor store parking lot amidst drug dealers, gamblers, and

cholos, depicting "the wickedness of contemporary life," or "la vida loca." Integrated into the liquor store wall is a mural of the Sacred Heart of Jesus, with Jesus looking down beneficently upon the scene. In deploying the signs of "la vida loca" under the purvey of the "*corazon sangrante*" (bleeding heart), the mural incorporates two gazes— that of Jesus and that of the public. The image is an appeal for God's love and a sympathetic public audience. The presence of Jesus has the iconographic effect of interpreting the scene of decadence, pleasure, and hopelessness, all experiences born of the ghetto, as one of pain and suffering, in which people seek the release of their sufferings in unfilling addictive and "impure" substances. The offering of Jesus's own bleeding heart, a sign of suffering, love, and purification, embodies the owner's hope of the healing possibility of tradition.[11] In its juxtaposition of "pure and impure" substances, the mural casts the scene as the sacrifice of humanity and "replaces the violence of sacrifice with the ritual of purification" (Kristeva 1982:82).

Negotiated in the image is the boundary between good and evil, especially metropolitan-based boundaries such as are created through the de facto segregation of reindustrialization and the constant media and police attention on drugs and poverty in central Los Angeles. In the media and police bureaucracy, poor people of color are portrayed as evil, lazy, childlike, and subhuman. They exhibit improper "individuality" and social behaviors. Their "color" or "culture" is conflated with their poverty, behaviors, and part of town. This mural shifts the locus of the definitions of good and evil. In it, the characters are sinful, not evil. As sinners, they are entitled to the redemptive gift of Jesus's love. Likewise, the car as an object of skill and beauty is a secular object of transcendence. This is not a mural that glorifies or vilifies "la vida loca," but presents it as a situational melodrama.

An alternate city is depicted in the murals on the '39 Chevrolet of figure 4.4 (*Low Rider Magazine*, May 1990, pp. 16–20). Called "The Gangster of Love," it is covered with murals on the trunk and hood, on the rear panels, on the front side panels, and under the hood. Each large mural portrays a gangster theme: "Al Capone's Bank," "Dillinger's Saloon," "Old Memories Hotel and Casino," and a caravan of gangster cars cruising the Boulevard, in mythical Aztlán, past a movie theater playing *East Side Story*.[12] One smaller panel depicts the car's owner, Art Moreno, and his friends dressed up as gangsters. In another, they appear in zoot suits next to his car. On the hood are Mor-

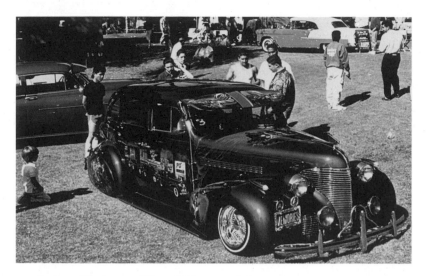

FIGURE 4.4 "Gangster of Love." Photograph by author.

eno and a beautiful woman next to his car with the night city in the
background. Each of the wheel wells is adorned with painting of a
beautiful "doll." Themes of sex, money, and guns predominate. But
the main theme is the staging of the man belonging to a society with
its own map—a geography of place and desire—of the city. In this
mural, the culture of money has been re-envisioned in a Chicano city
and "la vida loca" legitimated. Here the fantasy is of a hyper-reality,
of a fantasy city—Aztlán, the spiritual Chicano homeland—as the do-
main of the gangster life. The hallmark of gangster life is that while
it lies outside of the bounds of bourgeois rationality, it is nevertheless
preoccupied with the theoretical rewards of the bourgeois all-
American life. The gangster, in a truly American fashion, strives to
achieve "many of the goals—power, money, fame, status—that are
held out by society as symbols of success" (Gabree 1973:14). That
the gangster film first appeared during Prohibition and the Depres-
sion has important resonances with the appearance of this mural in
central Los Angeles in the late 1980s.

The "Joker's Revenge" (figure 4.5), a gold-yellow Lincoln, has no
mural on the car, but the credits board features a portrait of the Joker
from the 1989 movie, *Batman*. The Joker in *Batman* is a diabolical
character who was "created" at the hands of vigilante justice. Origi-
nally just a two-bit hood, Jack Napier became the demented Joker as

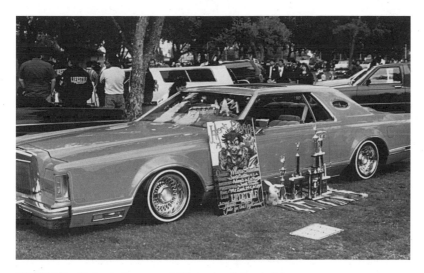

FIGURE 4.5 "Joker's Revenge." Photograph by author.

a result of being double-crossed by his boss, a chemical plant owner who set him up to be busted by the police. The encounter resulted in Napier's being dumped into a vat of chemicals by Batman. The Joker takes over the chemical plant and begins sabotaging the cosmetics. He calls himself an artist promoting a new aesthetic. In naming his car "Joker's Revenge," this low rider (an aerospace industry machinist) metaphorizes his ability, as a product of the metropolitan and industrial system, to thwart that same system by promoting a new aesthetic. In the concise fashion of iconic images, the Joker evokes the conflicts, experiences, and visions inherent in the industrial metropolis. Through the use of this association, the owner stages his desire to operate powerfully from an experience of being "outside" the metropolitan powers that be. In this image, as in the other murals, aesthetics emerges as an important site of struggle.

These murals were painted in the late 1980s and early 1990s, after ten years of Reaganomics and as the deindustrialization of Los Angeles begun in the early seventies became nearly complete. They are part of one current trend in low rider aesthetics toward the interpretation of experiences of alienation based upon metropolitan decline.[13] On the one hand, they are part of a long tradition within low riding of expressing oppositional identities through comic book and movie characters, rock and roll stars, and the cultural national images

of the Chicano movement. On the other hand, what appears as an important theme in these images is the metropolis, not simply as a site of pleasure, as depicted in so many low rider mural images of cruising and nightlife, but as a site of struggle.

ETHNOGRAPHIC REMAPPING

Current writings on ethnography (Marcus and Fischer 1986; Clifford and Marcus 1986; Marcus 1990; Thornton 1987) critique the ethnographic move of positing the ethnographic scene and subject as a "knowable, fully probed micro-world with reference to an encompassing macro world . . . which, presumably, is not knowable or describable in the same terms" (Marcus 1990:7). Jack Rollwagen calls this the "tradition of 'absolute relativism'" (1980:377), which assumes that "place is the most distinctive dimension of culture" (Marcus 1990a:21). What the tradition of absolute relativism fails to take into account are the ways in which transnational processes of global capitalism challenge the notion of identities as the products of strictly local processes. Not only must these be theorized to include the internationalization of the labor force and the community politics set into play by global restructuring (Davis 1990; Mollenkopf 1983; Soja 1989), but also the restructuring of metropolitan areas due to deindustrialization and reindustrialization, as well as the influences of mass communication media and the importance of commodified mass culture as resource (Watkins 1991; Abu-Lughod 1990). These processes indicate an important need for reconceptualizing social process, cultural systems, and the means of ethnographic exposition. These critiques point to the necessity of rethinking the problem of holism in anthropology, especially as it concerns the macro-micro relationship. If what Nestór García-Canclini describes is true—that contemporary identity processes are becoming increasingly deterritorialized (1990)—then the concerns of ethnographic projects need to be remapped, since "place" is no longer a suitable frame for ethnography. My research on low riders in Los Angeles and the Southwest suggests that participation in popular culture entails contemporary identity processes that are multidimensional. They are often locally based but quickly become translocal, and it is the translocal, mediated dimensions of popular culture that are most troubling to anthropology.

Rollwagen advocates a world-systems approach through a focus on cities, inasmuch as cities provide and perform functions necessary to keep the integrating and overarching world system functioning. He criticizes the term "subculture" as a unit of society, because it implies a relationship of equivalency between culture and society, which Rollwagen does not see. Instead, he argues that "[a]ccepting the perspective that culture is a process of cognitive elaboration and interpretation that human beings engage in continuously as individuals in all of their associations facilitates the comprehension of an infinite set of culture elaborating units different from societies in form and function. The participation of individuals in the elaboration of interpretations and their agreement to participate in the application of these elaborations in some mutually understood manner are the bases of the formation of a culture-evolving system" (1980:375). He advocates a "holistic approach," suggesting that "any aspect of a cultural system that is chosen for study be examined in terms of that which forms its pertinent or significant contexts in the larger system of which it is a part" (376). This represents an important shift in ethnographic focus. "In terms of population, cities are very large. But the fact that they are composed of numerous kinds of cultural systems arranged into a hierarchy of power allows exploration of individual cultural systems through emic approaches on the nature of that cultural system itself, through exploring emically the nature of the view that participants hold of other cultural systems in a city (or of a city taken as a whole), and through etic approaches to all of a city's cultural systems" (1980:378).

Rollwagen's advocacy of emic approaches to views of the city parallels recent research on urban consciousness. This work emphasizes two important processes. On the one hand, radical geographers and cultural critics such as Mike Davis and David Harvey are engaged in conceptualizing the politics of culture in relation to the urbanization of capital and the urbanization of consciousness. Others (Abu-Lughod 1990; Moorhouse 1991, Olalquiaga 1992; Ross 1989; Watkins 1991) are concerned with tying mass media to cultural processes and the rise of particular cultural sensibilities. Both processes are important here. Harvey's discussion of urban consciousness draws attention to a very important aspect of urban processes, namely, that "increasing urbanization makes the urban the primary level at which individuals now experience, live out, and react to the totality of social transforma-

tions and structures in the world around them.... It is out of the complexities and perplexities of this experience that we build an elementary consciousness of the meanings of space and time; of social power and its legitimations; of forms of domination and social interaction; of the relation to nature through production and consumption; and of human nature, civil society, and political life" (Harvey 1985:251). He continues, "The tendency to produce a structured coherence in urban politics and economy is consequently paralleled by a tendency to produce unique configurations of consciousness in each urban context. This typically gives rise to distinctive urban traditions, an urban folklore and an urban folk culture, and even produces mythologies representing the qualities of life, thought and character of particular places in symbolic form. Yet here too, relatively autonomous processes of cultural development are constrained by spatial and interurban competition, the formation of hierarchies of cultural domination, and the ravages of cultural imperialism" (266).

Needed are new ways to think about cultural geography and new ways to expose symbolic landscapes. As George Lipsitz writes, "New technologies do lend themselves to new forms of exploitation and oppression, but they also have possible uses for fundamentally new forms of resistance and revolution" (1990:vii). These challenges are of particular importance to the study of contemporary popular culture, one of the key manifestations of the market-commodity mode of global capitalism.

Michael Hannan has argued that modernization creates ethnic distinctions in a way that is somewhat paradoxical. Modernization, in reducing ethnic diversity, results in the elimination of smaller-scale ethnic boundaries. Yet the organizational potential of larger-scale ethnic organizations is increased. I would add that if these conditions are experienced coterminously with racial discrimination, they enhance the importance of a large-scale identity, such as Chicano identity. This then is the connection to Chicano identity that is expressed in all of the sites of my research. It is a large-scale ethnic identity based on resistance to dominant notions about Mexican Americans that values empowerment. Low riding as a regional phenomenon is facilitated by the circulation of people and media, most notably *Low Rider Magazine* but increasingly by other car magazines, low rider videos, and, in some instances, the cars themselves. Low riding is also a cross-over phenomenon, popular in Hawaii, Japan, and Puerto Rico as well as in African American and some white Southern communities. This re-

cent popularity has been enhanced by the depiction of low riders in rap and hip hop music videos. Increasingly, low riders are local manifestations of larger processes involving both popular culture and ethnic identity.

Automobile culture provides one route to understanding to what extent place is an important dimension of culture. This essay on low rider car culture in Los Angeles is part of a larger project researching the local meanings of what is by now a national and international phenomenon facilitated largely by *Low Rider Magazine*, recent developments in automobile manufacturing (Watkins 1991), and, increasingly, through popular music. This project addresses the problem of doing research in urban communities not necessarily constituted "on the ground" and resistant to the kind of microworld research traditionally practiced in anthropology and represented in ethnographies. This research suggests that local issues are not unimportant, but that subcultural practices "re-map" the local by using technology and communications media to create new cultural spaces. Juan Flores and George Yúdice utilize the idea of remapping in their article on languages of Latino self-formation. Discussing Tato Laviera's coining of the term "AmeRícan" ("I'm a Rícan"/American), they note: "The hallowed misnomer unleashes the art of brazen neologism. The arrogance of political geography backfires in the boundless defiance of cultural remapping. The imposed border emerges as the locus of redefinition and re-signification" (1990:60). My interest in this essay has been to trace the shifting geographies of Chicano car culture in Los Angeles through their configuration in symbolic landscapes. Here popular culture re-territorializes pleasure and visibility into practices of leisure. The promise of popular culture research lies in its challenge to conventionally conceived cultural boundaries and their concomitant identities. It may also serve to make us more culturally literate, expanding our notions of the kind of cultural work that popular culture accomplishes, and, with this awareness, contribute to our understanding of the contingencies of cultural participation in the United States.

NOTES

1. See Soja 1989, Morales 1983, and Davis 1990 on the relationship of these developments. In the Los Angeles area, many towns with predominantly Latino populations (averaging 30,000 to 50,000 residents) such as Montebello,

El Monte, and Whittier, are segregated by class. Working-class, middle-class, and upper-class neighborhoods are usually separated by major streets and geographical features. Property values rise from the flatlands to the hills in each area. Melvin Oliver and J. H. Johnson, Jr. (1984) examine the factors leading to ethnic conflict between Blacks and Latinos in the inner city as a result of deindustrialization and Latino in-migration into a previously Black-dominated Watts. See Gregory 1992 for a discussion of further segregation of Black communities according to class and the development of Black home-owner associations after the civil rights movement. Wilkerson 1992 describes the development of Black upper-class suburbs as a solution to the alienation associated with living in predominantly Anglo suburbs.

2. This essay is a version of my dissertation chapter on Los Angeles. The dissertation (1994) features chapters on low riding in Houston, Texas, Los Angeles, and the Española area of northern New Mexico. I went to Los Angeles after completing research in Houston, Texas, in order to research low riding there and to learn more about its history. Since I was often told by Houston low riders that they were different from Los Angeles low riders— that they were not into gangs—I also hoped to learn what relationship, if any, low riding had with gang participation.

3. I had come to Los Angeles with the names and numbers several people had given me. Anthropologist James Diego Vigil gave me the name of folklor-ist Deidre Evans-Pritchard as someone who had organized a car show for the city. He also gave me the name of Richard García, who had served as a con-sultant for Vigil and Joan Moore's research on Los Angeles gangs. One of my classmates in a summer Spanish program who used to work as a social worker in Los Angeles gave me the name of his supervisor. Renato Rosaldo had given me Teresa McKenna's name as someone who shared my interest in Chicana/o poetry.

4. Davis reports 75,000 jobs lost in Southern California between 1978 and 1982 (1990:304). For trends in industries remaining in Los Angeles's central manufacturing district, see Soja 1989 and Morales 1983, 1986.

5. Los Angeles was once the largest automobile-tire-glass manufacturing center in the United States outside of Detroit. Five of the seven automobile plants were located in the central manufacturing zone just south of downtown in the cities of South Gate, Vernon, Maywood, Commerce, and Pico Rivera. Production peaked in the mid- to late 1960s, coinciding with the postwar boom. Beginning in the 1970s, plant closings in the steel and automotive in-dustries began the deindustrialization of central Los Angeles and ended an era of skilled, high-paying, and unionized jobs. Reindustrialization occurred within aerospace and electronics industries, most often outside of the old industrial area. For the working class and poor living adjacent to the central manufacturing areas, the process of deindustrialization has meant two things: one, a decrease in both the quantity and quality of jobs; and two, some in-crease in available housing stock in areas previously unavailable to them due to housing discrimination, as whites moved out to other suburbs (Davis 1990; McWilliams 1946).

6. "Pachucos" refer to Mexican American youth in the 1940s known for wearing zoot suits, suits with broad shoulders and baggy pants that were tied at the ankle. They were referred to as "zoot suiters," a term media sensationalism made synonymous with "hoodlums." In 1943, zoot suiters were hunted down and beaten by U.S. servicemen stationed in Los Angeles in what is known as the Zoot Suit Riots, although as Marcos Sanchez-Tranquilino so adroitly points out, "it is more appropriate to call them the 'Servicemen Riots.'" See Mauricio Mazón 1984 and Sanchez-Tranquilino 1987 for descriptions and interpretations of these events.

Cholos were the next generation of Mexican Americans with distinctive dress, namely, neatly pressed baggy khakis worn with T-shirts. Pachucos are important in Chicano interpretations of history, inasmuch as their dress, manners, identity, and persecution are understood as important markers of the conflicts endemic to their bicultural (Mexican and American) subjectivity.

7. Anglos who moved from Oklahoma to Los Angeles, especially during the Depression, were known as Okies. See McWilliams 1946.

8. See Moorhouse 1991 for a detailed account of the relationship between leisure, masculinity, technology, media, and professionalism manifested over the years in hot rod and car racing practices.

9. While there were attempts to break out of territorial and racially defined identities, these ties were difficult to sever precisely because of their embodiment in discourses of status, technology, and difference. The increased interaction of people from different areas sometimes resulted in violence when different clubs and cruisers got together. Even though clubs would have members from a variety of areas, they might have six or seven members from a particular barrio such as Lopez or Geraghty. This often resulted in conflicts when clubs got together. In an attempt to remedy this problem and reduce the volatility of the cruising scene, in 1970 and 1971 the club presidents formed a car club federation and met once a month to iron out mutual problems. The federation encouraged increased cooperation between the clubs and organized competitions such as football games.

10. See Wolfe 1965 and Teen Angel 1978 for descriptions of early car customizing. See Moorhouse 1991 for a thoughtful treatment of hot rodding. My criticism of Moorhouse is that he does not adequately treat the important relationships between racing, craft and fuel technologies, and industry in Southern California (see Morales 1986).

11. It is possible that some might interpret the customized car as a sign of improper substance addiction. This scene replicates the melodrama staged in the movie *Boyz in the Hood*. Here, life in South Central is presented as an ever-present struggle for daily life against poverty, drugs, and joblessness. The hope presented in the movie is embodied in the figure of the responsible, politically aware, and street savvy father who is willing to guide his son to manhood through his teachings and discipline.

12. The fiction of Aztlán here also suggests an alternate city, one that corresponds to the Chicano working-class areas east of downtown Los Angeles known as the "East Side." This includes unincorporated East Los Angeles

and the predominantly Chicano suburban cities of Montebello, Pico Rivera, and El Monte. The boulevard suggests Whittier Boulevard in East Los Angeles, the famous cruising strip in the heart of the Chicano barrio. "East Side Story" is also the name of a collection of songs recorded over the years by artists from the East Side.

13. See Katherine Newman 1988 for a depiction of cultural discourses of success, failure, and alienation in the current economic climate.

REFERENCES

Abu-Lughod, Lila
1990 "The Romance of Resistance: Tracing Transformations of Power Through Bedouin Women." *American Ethnologist* 17(1):41–55.
Anaya, Rudolfo, and Francisco Lomelí, eds.
1991 *Aztlán: Essays on the Chicano Homeland.* Albuquerque: University of New Mexico Press.
Baker, Bob
1991 "L.A's Booming Auto Industry Now a Memory." *Los Angeles Times*, July 20.
Bright, Brenda Jo
1991 "Recasting the Devil: Images of Violence, Sexuality, and Morality in Low Rider Murals of Central Los Angeles." Unpublished manuscript.
1994 "Mexican American Low Riders: An Anthropological Approach to Popular Culture." Ph.D. diss., Rice University.
Camarillo, Alberto M.
1972 "Chicano Urban History: A Study of Compton's Barrio, 1936–1970." *Aztlán* 2(2):79–106.
Clifford, James, and George Marcus, eds.
1986 *Writing Culture: The Poetics and Politics of Ethnography.* Berkeley: University of California Press.
Collins, Keith
1980 *Black Los Angeles: The Maturing of the Ghetto, 1940–1950.* Saratoga: Century Twenty-One Publishing.
Cruz, Manuel
1979 "Gang History." *Low Rider Magazine* 2(5):35–37.
Davis, Mike
1990 *City of Quartz: Excavating the Future in Los Angeles.* London, Verso.
Dent, David
1992 "The New Black Suburbs." *New York Times Magazine*, June 14.
Flores, Juan, and George Yúdice
1990 "Living Borders/Buscando America." *Social Text* 24(Fall):57–84.
Fox, Richard G.
1977 *Urban Anthropology: Cities in Their Cultural Settings.* Englewood Cliffs, N.J.: Prentice-Hall.
Gabree, John
1973 *Gangsters from Little Caesar to the Godfather.* New York: Pyramid.

García, Mario T.
1989 *Mexican Americans: Leadership, Ideology, and Identity, 1930–1960.*
New Haven, Conn.: Yale University Press.
García-Canclini, Néstor.
1990 "Escenas sin territorios." *Revista de Crítica Cultural* 1(1): 9–14.
Gregory, Stephen
1992 "The Changing Significance of Race and Class in an African American
Community." *American Ethnologist* 19(May): 255–74.
Griswold del Castillo, Richard, Teresa McKenna, and Yvonne Yarbro-
Bejarano, eds.
1991 *Chicano Art: Resistance and Affirmation, 1965–1985.* Tucson and Lon-
don: University of Arizona Press.
Harvey, David
1985 *Consciousness and the Urban Experience: Studies in the History and The-
ory of Capitalist Urbanization.* Baltimore: Johns Hopkins University
Press.
Hebdige, Dick
1988 *Hiding in the Light: On Images and Things.* London: Routledge.
Jules-Rosette, Bennetta
1985 *The Messages of Tourist Art: An African Semiotic System in Comparative
Perspective.* New York: Plenum.
Kristeva, Julia
1982 *Powers of Horror: An Essay on Abjection.* New York: Columbia Univer-
sity Press.
Lipsitz, George
1989 "Land of a Thousand Dances: Youth, Minorities and the Rise of Rock
and Roll." Pp. 267–84 in *Recasting America: Culture and Politics in the
Age of the Cold War,* ed. L. May. Chicago: University of Chicago Press.
1990 *Time Passages: Collective Memory and American Popular Culture.* Min-
neapolis: University of Minnesota Press.
Marcus, George E.
1990 "Imagining the Whole: Ethnography's Contemporary Efforts to Situ-
ate Itself." *Critique of Anthropology* 9(3):7–30.
Marcus, George E., and Michael M. J. Fischer
1986 *Anthropology as Cultural Critique: An Experimental Moment in the Hu-
man Sciences.* Chicago: University of Chicago Press.
Mazón, Mauricio
1984 *The Zoot Suit Riots: The Psychology of Symbolic Annihilation.* Austin:
University of Texas Press.
McWilliams, Carey
1946 *Southern California Country: An Island on the Land.* New York: Duell,
Sloan and Pearce.
Meyerhoff, Barbara, and Stephen Mongulla
1986 "The Los Angeles Jews' 'Walk for Solidarity': Parade, Festival, Pilgrim-
age." Pp. 119–38 in *Symbolizing America,* ed. H. Varenne. Lincoln: Uni-
versity of Nebraska Press.
Mollenkopf, John H.
1983 *The Contested City.* Princeton: Princeton University Press.

Moore, Joan, with Robert García, Carlos García, Luis Cerda, and Frank Valencia
1978 *Homeboys: Gangs, Drugs and Prisons in the Barrios of Los Angeles*. Philadelphia: Temple University Press.

Moorhouse, H. F.
1991 *Driving Ambitions: An Analysis of the American Hot Enthusiasm*. Manchester: Manchester University Press.

Morales, Rebecca
1983 "Transitional Labor: Undocumented Workers in the Los Angeles Automobile Industry." *International Migration Review* 17(4):570–97.
1986 "The Los Angeles Automobile Industry in Historical Perspective." *Environment and Planning D: Society and Space* 4: 289–303.

Newman, Katherine
1988 *Falling from Grace: The Experience of Downward Mobility in the American Middle Class*. New York: The Free Press.

Olalquiaga, Celeste
1992 *Megalopolis: Contemporary Cultural Sensibilities*. Minneapolis: University of Minnesota Press.

Oliver, Melvin, and J. H. Johnson, Jr.
1984 "Interethnic Conflict in an Urban Ghetto: The Case of Blacks and Latinos in Los Angeles." *Research in Social Movements, Conflict and Change* 6: 57–94.

Ortner, Sherry
1991 "Reading America: Preliminary Notes on Class and Culture." Pp. 163–90 in *Recapturing Anthropology: Working in the Present*, ed. Richard G. Fox. Santa Fe: School of American Research Press.

Plascensia, Luis
1983 "Low Riding in the Southwest: Cultural Symbols in the Mexican Community." Pp. 141–75 in *History, Culture and Society: Chicano Studies in the 1980s*. Ypsilanti: Bilingual Press.

Preziosi, Donald
1989 *Rethinking Art History: Meditations on a Coy Science*. New Haven: Yale University Press.

Rodriguez, R.
1984 *Assault with a Deadly Weapon: About an Incident in E.L.A. and the Closing of Whittier Boulevard*. Los Angeles: Rainbow Press.

Rollwagen, Jack
1980 "New Directions in Urban Anthropology: Building an Ethnography and an Ethnology of the World System." Pp. 370–82 in *Urban Life: Readings in Urban Anthropology*, ed. G. Gmelch and W. Zenner. New York: St. Martin's Press.

Romo, Ricardo
1983 *East Los Angeles: History of a Barrio*. Austin: University of Texas Press.

Ross, Andrew
1989 *No Respect: Intellectuals and Popular Culture*. New York: Routledge.

Sanchez-Tranquilino, Marcos
1987 "Mano a mano: An Essay on the Representation of the Zoot Suit and Its Misrepresentation by Octavio Paz." *Journal of the Los Angeles Institute of Contemporary Art* (Winter): 32–42.

1990 "Murales del Movimiento: Chicano Murals and the Discourses of Art and Americanization." Pp. 85–101 in *Signs from the Heart: California Chicano Murals*, ed. E. Cockcroft and H. Barnett-Sanchez. Santa Monica: Social and Public Art Resource Center.

Shields, Rob
1991 *Places on the Margin: Alternative Geographies of Modernity*. London: Routledge.

Soja, Edward
1989 *Postmodern Geographies: The Reassertion of Space in Critical Social Theory*. London: Verso.

Stone, Michael C.
1990 "'Bajito y Suavecito': Low Riding and the 'Class' of Class." *Journal of Latin American Popular Culture* 9: 85–126.

Teen Angel
1978 "Cruising into the Past." *Low Rider Magazine* (January): 26–27.

Thornton, Robert
1987 "The Rhetoric of Ethnographic Holism." *Cultural Anthropology* 3(3): 285–303.

Trillin, Calvin
1978 "Our Far-Flung Correspondents: Low and Slow, Mean and Clean." *New Yorker* 54:70–74.

Vigil, James Diego
1988 *Barrio Gangs: Street Life and Identity in Southern California*. Austin: University of Texas Press.

Watkins, Evan
1991 "'For the Time Being, Forever': Social Position and the Art of Automobile Maintenance." *Boundary 2* 18(2):150–65.

West, Ted
1976 "Low and Slow: Scenes from a Revolution." *Car and Driver* (August): 47–51.

Wilkerson, Isabel
1992 "Two Neighborhoods, Two Worlds." *New York Times*, June 21, sect. A1, and June 22, sect. A1.

Willis, Paul
1977 *Learning to Labor: How Working Class Kids Get Working Class Jobs*. New York: Columbia University Press.

Wolfe, Tom.
1965 *The Kandy-Kolored Tangerine-Flake Streamline Baby*. New York: Farrar, Straus and Giroux.

Ybarra-Frausto, Tomás
1991 "Rasquachismo: A Chicano Sensibility." Pp. 155–62 in *Chicano Art: Resistance and Affirmation*, ed. Richard Griswold del Castillo, Teresa McKenna, and Yvonne Yarbro-Bejarano. Los Angeles: Wight Art Gallery.

Zizek, Slavoj
1991 *Looking Awry: An Introduction to Popular Culture Through Jacques Lacan*. Cambridge: MIT Press.

5 MARKETING MARIA

THE TRIBAL ARTIST IN THE AGE OF MECHANICAL REPRODUCTION

BARBARA A. BABCOCK

The subordinated are, indeed, always vulnerable to representation: the lower classes "may at most times be represented almost without restraint."
—Stephen Greenblatt, *Shakespearean Negotiations*, quoted in Peter Stallybrass, *Marx and Heterogeneity: Thinking the Lumpenproletariat*

A man came from Germany to take a picture of my hands. Germany. He came to take a picture of me. And I was telling him why he want picture taken of me. He said because too many people know you and you've been making pottery. I don't know why he want picture of [only] my hands.
—Maria Martinez, quoted in Richard Spivey, *Maria*

To study Pueblo ceramics is to confront the paradoxical and politically charged situation that occurs when those signifiers of stability,

Pueblo women potters, become agents of change and cultural bro-
kers precisely because they embody a synchronic essentialism for
postindustrial Anglo consumers. For over a century, Anglo America
has displaced, dehistoricized, and romanticized conflict, ethnicity, and
poverty through figures of Pueblo women artisans shaping mud into
"classic" forms.[1] The endless reproduction of images of "mudwomen"
and "*olla* maidens" shaping and carrying vessels of desire entails
nothing less than the continuing aestheticization, domestication, and
commodification—not to mention feminization—of the Pueblo. Eliza-
beth Sergeant's description of the Pueblo woman and her pots is but
one of countless examples: "the Pueblo woman . . . for some two thou-
sand years had been making pots strong and watertight, good to hold
in the hands or carry on the head; pots whose form, decoration, and
function expressed her innate feeling as a primitive woman for her
home, her connection with earth and its springs, her wonder before
the earth mysteries and magical invocation of them" (1935:59).

In this essay, I discuss some of the political and economic causes
and consequences of such image maintenance—including self-
commodification and the indigenous commodification of ethnic iden-
tity—by focusing on Maria Martinez, *the* Pueblo potter, and the ways
in which both the artist and her art have been produced and repro-
duced in a variety of discourses and institutions from postcards to
books to videotapes and from world's fairs to museums to the White
House (figure 5.1).

Probably the most famous and unquestionably the most photo-
graphed of Native American artists, Maria Martinez of San Ildefonso
has become synonymous with Pueblo pottery in general, with the re-
discovery of black-on-blackware in particular, and with the revival of
traditional ceramics encouraged by the Museum of New Mexico
among the Rio Grande Pueblos in the 1920s. In essays on Pueblo
acculturation and pottery revivals published in 1925 and 1926, one of
these museum employees, Odd Halseth, made the following patroniz-
ing and self-congratulatory remarks, which epitomize the nostalgic
lament, ethnographic pastoral, and aesthetic primitivism of over a
century of Anglo inscriptions of Pueblo life and indigenous crafts:
"Like all other races with an inferior mechanical civilization, the Indi-
ans readily accepted the material culture of the Americans, much to
the detriment of their own art, health, and happiness. Tin pails re-
placed their beautifully decorated pottery vessels, destroying the
erect posture of the watercarrier with the olla on the head, causing

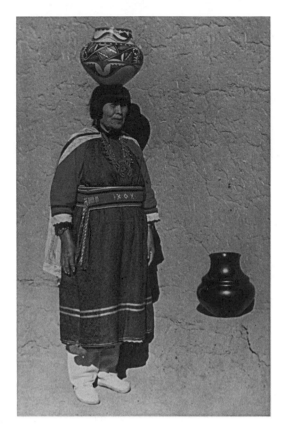

FIGURE 5.1 Maria Martinez, traditionally posed as an olla maiden with two of her pots at San Ildefonso Pueblo, ca. 1954. Both this image and another of Maria, sitting with her pot on her lap instead of her head, were reproduced and widely distributed as postcards by Petley Studios and by Southwest Post Card Co., Albuquerque, N.M. The seated image of Maria has reappeared in recent decades as an advertisement for "Tradition" and the state of New Mexico. Photograph by New Mexico State Tourist Bureau, courtesy of the Museum of New Mexico, negative no. 43447.

stooped shoulders from carrying a pail in each hand, and, besides, the loss of the creative desires and love for beauty, and gave more time for idleness, resulting either in a deadening inertia or giving vent to family quarrels and conflict." However, he continues, "[a]ttempts to revive the pottery making in pueblos where the art has died out, are now being made, and it has been stated by a government official, that since the younger women have taken to the pottery making again, half the domestic troubles have disappeared" (1925: 263–64).

And, in chronicling the results of these revival efforts a year later, Halseth makes the patronizing observation that "[y]oung women, who formerly came home from the government schools without any knowledge of pottery-making and without that keen love of the creation of beauty which filled the lives of their grandmothers with happiness, have successfully been encouraged to take up this work, with the result that idleness, with its deadening inertia to the individual and gossip and trouble to the whole community, has given way to happiness, pride, and self-respect, while the revenue from pottery-making in some families now exceeds the yearly income from their farm products" (1926:136). The ironies, contradictions, and levels of colonization and commodification in these verbal and visual images are astonishing. Such aesthetic otherworldliness—"of those days 'a long time ago' when every woman was an artist and made many beautiful pots every year," and of a Pueblo life seemingly exempt from the power relations and tin pails of modern society—is, however, as both museum officials and Pueblo potters discovered, a profitable business.

Halseth continues to detail the benefits of pottery revivals as follows: "In the Pueblo of San Ildefonso, for example, new houses with better sanitary conditions and improved comforts and happiness can, in large degree, be traced to the economic success of the ceramic artists" (1926: 136). Not surprisingly, Halseth's remarks echo those that his superior, Edgar Hewett, made to the American Federation of Art in 1922. In a lecture entitled "The Art of the Earliest Americans," Hewett lauded the aesthetic success of the revivals encouraged by the Museum of New Mexico: "We are now prepared to definitely extend the hope that the art of the earliest Americans is not simply a glory of past ages but a living asset of today. We have demonstrated in the Southwest that the esthetic spirit of the people lives and responds to friendly encouragement. In pueblo villages about Santa Fe potters are rivalling, even excelling, the finest works of the ancients. If we give them only the same encouragement that we offer to art in general we see astonishing results" (1922: 9).

The village of San Ildefonso, "a special nurseling of lovers of Indian arts and crafts," received the most encouragement, and the most successful of these "young women" potters producing "astonishing results" was Maria Martinez.[2] Her domestic trouble, like that of many other Pueblo women, was her husband Julian's alcoholism. Contrary to Halseth's contentions, the increased wealth and changed status of

Maria and other Pueblo women potters challenged not only the egalitarian nature of Pueblo society but traditional gender roles. As Edwin Wade (1986) has recently pointed out, increased resentment and decreased morale occasioned by pottery prestige contributed significantly to the men's drinking at the same time that it "improved" living conditions in the pueblo.[3] Yet, if Maria's other interpreters mention Julian's drinking at all, they—notably Marriott (1948)—present her pottery making and his painting as a healing as well as profitable antidote rather than a contributing factor to his alcoholism.

Maria's remarkable production began a revolution in Pueblo ceramics, which resulted in several significant transitions experienced by the individual artists as well as by their communities: (1) in the villages' economic structure (from agrarian to cash economies), (2) in the role and position of native artist in the community and the outside world (from anonymity to named success), (3) in gender roles, and (4) in the status of their ceramics (from craft to art). The repeated imaging of Maria and of Maria and Julian also marks a transition in the tradition of representing Pueblo women from what Laura Mulvey (1975) has termed "her to-be-looked-at-ness" to what Tzvetan Todorov (1984) has described as "subject-producer-of-objects"—from woman as aesthetic object to woman as producer of objects. The popular representation of Pueblo woman was not intended to produce knowledge of Pueblo women but, rather, the experience of nonrational, nonquotidian areas of metaphysical being. Whether in photographs like "Water Carriers," taken in the 1880s by William H. Jackson, the "father of the picture postcard," or in lifesize bronze figures sculpted by Glenna Goodacre in the 1980s, the Pueblo woman has had the same cultural status as an art object. By appearing to have a transhistorical value and by embodying imaginary desires (Rauch 1988:78–79), she participates in the same "aura" as the works of art she carries or makes. Indeed, in the pervasive orientalism characteristic of imaging the Native American Southwest, this "classic sight"— these "mudwomen" or "water carriers"—are not infrequently described as "Maids of Palestine" or "New Mexican Rebeccas."[4]

In *The Conquest of America*, Todorov significantly extends the art object argument, suggesting that "if instead of regarding the other simply as an object, [she] were considered as a subject capable of producing objects which one might then possess, the chain would be extended by a link—the intermediary subject—and thereby multiply

to infinity the number of objects ultimately possessed. This transformation, however, necessitates that the intermediary subject be maintained in precisely this role of subject-producer-of-objects and kept from becoming like ourselves" (1984:175–76). Examples of such image construction and maintenance in the portrayal of Pueblo women creating and carrying vessels of desire, despite the reality of tin pails and running water, have persisted into the late twentieth century. The nostalgic etching on the cover of Ruth Underhill's *Pueblo Crafts*, published in 1944, is but one of countless cases in point (figure 5.2).

And, in further confirmation of Todorov's observation, the frontispiece of Underhill's text is an image of Maria preparing pots for firing. Indeed, throughout this as well as numerous other books and essays on Pueblo culture in general and Pueblo arts and crafts in particular, Maria—endlessly shaping mud into pots or occasionally posed as an olla maiden—is *the* featured native (See, e.g., figure 5.1 above.) And, in text after text on Pueblo pottery and ceramic technology—articles, pamphlets, books, slide shows, films, and videotapes—published in the last seventy years, "this most skillful potter of San Ildefonso" (Guthe 1925: Plate 1) has been presented as the "living legend of Pueblo pottery." Or, better yet, since it is after all a matter of the reproduction of culture, the husband and wife pottery-making team of Maria *and* Julian (figure 5.3).

Maria and Julian were married in 1904 and went immediately to the St. Louis World's Fair. In talking with Richard Spivey, Maria recalled: "We were married in the morning and at three o'clock we went in a train. And there I made little pots" (Spivey 1979: 22). Three years later, the Museum of New Mexico began excavations on Pajarito Plateau in 1907 under the direction of Edgar Hewett. Julian worked on the dig and copied petroglyphs, and within a year Maria was experimenting at reproducing the prehistoric pottery. From 1909 to 1912, they lived at the museum in Santa Fe, where Julian worked as a janitor and painted the pottery that his wife shaped. Initially, Julian had gone alone to work in Santa Fe, but when he started drinking again, Maria was persuaded to take the children and join him. According to Alice Marriott (1948:195), "Maria never felt at home there. . To Maria, being away from home was being away from a part of life that was bigger and more important than herself. She needed to feel the pueblo around her to feel that she was safely alive. . . . Here she and Julian and the children were; and there, away from them, was the

FIGURE 5.2 Olla maidens in cover illustration of *Pueblo Crafts* (1979) by Ruth Underhill. Originally published by the U.S. Bureau of Indian Affairs in 1944.

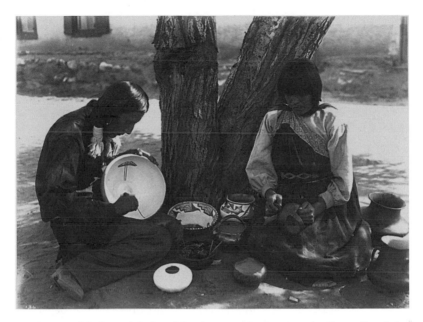

FIGURE 5.3 Maria and Julian Martinez making pottery in the patio of the Palace of the Governors, Santa Fe, N.M. (1912). Photograph by Jesse L. Nussbaum, courtesy of the Museum of New Mexico, negative no. 40814.

pueblo that should have been all around them. It was as if they had stepped aside from the main part of their lives and were living in time that belonged to somebody else." Indeed, for they *were* a living museum exhibit, firing their pottery in the backyard of the museum, selling their pots in the museum shop, and demonstrating for visitors and photographers.

Can we doubt that these "subject-producers-of-objects" in the museum courtyard are less a representation of Pueblo life than of Anglo desire "to fix the Other in a stable and stabilizing identity" (Owens 1983:75) capable of unlimited production? Woman as maker and user of pottery with man as helpmate combines not only exotic and domestic but aesthetic and utilitarian stereotypes of the Pueblo into one image of heterosexual romance as well as cultural production and reproduction. And "heterosexuality," Luce Irigaray tells us, "is nothing but the assignment of economic roles: there are producer subjects and agents of exchange on the one hand, productive earth and commodities on the other" (1985:192).

One of the most remarkable things about this particular image of "producer subjects" is the frequency with which it is reproduced and sold as *the* icon of Pueblo culture/ceramics—most notably as a frontispiece of Jonathan Batkin's *Pottery of the Pueblos of New Mexico* (1987). Another is the fact that although Maria regularly worked with her sisters and later with her daughter-in-law, they almost never appear in published photos. Yet another is the fact that although men have been documented painting pottery as early as 1890 at San Ildefonso, it was only between the wars that Anglo-Americans endlessly imaged and reproduced this husband-and-wife team. And after World War II, when Julian was dead and America was again preoccupied with domesticity, traditional roles, and women's place, Maria's son Popovi Da stood in as her male helpmate.

Maria and Julian were also featured in a 1936 children's book, *The Indians of the Southwest*. Pictured here at home polishing and painting pottery in front of their fireplace, they again exemplify the domestication of the exotic and the presentation of the Pueblo as "a peaceful, home-loving, and naturally artistic people" (Kellogg and Kellogg 1936). Not surprisingly, such a desirable and exemplary Other has been subject of several children's books. Another children's book of the 1930s, Hazel Hyde's *Maria Making Pottery*, also presented a "subject-producer-of-objects" and reflected the WPA's glorification of handcrafts. Much more recently, Mary Carroll Nelson (1972) has published a biography of Maria for children.

A series of photographs of Maria and Julian making pottery was taken in the 1930s by Wyatt Davis for the New Mexico Department of Development. These, too, have been endlessly reproduced to promote tourism, identifying the state of New Mexico with the Pueblo and their pottery. In her Museum of New Mexico guidebook *Pueblo Pottery of the New Mexico Indians: Ever Constant, Ever Changing*, Betty Toulouse uses these photographs as chapter dividers, making Maria and Julian literally stand in for *all* Pueblo potters before and since (figure 5.4). Although not published until 1977, Toulouse's text, like most discussions of Pueblo pottery in general and of the achievement of Maria in particular, echoes the pragmatic/romantic rhetoric of the 1930s, of the WPA, and of the Indian New Deal. There can be both assembly lines and individual creativity, both tradition and innovation, both handcrafts and capitalism. One can simultaneously be wife, mother, successful artist, and member of the tribe, and can have ma-

terial success without sacrificing spiritual wholeness. "To the Pueblo woman pottery making is simply one of the mechanical household tasks, just as dishwashing is among us. Nearly every woman is a potter, good, bad, or indifferent" (Guthe 1925:17).[5] However, as Alfred Kidder wrote of Maria in his introduction to this 1925 study, *Pueblo Pottery Making*, by Carl Guthe, "by 1915 she had far surpassed all the others, her pots were in great demand, and at the present time she has a ready market, at prices which ten years ago would have seemed fantastic, for everything she can find time to make. Her income is probably not less than $2,000.00 a year, and following her example, many other women are now doing fine work and are earning substantial amounts. The beneficial effect of this on the pueblo has naturally been great. New houses have been built, new farm machinery, better food, and warmer clothing have been bought, and, best of all, there has been acquired a wholesome feeling of independence and of accomplishment, the value of which cannot be gauged in dollars and cents" (Guthe 1925:14).

Henrietta Burton's doctoral dissertation (1936) elaborates this narrative of rehabilitation and survival through revival:

[As a consequence of] Mr. Chapman and his assistants awaken[ing] the pottery makers [notably Maria] to the great esthetic and commercial possibilities inherent in their art . . . the pueblo of San Ildefonso affords a shining example of what may be done toward the re-establishment of wholesome and successful community life, not through immediate and superficial relief, but by gradual restoration of ancient occupations, skills, habits, customs, and ceremonials of the particular tribe. Especially significant has been the revival of their traditional crafts . . . ; the prosperity at San Ildefonso had its inception when ancient tribal crafts were reinstated. This revival brought not only economic security but also a renaissance of idealism and spiritual and social values. Through restoration of an ancient cultural pattern it furthered group and community solidarity. (56, 77–78)

Four decades later, speaking of Maria's granddaughter Barbara Gonzales, Susan Peterson again tells us that "in these gleaming black pots scattered on the ground, part of the life of this pueblo is represented: the Indian way, singular devotion to their own artistic roots, and the naturally flowing repetition work that lets them relate directly to their

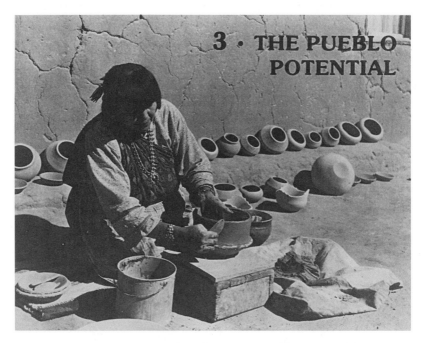

FIGURE 5.4 Maria Martinez making pottery at San Ildefonso Pueblo, ca. 1941. Used as the chapter divider for Chapter 3, "The Pueblo Potential," in Betty Toulouse's Museum of New Mexico guidebook to Pueblo pottery in 1977. Photograph by Wyatt Davis, courtesy of the Museum of New Mexico, negative no. 44191.

materials. These are true craftsmen. Maria's contribution has been to revive and build on the black pottery technique of the ancient pueblo people. Other Indian women in other pueblos have become part of a similar lineage, and with their own methods. But Maria's personality and her particular love for people and ability to relate to them carried her name and craft out into the Anglo world. At the same time she became a standard, held high for her own people" (1977:226).

For almost seventy years, we have been told repeatedly that Maria's "greatest achievement" was her merging of the tribal and the modern, her ability to be both domestic and worldly. She was, Susan Peterson tells us, "outstanding among her people as a bridge between the cultures of the Pueblo peoples and other Americans" (1978:7). After her death, Harold Littlebird wrote in the 1981 Indian Market Program that "she had lived a life of accomplishment and world-wide recognition, yet she had retained her Pueblo sense of simplicity and

harmony with all life around her." Somewhat less felicitously, Edwin Wade describes her and other successful San Ildefonso potters as "straddling the cultural fence." The figures of indomitable women and their work—"matriarchs of Pueblo pottery"—negotiating and mediating among a variety of worlds is a trope that is repeated again and again in descriptions of Maria in particular and of Pueblo potters in general. Not only do Maria and her pottery mediate between Indian and Anglo worlds; both the potter and her pots are described as being so successful because they embody the values and qualities of both worlds. Maria is described as a "dignified, immensely strong, and stable matriarchal personality" (Sergeant 1948.10), who exemplifies "the essence of the Indian way" (Peterson 1977:227). "There is," according to Zahrah Hodge, "something firm and substantial about this remarkable woman, like the very earth from which she fashions her pottery" (Hodge 1933:215). At the same time, as Elizabeth Sergeant tells us, "On gala occasions these handsome quiet women, especially Maria and her sisters, give out an atmosphere of good breeding, confident superiority, intelligence and power that suggest a group of Lowells or Cabots at a Boston gathering" (Sergeant 1935:77). Her gleaming black pots "could be fitted into any white home without a violation of aesthetics" (Sergeant 1948:10), and are shapes "not for carrying or storing beans, but for perfectly designed ornament in a modernistic room" (Underhill 1976:125).

This matte-and-polish, black-on-blackware that has made Maria, San Ildefonso, and Pueblo pottery so famous was invented in 1918 when Julian painted an *avanyu* or stylized plumed serpent on one of the jars Maria had polished and readied for firing (figure 5.5).[6] This experimentation was encouraged by Kenneth Chapman and Wesley Bradfield of the Museum of New Mexico and was funded by Miss Rose Dougan and Mme. Vera von Blumenthal, who initiated a project to improve San Ildefonso ceramics in 1917. Such "unique" and "refined" pottery caught on immediately. Maria sold her pots as fast as she could shape them and Julian could paint them. By 1921, they were teaching their techniques to other potters in the village, believing as did Maria's Tia Nicolasa that "pottery-making belongs to everybody" and that "if it helps one family, it can help all the families" (Marriott 1948:223–24). By the end of that decade several families in addition to Maria's were supporting themselves with pottery. This remarkable revival was supported not only by the Museum of New Mexico but

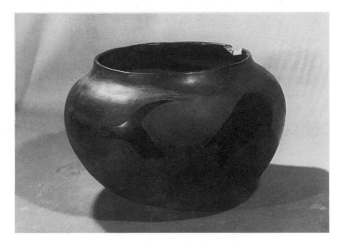

FIGURE 5.5 First recorded black-on-black pot with *avanyu* or water serpent design by Julian Martinez, ca. 1919. Museum of New Mexico Artifact no. 18702/12. Photograph by Arthur Taylor, courtesy of the Museum of New Mexico, negative no. 90627.

by the exposure and awards of the Santa Fe Indian Market and the Gallup Ceremonial, both instituted in 1922; the marketing campaigns of the Fred Harvey Company and the Santa Fe Railroad; highway improvements and the completion of a bridge across the Rio Grande near San Ildefonso; and the Indian Arts Fund, established in 1925.

As more and more potters in San Ildefonso produced finer and finer black-on-black ware, their vessels moved from the curio category into the domain of fine art. With this reclassification came an emphasis on name recognition, and signatures were encouraged by Anglo dealers and collectors. By 1923, Maria had begun to sign her pots. Realizing that pots with her signature sold more readily and commanded higher prices, the other potters asked her to sign theirs as well. Maria obliged, and in addition to selling the work of other potters in the store she had opened in her home, she signed them as well. The result was a semiotic riot that museum officials tried in vain to control and the beginning of authenticity debates and signature arguments that have continued to the present day. As Ruth Bunzel remarked in 1929 in her classic study of the creative imagination in primitive art: "At San Ildefonso, individualism has in some ways reached its highest development. All the more expert potters are known by name to trad-

ers and collectors in Santa Fe and elsewhere. A number of them, in fact, sign their names to all their products. The name is frequently misleading. By no means all of the pottery that goes under Maria Martinez' name is hers" (1972:66). Such uncontrolled production expresses not only a Pueblo communal ethos—"It's all San Ildefonso" (Marriott 1948:232)—but a shrewdness on the part of Maria and other potters of giving "white people [who] can't tell much about pottery anyway" what they want (235). Paradoxically, it also confirms Homi Bhabha's contention concerning representation in colonial discourse that "all these evocations of aesthetic autonomy are, in fact, the ideological conditions for its reproduction" (1984:103).

Julian was happiest away from the pueblo, and their increasing recognition and "distinction" meant countless trips—after 1924, in their own black car, which he painted with an *avanyu* design ("he painted it all around just like the pots. That was the first car in the pueblo!" [Spivey 1979:85]).[7] The Martinezes spent their life going to and demonstrating at World's Fairs; they were at every World's Fair from 1904 until World War II, beginning with their honeymoon. In 1934, Maria and Julian were invited as special exhibitors to the Chicago World's Fair Century of Progress and were awarded a bronze medal. Maria was also awarded a bronze medal for Indian Achievement by the Indian Fire Council, being the second person and first woman to receive this award. In addition to continuing to win prizes for her pottery at Indian Market and Gallup Ceremonial, Maria received countless national and international as well as regional honors and awards, including several honorary doctorates. And with either her husband or her son, Popovi Da, she visted the White House four times before her death in 1980. As Zahrah Hodge predicted in 1933, "Any woman who can develop an art into an industry which becomes the main product of a whole village must have such strength of character and steadfastness of purpose as to be worthy of the attention of the entire country" (213).

The most famous version of this "redwoman's success story" (Sergeant 1948:10) is Alice Marriott's partial biography, *Maria: The Potter of San Ildefonso*. In a third-person narrative that reads like a children's novel, Marriott describes Maria's life and marriage as well as her art in terms of the the pottery-making process—for example, "Part I: The Clay is Shaped" and "Part III: The Bowl is Fired." The book ends with World War II and Julian's death in 1943. While Marriott does not

elide Julian's alcoholism, she does suppress "the ugly side" of pueblo life (Underhill 1948:670) and produces what Debbie Gordon (1986) has described as a "matronising" text marked by an intensification of the romantic ties between men and women, a stress on the comple- mentarity of the sexes, and the necessity and desirability of hetero- sexual coupling and traditional gender roles:[8] "It was the woman's part of living to hold things together. Men could build up or tear down houses and ditch banks; but women put clay and sand together to make pottery, or cooked several foods at one time to make one dish. That was part of a woman's life, to make things whole. . . . Neither could live a complete life without the other" (Marriott 1948:182).

In this and subsequent books and films about Maria, she is por- trayed as exemplary, as too good to be true, as the person who not only kept her family together but, literally with her hands, "saved her village" economically, "arrested the tide of deculturation," and kept San Ildefonso from becoming just "a poverty-stricken little Mexican town" (Underhill 1948:669–70). Published in 1948, Marriott's *Maria* offered white America a redemptive alternative life. In the wake of World War II's destruction, this evocative vision of "wholeness, conti- nuity, and essence" was, in the words of reviewer Erna Fergusson, "healing": "In this book Maria lives as a woman, a noble woman, calm and finely tempered in herself and firmly integrated as one of an inte- grated society. Her book is refreshing and healing for us to read, es- pecially now when we see our own society so sadly shattered by the results of our own cleverness. It is healing to see how people can live unquestioningly knowing that each individual must make his contri- bution to the goodness of the whole" (Fergusson 1948:2).[9]

The shattering, of course, was the atomic bomb, which was con- structed on the same Pajarito Plateau where Edgar Hewett and the Museum of New Mexico excavated the ancient pottery sherds that had inspired Maria's artistry. However, World War II, the proximity of Los Alamos, and the facts that her husband and several sons worked there and that the tin mess trays later used for firing her pottery came from the Los Alamos cafeteria staffed by Pueblo women, who also worked as maids for the likes of Oppenheimer, are mentioned only in passing if at all in the narratives of Maria's life. Only Peterson (1977:76) even tells us that Julian worked at Los Alamos. Just as surely as in the ethnographic pastoral of Edward Cur- tis's photographs, history is airbrushed out. So too are the negative

consequences of Maria's fame and San Ildefonso's successful pottery revival: the resentment she generated by employing other Pueblo women to make the pottery she signed and Spanish American women to do her household duties, and, as already mentioned, the lower morale and increased propensity for alcoholism on the men's part as a consequence of the women's increased prestige and economic power. Neither are we told about the scientists and their wives who "went Native": attending dances at San Ildefonso, decorating their drab quarters with "strange and beautiful" Pueblo pots, and carrying Maria's name along with these "pieces of New Mexico Earth" back to Berkeley, Chicago, and Princeton. "It was this group," one of them recalls, "who changed, temporarily, the entire economy of northern New Mexico with their free-handed spending and their sudden demand of a handicraft people for something like mass production" (Masters 1988:117–24) (figure 5.6). Such facts were of necessity suppressed, for they not only contradicted the romantic and nostalgic image of the Pueblo that Anglos valued but challenged the modern construction of both woman and art—especially primitive ones—as redemptive spaces of "unalienated wholeness," of "artistic other-worldliness" outside modern life.[10]

Despite her singular recognition as *the* Pueblo potter, Maria never worked in isolation and never painted her pots. After Julian's death in 1943, she collaborated primarily with her daughter-in-law Santana until 1956, when her much more famous and recorded collaboration with her son Popovi Da began. In addition to countless photographs by such famous photographers as Laura Gilpin, several films were made of mother and son making pottery, one of which, produced by the National Park Service in 1967, is presently sold as a videotape under the title *Maria, Indian Pottery Maker of San Ildefonso*, with a picture on the case of Maria alone holding one of her pots.[11] The Maria/Popovi collaboration, the development of Maria and Julian's frontroom store into Popovi Da's Studio of Indian Arts, and their self-promotion in a variety of media, such as the brochure pictured in figure 5.7, is a classic case of "interpellation."[12] The brochure states: "Maria and Popovi Da still produce the traditional pottery in the traditional way, much as was done by their ancestors for centuries past. Today, Maria is a living legend of all that is finest in Indian art and life. In her lives a wisdom that well might be valuable to many who live only a few steps from her Pueblo." The male voiceover in the

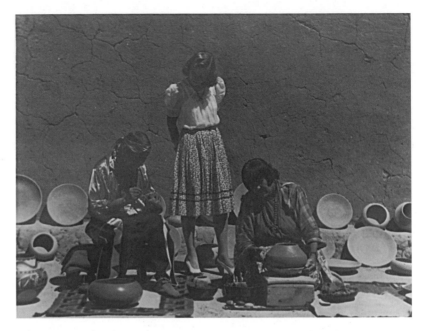

FIGURE 5.6 An Anglo woman watching Julian and Maria making pottery at San Ildefonso, ca. 1940. Courtesy of the Museum of New Mexico, negative no. 9185.

aforementioned videotape speaks a similar language of redemptive otherness, emphasizing the desirable (and profitable) differences between Maria and the capitalist consumers of both her pottery and her videotape. For example, pride, not profit, he tells us, is what motivates Indian potters.

After Po's death in 1971, Maria again worked with Santana, who, with her husband and Maria's son Adam, figures prominently in Susan Peterson's book *The Living Tradition of Maria Martinez* (1977). As the title implies, this text focuses on the legacy of Maria Martinez—her extended pottery-making family and, not surprisingly, the creative process, since Peterson is herself a potter. In contrast to Marriott's verbal narrative with a few line drawings, this is a large-format book, lavishly illustrated with over 300 photos. Doubly authorized with prefaces by pottery experts Frank Harlow and Bernard Leach, Peterson's text concludes with a forty-page gallery of pots and yet further authorization in the form of an appendix on black pottery by Bertha Dutton. In her other book, *Maria Martinez: Five Generations*

San Ildefonso Potters

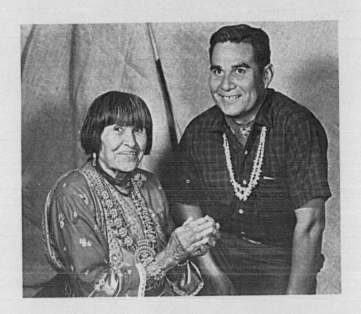

MARIA AND POPOVI

FIGURE 5.7 Cover of brochure advertising Popovi Da's Studio of Indian Arts.

FIGURE 5.8 Maria's hands smoothing pottery walls and forming lip of jar at San Ildefonso Pueblo, ca. 1950. Photograph by Tyler Dingee, courtesy of the Museum of New Mexico, negative no. 120171.

of Potters (1978), the catalog of a Smithsonian show, Peterson focuses almost entirely on product—on the pots that five generations of this dynasty have made.

Another glossy, lavishly illustrated, large-format book, entitled simply *Maria*, appeared in 1979 and was produced by Richard Spivey, Pueblo pottery authority and broker and personal friend of Popovi Da. In contrast to Peterson, Spivey takes a collector's perspective, focusing on chronology, signatures, awards, and large-format plates of individual pots. The text is something of a postmodern pastiche of a legend—Maria's hands (figure 5.8), Maria's words, Popovi's hands, Popovi's words, historic photos, and some fifty Jerry Jacka color photographs (see figure 5.9 for comparable photo).

Maria died July 20, 1980, at the age of ninety-four. In August 1981, the Sixtieth Santa Fe Indian Market was dedicated to her. The Indian

FIGURE 5.9 Plate and jar with feather design by Maria and Popovi, ca. 1950. Photograph by Tyler Dingee, courtesy of the Museum of New Mexico, negative no. 120183.

Market poster that year was a 1971 Jerry Jacka photo of Maria surrounded by her pots at the Laboratory of Anthropology in 1977. The image is accompanied by a poem by Pueblo poet Harold Littlebird:

Her Pottery Speaks

We will remember, Poveka, this gentle lady of clay
 She who shaped the earth fondly
 as if caressing a child's hand
worked a smooth river stone with ageless care and wisdom
 polishing with prayer, blessing with fire
 and shared with all humanity her life's harmony

"Artists of the Sun," the official program for Indian Market, featured a serigraph of Maria by John Nieto on its cover that year (figure 5.10) and included a memorial photo essay, which opened with the classic image of Maria and Julian (see figure 5.3). Within this special supplement to the *Santa Fe Reporter*, numerous businesses simultaneously honored Maria and advertised themselves. Sunstone Press's adver-

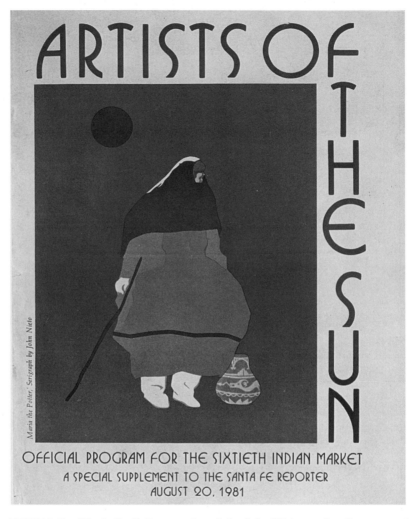

Maria the Potter, Serigraph by John Nieto

ARTISTS OF THE SUN

OFFICIAL PROGRAM FOR THE SIXTIETH INDIAN MARKET
A SPECIAL SUPPLEMENT TO THE SANTA FE REPORTER
AUGUST 20, 1981

FIGURE 5.10 *Maria the Potter*, a serigraph by John Nieto used as the cover of "Artists of the Sun," the official program for the sixtieth Indian Market (special supplement to *The Santa Fe Reporter*, August 20, 1981).

tisement for two Maria books by Susan McGreevy and Hazel Hyde, for example, was a full-page, black-and-white drawing of Maria's hands shaping a bowl. Five years later in the 1986 Indian Market program, the state of New Mexico again paid homage to Maria, to tradition, and to itself with a full-page ad for "The Land of Enchantment" that began, "TRADITION . . .," and featured a 1954 photograph of Maria in a seated pose (see figure 5.1).

Now, more than a decade after her death, Maria and her pots continue to be reproduced and re-presented in a variety of contexts, functioning metonymically not only for the Pueblo and for the state of New Mexico but for all Native American art. Most recently, her disembodied words alone, "I am here," were used as the title of the first publication of the Museum of Indian Art and Culture (*I Am Here: Two Thousand Years of Southwest Indian Arts and Culture* [Whiteford et al. 1989]). We are told on the frontispiece that "Anthropologist Kenneth Chapman visited San Ildefonso Pueblo in the 1930s and talked with potter Maria Martinez. Chapman asked her when she was born, to which she is said to have responded, 'I am here.'"

In conclusion, I want to suggest that in the continuing textualizations of Maria, there is a progressive dematerialization and depersonalization from woman to maker to hands to pots to words alone. This is accompanied by an increasing aestheticization, fetishization, and commodification that I have remarked on previously in this and other essays—from Pueblo woman as aesthetic object to "subject-producer-of-objects" and/or other subjects to objects themselves without subjects or at best only the hands that shaped them. The appropriative economies of visual "possession" of both artist and art are doubled and redoubled in books, tapes, slide shows, films, paintings, postcards, and museum exhibits featuring Maria. And, as Jerry Milord's recent "Maria Manypots" cartoon exemplifies, such reproduction and fetishization is itself a saleable commodity. These unending re-presentations exemplify how our society has collected the other, then reproduced the collectible, which reproduction in turn becomes collectible—standing in for the unaffordable real thing. Even when the subject-producer is another Pueblo potter, the narrative and imaging of Maria provides a model for the presentation. The books and articles and museum catalogs look remarkably alike, the narratives are almost interchangeable,[13] and the texts are replete with the language of tradition, authenticity, and redemptive otherness, confirming again and again that "the need of our society both to engulf Others and to exploit 'otherness' is not only a structural and ideological phenomenon; it has been at the root of the very development of capitalism, founded as it is on imperialist relations. . . . Economically, we need the Other, even as politically we seek to eliminate it. . . . Capitalism feeds on different value systems and takes control of them, while nourishing their symbolic difference from itself. . . . different systems

of production . . . which are suppressed by capitalism are then incorporated into its imagery and ideological values: as 'otherness,' old-fashioned, charming, exotic, natural, primitive, universal (Williamson 1986:112).

NOTES

1. This essay is part of a larger project entitled *Mudwomen and Whitemen*, concerned generally with the constitution of the Pueblo Other and particularly with the representation of Pueblo women and potteries in the discourse that Anglo America has produced about the Southwest. In two other essays, I have argued that the figure of the mudwoman/olla maiden is "the metonymic misrepresentation of the Pueblo" (Babcock 1990 and in press).

2. For further discussion of San Ildefonso being singled out for its "traditional" painting, dancing, and pottery, see Elizabeth Sergeant 1935:55ff.

3. For more on the economic, political, and gender consequences of pottery production for an Anglo art market, see, in addition to Wade, Reynolds 1986 and Babcock 1988.

4. For more on orientalism and on such imaging, see Babcock 1990 and in press.

5. In discussing our folk model of the relationship between reproduction and production, Yanagisako and Collier (1987:24–25) remark that "we contrast the following pairs, each linked, respectively, to the productive and reproductive spheres:

material goods	people
technology	biology
male or gender neutral	female or gendered
wage work	nonwage work
factory	family
money	love."

The rhetoric of discussions of Maria in particular and Pueblo pottery in general suggests that its appeal to Anglo viewers is that it is primarily a sphere of reproduction but also one of production, reversing the manifest valuation of these domains in Western culture.

6. While some scholars date Julian's discovery as 1918, others, notably Chapman, date his invention as 1919 (Chapman 1970:34–35). All concur, however, that the process was perfected and popular with customers by 1921, at which time Maria and Julian began sharing the secret with other San Ildefonso potters.

7. I use the word "distinction" in Bourdieu's sense (1984). I am indebted throughout this essay to his elaboration not only of that concept but of "symbolic capital" and "cultural reproduction" (Bourdieu 1977) as well.

8. In one of the few critical contemporary reviews of Marriott's text, Charles Allen suggests that "the reader may in the end have an itching feeling that he has read the biography of an Arkansas housewife—or of Alice Marriott—rather than of Maria Martinez. He may slightly resent, also, Miss Marriott's not too subtle implication that the above average American of voting age must be addressed with a language slightly similar to that which Uncle Wiggly readers are customarily expected to relish" (1948:357).

9. Clara Lee Tanner (1948:253) begins her review similarly: "In this day when warmer race relations are essential to world peace, and when such relations must be based on the firm foundation of understanding people, *Maria, the Potter of San Ildefonso* should be read by one and all."

10. For further discussion of the negative consequences of Maria's and San Ildefonso's success, see Wade 1986. For more on women and art as redemptive experiences in modernity, see Schulte-Sasse 1989.

11. According to Susan Peterson (1977:295–96), between 1965 and 1975 no fewer than five films were made of Maria and other members of her family—especially her son and grandson—making pottery.

12. For elaboration of this process, see Althusser 1971.

13. In one notable and much-repeated narrative—the story of the Hopi Sikyatki revival occasioned by potter Nampeyo—history is revised, à la the Julian and Maria story, to include her husband Lesu as a worker at the dig and to give archaeologist Jesse Fewkes credit in the legend comparable to Hewett's in the San Ildefonso revival.

REFERENCES

Allen, Charles
1948 Review of *Maria: The Potter of San Ildefonso*, by Alice Marriott. *New Mexico Quarterly Review* 18:356–57.
Althusser, Louis
1971 Ideology and Ideological State Apparatuses (Notes Towards an Investigation). Pp. 123–73 in *Lenin and Philosophy*. New York: Monthly Review Press.
Babcock, Barbara A.
1988 "'At Home, No Womens Are Storytellers': Potteries, Stories, and Politics in Cochiti Pueblo." *Journal of the Southwest* 30(3):356–89.
1990 "'A New Mexican Rebecca': Imaging Pueblo Women." *Journal of the Southwest* 32(4):400–437.
In press "Mudwomen and Whitemen: A Meditation on Pueblo Potteries and the Politics of Representation." In *The Material Culture of Gender/ The Gender of Material Culture*, ed. Kenneth Ames and Katharine Martinez. New York: W. W. Norton.
Batkin, Jonathan
1987 *Pottery of the Pueblos of New Mexico, 1700–1940*. Colorado Springs: Taylor Museum.
Batkin, Jonathan, Jerold L. Collings, Patrick Houlihan, and Sarah Nestor

1987 *Harmony by Hand: Art of the Southwest Indians.* San Francisco: Chronicle Books.

Bhabha, Homi
1984 "Representation and the Colonial Text: A Critical Exploration of Some Forms of Mimeticism." Pp. 93–122 in *The Theory of Reading*, ed. Frank Gloversmith. Sussex: Harvester.

Bourdieu, Pierre
1977 *Outline of a Theory of Practice.* Cambridge: Cambridge University Press.
1984 *Distinction: A Social Critique of the Judgement of Taste.* Cambridge: Harvard University Press.

Bunzel, Ruth L.
1972 *The Pueblo Potter: A Study of Creative Imagination in Primitive Art.* 1929. Reprint, New York: Dover Publications.

Burton, Henrietta K.
1936 *The Re-establishment of the Indians in Their Pueblo Life Through the Revival of Their Traditional Crafts: A Study in Home Extension Education.* New York: Bureau of Publications, Teachers College, Columbia University.

Chapman, Kenneth
1970 *The Pottery of San Ildefonso Pueblo.* Albuquerque: University of New Mexico Press.

Fergusson, Erna
1948 Review of *Maria: The Potter of San Ildefonso*, by Alice Marriott. *New York Herald Tribune Weekly Book Review*, July 4, p. 2.

Gordon, Deborah
1986 Among Women: Gender and Ethnographic Authority in the Southwest, 1930–1980. Paper prepared for the Daughters of the Desert Symposium, Wenner-Grenn Foundation. March 12–23, Tucson, Arizona.

Gridley, Marion E.
1974 "Maria Montoya Martinez: Master Artisan." Pp. 105–18 in *American Indian Women*, ed. Marion E. Gridley. New York: Hawthorn Books.

Guthe, Carl E.
1925 *Pueblo Pottery Making: A Study at the Village of San Ildefonso.* New Haven: Yale University Press.

Halseth, Odd S.
1925 "The Acculturation of the Pueblo." *El Palacio* 18:12, 254–68.
1926 "The Revival of Pueblo Pottery Making." *El Palacio* 21:6, 135–54.

Hewett, Edgar L.
1922 "Primitive Art." *El Palacio* 13:1, 9.

Hodge, Zahrah Preble
1933 "Marie Martinez, Indian Master-Potter." *The Southern Workman* 62:5, 213–15.

Hyde, Hazel
1973 *Maria Making Pottery.* Santa Fe: Sunstone Press.

Irigaray, Luce
1985 *This Sex Which Is Not One*. Ithaca: Cornell University Press.
Kellogg, Harold, and Delain Kellogg
1936 *Indians of the Southwest*. Chicago: Rand McNally.
Lyon, Dennis
1976 "The Polychrome Plates of Maria and Popovi." *American Indian Art* 1:2, 76–79.
Marriott, Alice
1948 *The Potter of San Ildefonso*. Norman: University of Oklahoma Press.
Masters, Charlie
1988 "Going Native." Pp. 117–30 in *Standing By and Making Do: Women of Wartime Los Alamos*, ed. Jane S. Wilson and Charlotte Serber. Los Alamos: Los Alamos Historical Society.
McGreevy, Susan Brown
1982 *Maria: The Legend, The Legacy*. Santa Fe: Sunstone Press.
Michalski, Michael
1975 "Maria Martinez at Idyllwild." *Ceramics Monthly* 23:3, 24–26.
Mulvey, Laura
1975 "Visual Pleasure and Narrative Cinema." *Screen* 16:3, 6–18.
Nelson, Mary Carroll
1972 *Maria Martinez*. Minneapolis: Dillon Press.
Owens, Craig
1983 "The Discourse of Others: Feminists and Post-Modernism." Pp. 57–82 in *The Anti-Aesthetic: Essays on Post Modern Culture*, ed. Hal Foster. Port Townsend, Wash.: Bay Press.
Peterson, Susan
1977 *The Living Tradition of Maria Martinez*. Tokyo: Kodansha International.
1978 *Maria Martinez: Five Generations of Potters*. Washington, D.C.: Renwick Gallery.
1980 "Matriarchs of Pueblo Pottery." *Portfolio* 2:5, 50–55.
Rauch, Angelika
1988 "The *Trauerspiel* of the Prostituted Body, or Woman as Allegory of Modernity." *Cultural Critique* 10:77–88.
Reynolds, Terry
1986 "Women, Pottery, and Economics at Acoma Pueblo." Pp. 279–300 in *New Mexico Women: Intercultural Perspectives*, ed. Joan M. Jensen and Darlis A. Miller. Albuquerque: University of New Mexico Press.
Schulte-Sasse, Jochen
1989 "The Prestige of the Artist Under Conditions of Modernity." *Cultural Critique* 12:83–100.
Sergeant, Elizabeth S.
1935 "Phases of Decline and Recovery of Craft." Pp. 54–78 in *The Tewa Basin Study*. Vol. I, *The Indian Pueblos*. Indian Land Research Unit, Office of Indian Affairs, University of New Mexico, Collier Papers no. 413. Albuquerque: Soil Conservation Service.

1948 Review of *Maria: The Potter of San Ildefonso*, by Alice Marriott. *Saturday Review* 31(10):10.

Spivey, Richard
1979 *Maria*. Flagstaff: Northland Publishing.

Stallybrass, Peter
1990 "Marx and Heterogeneity: Thinking the Lumpenproletariat." *Representations* 31:69–95.

Tanner, Clara Lee
1948 Review of *Maria, The Potter of San Ildefonso*, by Alice Marriott. *Southwestern Social Science Quarterly* 29:253–54.

Todorov, Tzvetan
1984 *The Conquest of America: The Question of the Other*. New York: Harper and Row.

Toulouse, Betty
1977 *Pueblo Pottery of the New Mexico Indians: Ever Constant, Ever Changing*. Santa Fe: Museum of New Mexico Press.

Trimble, Stephen
1987 *Talking with Clay: The Art of Pueblo Pottery*. Santa Fe: School of American Research Press.

Underhill, Ruth
1948 Review of *Maria: The Potter of San Ildefonso*, by Alice Marriott. *American Anthropologist* 50:669–71.
1976 *First Penthouse Dwellers of America*. 1938. Reprint, Santa Fe: William Gannon.
1979 *Pueblo Crafts*. 1944. Reprint, Palmer Lake, Colo.: Filter Press.

Wade, Edwin L.
1986 "Straddling the Cultural Fence: The Conflict for Ethnic Artists Within Pueblo Societies." Pp. 243–54 in *The Arts of the North American Indian: Native Traditions in Evolution*, ed. Edwin L. Wade. New York: Hudson Hills.

Warner, John Anson
1986 "The Individual in Native American Art: A Sociological View." Pp. 171–202 in *The Arts of the North American Indian: Native Traditions in Evolution*, ed. Edwin L. Wade. New York: Hudson Hills.

Whiteford, Andrew Hunter, Stewart Peckham, Rick Dillingham, Nancy Fox, and Kate Peck Kent
1989 *I Am Here: Two Thousand Years of Southwest Indian Arts and Culture*. Santa Fe: Museum of New Mexico Press.

Williamson, Judith
1986 "Woman Is an Island: Femininity and Colonization." Pp. 99–118 in *Studies in Entertainment: Critical Approaches to Mass Culture*, ed. Tania Modleski. Bloomington: Indiana University Press.

Yanagisako, Sylvia, and Jane Fishburne Collier
1987 "Toward a Unified Analysis of Gender and Kinship." Pp. 14–50 in *Gender and Kinship: Essays Toward a Unified Analysis*, ed. Jane Fishburne Collier and Sylvia Junko Yanagisako. Stanford: Stanford University Press.

6 AESTHETICS AND POLITICS

ZUNI WAR GOD REPATRIATION AND KACHINA REPRESENTATION

BARBARA TEDLOCK

On September 16, 1984, the segment of the American public that reads the *New York Times* was presented with an art and anthropology quiz that they simply could not fail. The pop quiz was positioned halfway between a public service announcement for the exhibition *"Primitivism" in Twentieth Century Art: Affinity of the Tribal and the Modern*, at the Museum of Modern Art (MOMA), and an ad for Philip Morris, Inc., the makers of Marlboro, Benson & Hedges 100s, Merit, Parliament Lights, Virginia Slims, and Players; Miller High Life Beer, Lite Beer, Löwenbräu Special and Dark Special Beers, Meister Bräu, and Milwaukee's Best; and 7UP, Diet 7UP, LIKE Cola, and Sugar-Free LIKE Cola.

The quiz, which filled most of a double-column, 12-by-6½-inch space on the first page of the "Museums, Galleries, Exhibitions, and Auctions" section of the *Times*, consisted of two juxtaposed 3¾-by-3⅛-inch black-and-white photos of decontextualized art objects presented side-by-side, like slides in an art-history lecture (figure 6.1). On the left was a detail from a large two-dimensional oil painting consisting of a twisted masklike face, while on the right was a reduced image of a life-sized, three-dimensional carved wooden mask in the form of a twisted face. The paired photographs were cropped and laid out in such a way that the left-handed twist of the painted mask mirrored the right-handed twist of the carved mask. But before we become seduced by this manipulation of images it would be good to remember André Malraux's famous warning that "black-and-white photography tends to intensify the 'family likeness' between objects that have but a slight affinity. With the result that very different objects—a square of tapestry, a stained-glass window, a miniature, a picture and a statue—when reproduced on the same page, become members of a family" (Malraux 1949:27). The pairing of images in this ad was clearly intended to convince the public that there was some sort of influence or affinity between these two masks.

Directly below the images are two questions in bold-face type: "WHICH IS 'PRIMITIVE'? WHICH IS 'MODERN'?" As anyone who has taken an introductory art-history exam knows, the reader of this ad is being asked to culturally and temporally locate the two objects on formal visual qualities alone. The test is an easy one, since the "primitive" object, as usual, is presented in toto as an artifact, while two-dimensional paintings are a far less well-known genre of non-Western art. On technological grounds (i.e., the use of paint and canvas), they are commonly disqualified from the category of "primitive" or "tribal," and classified instead as "folk," "popular," "tourist," "souvenir," "airport," or "acculturated" art. The answer to the quiz—which is found, upside down, at the bottom of the ad, directly beneath the Philip Morris logo—reads: "(top left) LES DEMOISELLES d'AVIGNON, Pablo Picasso, 1907 (detail). Collection: The Museum of Modern Art, New York, Acquired through the Lillie P. Bliss Bequest. (top right) MBUYA SICKNESS MASK, Pende, Zaire. Collection: Musée Royale de l'Afrique Centrale, Tervuren, Belgium." This seemingly careful documentation of the provenance of these art objects in the exhibition ad, together with the cultural internationalism of MOMA and commercial

FIGURE 6.1　Advertisement in the *New York Times*, September 16, 1984.

multinationalism of Philip Morris, implicitly promises the reader carefully selection and documentation of both the "primitive" and the "modern" objects in the upcoming exhibition.

But there is more to this ad than the paired photos, the simple bold-faced double question, and its inverted answer at the bottom of the page, for just below these questions is another double question: "How do they relate to each other—and we to them?" which, one is informed, is "the real question, of course." However, since we are given no dates for the African mask—neither the date of manufacture nor the museum accession date—how can we give an informed answer? By visiting the exhibition, of course, where "we can get a definitive view of the similarities and differences, the influences and affinities, which have intrigued us for nearly a hundred years. It is a show which sheds new light on, and challenges much of our received wisdom about, both 'primitive' and 'modern' and their relation to each other. It may be the first exhibition you have ever seen which asks and answers so many questions about our art—and ourselves."

Lest one think that this juxtaposition was invented by a New York advertising agency, in both the catalog and the exhibition one is also greeted with dozens of similar pairings of "modern" with "primitive" works (Rubin 1984c). Details from Picasso paintings are juxtaposed with a "sliced" Kwakiutl mask, which, the curator says, "Picasso could almost certainly never have seen. . . . [but] it nevertheless points up the affinity of his poetic thought in *Girl Before a Mirror* to the mythic universals that the tribal objects illustrate" (Rubin 1984b:329–30). On the cover of the catalog is another pairing of a Tusyan mask from Upper Volta and Max Ernst's sculpture *Bird-Head*, which is described as dramatizing the distinction between "affinities" and "influences." William Rubin, the show's curator, notes that both of these objects have a flat rectangular head, straight horizontal mouth, small round eyes, and a bird's head projecting from the forehead, and comments that "the resemblance between Ernst's *Bird-Head* and the African mask, striking as it is, is fortuitous, and must therefore be accounted a simple affinity. *Bird-Head* was sculpted in 1934, and no Tusyan masks appear to have arrived in Europe (nor were any reproduced) prior to WWI" (Rubin 1984a:25).

If the show had lived up to even a few of the advertised challenges to our received wisdom about the "primitive" and the "modern," then the curator and sponsor of the exhibition might have been congratu-

lated for having performed the important educational service of presenting and interpreting these "modern" and "primitive" masterworks of the historical past.[1] However, even though the educational service MOMA and Philip Morris thought they were providing to the public with their *Primitivism* show may be crucial for all members of a pluralistic "modern" society like America, which is in close contact with Native American and other fourth world societies both at home and abroad, providing this service has also been a strangely elusive goal, one that the fields of art history and anthropology are unable, if not unwilling, to accomplish.

That a major art museum should seriously undertake an educative mission seems ordinary enough, given the fact that such civic service was specifically mandated to cultural institutions beginning in the 1870s by the founders of the American museum movement, who sought to mitigate the legitimation of wealth and the quest for social status that benefactors sought through their sponsorship of the collection and exhibition of beautiful objects (Silverman 1986:15–16, 128). In this regard, Philip Morris would seem an ideal sponsor since, as they say in their ad, "It takes art to make a company great," and as their chairman says in his dedication of the two-volume 1,032-page celebratory exhibition catalog, "the idea of interchange between cultures is something we understand: we deal with people of all backgrounds in the United States, and in 170 other counties and territories" (Maxwell 1984). While the concept of an "interchange between cultures" sounds laudable, the real question is, In what sense was the "primitivism" practiced by Western artists early in this century and documented in this exhibition an "interchange," a term that, according to Webster's New International Dictionary, means "the act of mutually changing; of mutually giving and receiving; of changing each for the other or one for another; exchange"?

The curator of the show defines the first word of the exhibition title, "primitivism," as "the adherence to or reaction to that which is primitive" (Rubin 1984c:2), and warns us not to confuse this strictly Western phenomenon with the art of primitive people. So despite the promotional claims to interchange, the show was in fact designed *only* to document the interest of modern artists in tribal art.[2] In the free brochure available at the show, Rubin further explains that "the term 'primitivism' does not refer to tribal art itself, but only to modern Western interest in it. Our exhibition thus focuses not on the origins

and intrinsic meanings of tribal objects themselves, but on the ways these objects were understood and appreciated by modern artists."

As one examines the selection and display of the various objects in the show, which include slightly more than 150 "modern" works by artists such as Picasso, Gauguin, Brancusi, Giacometti, Ernst, and Klee, together with 200 "tribal" objects (mostly masks and sculptures) from Africa, Oceania, and North America, it becomes clear that enormous attention was lavished on the modern artists and that the primitive objects were kept subordinate. As Ingrid Sischy, then editor of *Artforum*, noted in her reaction to the show, "As I went along, I began to feel that yet again the Other was being used to service us. Yet again. Practically a thesis had been written on the label below a Brancusi work, but it was enough to say of the primitive sculpture beside it, 'From North Africa.' All the research had gone into the Brancusi, which the other thing was being used once again simply for affirmation of our values" (Malcolm 1986:81). Or, as Hilton Kramer, the editor of the *New Criterion* observed, "much of this show consists of a protracted *hommage* to the master [Picasso], making it in some respects yet another pendant to the mammoth retrospective which MOMA devoted to the artist in 1980" (Kramer 1984:4). Besides paintings, there were numerous drawings, watercolors, and non-Western objects from Picasso's private collection. The curators' purpose in displaying these objects was to indicate "that tribal art influenced Picasso . . . in significant ways . . . but that it caused no fundamental change in the diction of modern art . . . that is, they more bore witness to his enterprise than served as starting points for his imagery" (Rubin 1984c:117).

Hal Foster (1985), then an editor of *Art in America*, noted that not only was Picasso the star of the *Primitivism* show, but the most important painting displayed was *Les Desmoiselles d'Avignon*, which is credited with being the bridge between premodernist and modernist painting. In both the exhibition and the catalog, Rubin visually juxtaposed *Desmoiselles* with various "tribal" masks, including Dan, Etoumbi, Songye Kifwebe, and Torres Strait masks, as well as a Pende Mbuya (sickness) mask from Zaire. His next move was to disqualify each mask that had been suggested by scholars as a direct influence or a model, since as far as he could determine none of these types of masks were available in Europe as models for Picasso in 1907. He does suggest that since so many more affinities have been found by

art historians between Picasso's art and that of "tribal" peoples than is the case with the work of other pioneer modernists, this reflects, on Picasso's part, "a profound identity of spirit with the tribal peoples as well as a generalized assimilation of the principles and character of their art" (Rubin 1984b:265). From this and other statements found in both the wall plaques and in the catalog, it becomes clear that the purpose of the exhibition was to present Picasso's cubism as a totally creative act rather than in any sense an imitative or appropriative act.

These juxtapositions of visually "similar" objects, combined with an appeal to mythic universals and reasoning from negative evidence, did not impress art critics. As Arthur Danto said in the *Nation*, "We are told of 'affinities,' 'prototypes,' 'influences,' 'reflections,' 'compelling resemblances,'. 'uncanny similarities,' and similar tenuous relationships conveyed with the thin and dreary lexicon of the art-appreciation course. ... nothing I believe, could more seriously impede the understanding either of 'primitive' or of 'modern' art than these inane pairings and the question they appear to raise" (Danto 1984:590). Thomas McEvilley described, for *Artforum*, these "primitive" objects "ripped from their meanings and hung in mix 'n' match on our walls in New York," as "resonances . . . of an ancient violence" (McEvilley 1985b:66). Beginning even before the opening of the exhibition in September 1984, and continuing long after its closing in January 1985, there have been dozens of highly critical reviews of the show. In one case this included an *ad hominem* attack on the show's main curator, William Rubin, which resulted in a threatened lawsuit by him against the journal in which it was published, *Connaissance de arts*. The author of the review, Michael Peppiatt (1984:88–93), centered his discussion on the rather unlikely pairing of a Paul Klee painting, *Mask of Fear* (figure 6.2), with a Zuni War God sculpture (figure 6.3).

This particular Zuni War God was collected and/or manufactured in the early 1880s and sold to the Royal Museum in Berlin by Frank Hamilton Cushing, an early ethnologist at Zuni Pueblo. It is known that a Zuni War God was on display when Paul Klee visited the museum for the first time in 1906. But whether or not Klee paid much attention to the War God we cannot know. All we do know is that he did not mention having seen it in his diary entry for the day he visited the museum (Klee 1957:213). Nevertheless, Rubin combined the rather slim historical evidence of one documented visit to the

FIGURE 6.2 Paul Klee, *Mask of Fear*, 1932. Oil on burlap, 39½″ x 22½″. Museum of Modern Art, New York.

FIGURE 6.3 Computer-assisted illustration of Zuni War God based on photograph published in Rubin 1984, p. 30. (Illustration by r.b. gann)

museum with the hypothetical possibility of other visits, during Klee's subsequent sojourns in Berlin, with visual similarities he perceived between the images. Rubin noted the near-oval form of the top of the icon's head, the arrow projecting from it, the long, narrow nose, and the lack of a mouth, plus what he felt were more subtle transformations of feathers into multiple legs, and an arabesque. On this tenuous basis he rested his case, saying, "I am convinced that Klee's image contains a recollection, conscious or unconscious, of the Zuni sculp-

ture" (Rubin 1984a:29). Mr. Peppiatt was unconvinced by this slim evidence and called Rubin's discovery "tendentious," pointing out that Klee painted this picture in 1932, twenty-six years after the only one of his visits to the museum that can reliably be testified to. He further noted that, during this long interval, Klee executed several million images and saw an extraordinary number of visual forms, including children's drawings, that could just as easily have influenced him (Peppiatt 1984:93).

That Rubin may be unusual, perhaps even unique, in seeing or projecting similarities between the Zuni War God and *The Mask of Fear* seems probable, given that neither James Pierce nor Margaret Plant, who both devoted entire books to Klee's art, see any such an affinity. Pierce, for example, noted that "[t]he huge expressionless mask of *Mask of Fear* (1932) and *Ragamuffin Ghost* (1933) cover all but the legs of persons who pass incognito. The features of the masks are so simple and schematic that they are ageless; they cannot be assigned any particular time or place" (Pierce 1976:56). Plant mentioned that "the terrorized face first appears in the 1932 *Mask of Fear* where the head forms the total body, and is set with four legs," and that "it became one of Klee's major motifs from 1932–1940" (Plant 1978:169).

Whether or not one sees any similarities between Klee's *Mask of Fear* and the Zuni War God image, this visual pairing only appeared in color photographs in the exhibition catalog and in Peppiatt's review. At the exhibition itself the Klee painting alone, without the Zuni War God, was on display. In the blank space, where the War God would have been placed, was a sign reading: "Late in the show's preparations the Museum of Modern Art was informed by knowledgeable authorities that Zuni people consider any public exhibition of their War Gods to be sacrilegious and thus, although such figures are routinely displayed elsewhere, the museum decided not to bring the War God from Berlin." The actual situation, however, was a bit more complicated.

First of all, by the time of the opening of the show, Zuni War Gods were no longer on public display in *any* museum in the United States. Second, if the War God had been shipped from Germany to New York, it would most probably have been seized by the FBI as contraband, due to tough new laws (Messenger 1989; Tedlock 1990). In 1978, Zuni Pueblo called for the cessation of the theft and sale of War Gods and the return of all communal items on display or in storage

in world museums (Eriacho 1978:5; Canfield 1980:1). This formal request was followed by a legal argument that has been successfully applied by lawyers in order to block sales at Sotheby Parke-Bernet of Zuni War Gods (Eriacho and Ferguson 1979; Clifford 1985:215; Ferguson and Eriacho 1990:10–11). The argument is based on a U.S. federal law (Title 18 USC 1163) that makes it a felony to withhold stolen property from a tribe. All authentic War Gods in museums and personal collections are stolen property because, insofar as they are "property" at all, they are communal property, and no one has the right to remove them from their shrine homes, not even a War Priest (Talbot 1985:10).

When the Parke-Bernet Gallery tried to auction off a Zuni War God in 1978, the FBI seized it as contraband and it was transferred to the U.S. attorney general in New Mexico, who placed it in a safe until the "owner" decided to become a "donor," taking a tax break by giving it to Americans for Indian Opportunity, who then deeded the War God to the Pueblo of Zuni. Ten years later, when Parke-Bernet again attempted to auction a Zuni War God, this time one belonging to Andy Warhol's estate, it was immediately removed from sale and returned to Zuni Pueblo (Ferguson and Eriacho 1990:10–11). In both of these instances, when the War God was returned to the pueblo, it was placed in an appropriate outdoor shrine on Towa Yalanne Mountain in order to slowly decompose, thus returning to nature its awesome destructive powers causing thunder storms, tornadoes, hurricanes, floods, and wars.

A comment needs to be made here concerning critics of the *Primitivism* show who confidently made statements such as "primitive groups, when they have used an object ritually (sometimes only once), desacralize it and discard it as garbage. We then show it in our museums" (McEvilley 1984:59). Perhaps this same error was made by collectors who misinterpreted the stacks of old War Gods at outdoor shrines as discarded rubbish. This is not the true situation, however, since War Gods are purposefully left to decay in order to release their powers into the natural world. As Zuni Tribal Councilman Angus Mahooty explained, "a War God is left at a shrine for biodegrading. Not necessarily throwing it away, they are just making room" (Ferguson and Eriacho 1990:10).

This is not the only case in which indigenous peoples have successfully put a stop to the sale and display of their sacred religious icons

as "art," but it serves to bring us to the crux of our problem. What *is* art? Some forty years ago, André Malraux (1949:22) made a distinction between "art by destination" and "art by metamorphosis." In art by destination he lumped landscapes and still lives, narrative and genre pictures, nudes and mythological characters, and abstractions and nonfigurations, indicating that such two- or three-dimensional objects were drawn or painted, carved or cast, in order *to be* art objects. Art by metamorphosis, on the other hand, includes objects, handcrafted or industrially produced, that originally belonged in contexts other than art (e.g., objects made for use in religious ritual, government ceremonial, or family memorial) but that later were included in the network of galleries and museums. What is lacking in Malraux's discussion is a sensitivity to who owns the museums versus who owns the objects that are "magically" metamorphosed into art. In the Zuni case, the War Gods, at least until 1978, were art for non-Zunis in the sense of art by metamorphosis. The new laws, most especially the repatriation section of the 1978 American Indian Religious Freedom Act (Public Law 95–341), have enabled Zuni Pueblo to persuade thirty-seven individual collectors and museums around the world to give back sixty-nine War Gods (Merrill et al. 1993:527). These wooden carvings have ceased to be art objects for the contemplation of non-Zunis and have been re-placed as religious icons on top of their sacred mesas near the pueblo.

Turning now to the "supposed" aesthetic beauty of War Gods, figure 6.4 is a reproduction of an early drawing, based on a photograph, of a War God as it was set up at an indoor altar at Zuni prior to its placement at an outdoor shrine (Stevenson 1904). Note the flicker feather extending from the icon's nose, which is symbolic of the "breath of destruction" (Cushing 1895b:2). Flickers are ground-feeding woodpeckers living mainly on ants, a Zuni metaphor for urban people living together in their anthill towns. The twofold green-blue coloring of the face indicates this God's facility in metamorphosis (Parsons 1918:397). The colors of both the "green" and the "blue" halves of the face are labeled with a single monolexemic term *ak-walhi*, meaning "turquoise" in the Zuni language.[3] This, however, does not mean that Zunis cannot see the color difference. Instead, the rather narrow hue interval between the blue and green is an important indication that this deity is *attanni*, a Zuni aesthetic term indicating objects that are powerful, dangerous, untouchable, taboo, indistinct, static, muffled, shaggy, or old.

FIGURE 6.4 Drawing of the Elder God of War on a Zuni altar, Zuni Reservation. Photograph by Matilda Coxe Stevenson, Bureau of American Ethnology.

The Berlin War God (figure 6.3) is painted in the same manner, but there is something rather strange about the arrow emerging out of the top of its head. In a survey of historical photographs of Zuni War God icons, I have found no other example of an arrow emerging from a War God's head. In order to find a possible source of this icono-

graphic anomaly, one must recall that Frank Hamilton Cushing was the person who collected this War God for the museum (Green 1990:15, 305) and that he wrote an essay about its significance (Cushing 1895b). Second, he alone, of all the ethnologists who have ever worked at Zuni Pueblo, insisted on translating Towa Yalanne, the name of the sacred mesa with many War God shrines on top, as "Thunder Mountain" rather than "Corn Mountain," (Cushing 1901:65, 174, 345; 1920:38, 130–31, 632, 670); Zunis themselves refer to it as "Corn Mountain" when speaking in English. Third, as an initiated War Priest, Cushing was probably instructed as to how to carve and clothe War Gods, and if not, he could easily have figured it out, given his legendary skills in manufacturing Indian artifacts (Cushing 1895a). Fourth, Cushing contracted with the Royal Museum at Berlin to sell them duplicates of artifacts, including War Gods, that he was sending to the Smithsonian Institution as part of his job. To quote from a letter of August 13, 1883, from pioneer Southwestern ethnologist Adolph Bandelier to Cushing, "If we can make it [agreeable to the people in] Berlin, then a snug little [bit] of revenue might result from this—perfectly legitimate—traffic. It will have the advantage that, at the start, duplicates of what you have already sent to Washington is all that is required, so that you do not commit any breach of propriety. Later on we shall have to twist it into an irreproachable shape" (Green 1990:305).

Thus, it would seem quite plausible that the Berlin War God is a Cushing creation. If so, one possible visual source for the anomalous lightning arrow can be found at the shrine of the Elder War God on Kwili Yalaawe (figure 6.5). Note the carved zigzag lightning on top of the stick immediately to the right of the tallest wooden icon, and the cone-shaped arrow point on the top of the stick immediately to the left of this same icon. Cushing may have put these two elements together on top of his War God's head as an interpretive act, indicating the awesome meteorological power this deity controls. In short, I would like to suggest that the Berlin War God carving may be a prime example of Cushing's own "primitivism," in the art-historical sense of "the adherence to or reaction to that which is primitive" (Rubin 1984a:2).

While Frank Hamilton Cushing has been mythologized as a "gone native" anthropologist who *became* a Zuni, he continued to do fieldwork after his initiation as a War Priest and published a number of

FIGURE 6.5 Photograph of Elder Gods of War and wooden arrows at shrine on Twin Mountains, Zuni Reservation. Photograph by Matilda Coxe Stevenson, Bureau of American Ethnology.

ethnographic works, eventually marrying a white woman and settling down on the East Coast (Tedlock 1991:70–71). His fieldwork and life might better be described as "going primitive" in the sense of reveling in the mélange of Western and Zuni cultures (Torgovnick 1990). While his production of a War God with a lightning arrow emerging from its head is both an ethnographic and an artistic act, it is also a sly joke on his German patrons, who desired to possess an authentic "primitive fetish." Regardless of this particular War God's authenticity, however, Zuni religious authorities have argued that *any object* made on the basis of Zuni knowledge should be returned to the Pueblo (Merrill et al. 1993:542).

There remains the question of whether or not Zunis have any art by destination as opposed to metamorphosis. What is ironic about having to ask this question at all is that Zuni Pueblo, unlike our own society, might fairly be designated as an "art culture," since the major source of individual income at Zuni consists of money earned from art production, including jewelry, ceramics, wooden sculpture, and easel painting. All of these art objects fall into a single aesthetic cate-

gory known as *tso'ya* in the Zuni language. In the visual domain of the natural world, Zunis apply this term to the rainbow, the last stages of sunset, the collared lizard, the mallard drake, and the Rocky Mountain swallowtail butterfly—each of which has several bright, highly saturated hues. The rainbow, as Zunis represent it, is colored red, yellow, and blue-green, all highly saturated. Each of these colors is separated from the next by a black outline. The collared lizard is considered *tso'ya* because of the red and yellow iridescent (*shukkutuliya*) areas outlined in black on the collar of this otherwise totally green lizard. The wings of the Rocky Mountain swallowtail butterfly are bordered by a series of yellow spots heavily outlined in black; on the lower wing, the series is paralleled by black-bordered zones of iridescent blue, with the final zone occupied by a red spot. The drake mallard, unlike the female, has an iridescent green head and white collar and outer tail feathers, and thus is *tso'ya*. The female, in contrast, since she lacks the green head and complex banding of neck and outer tail feathers, is merely *k'okshi*, "attractive" or "good."

At Zuni nearly all painting and sculpture, as well as many jewelry designs, include multicolored *tso'ya* kachinas, spiritual beings that Zunis impersonate in hundreds of elaborate masked dances.[4] The Zuni painter Phil Hughte remarked on this when his eighteen-by-sixteen-foot outdoor Shalako mural at the Indian Pueblo Cultural Center in Albuquerque (see Durrie 1981) was judged objectionable by governors from other Southwestern Indian pueblos and painted over in 1981. He said, "Over here in Zuni, our art is kachina . . . the mural wasn't there to offend anyone. It was there to represent our art" (*Albuquerque Journal* 1981a).[5] According to Zunis, this mural was in quite a different aesthetic category from that of the *attanni*—"static, old, fearful, powerful, taboo, dark, shaggy, muffled, indistinct, dangerous"—War Gods. The kachina mural, like a Shalako shrine, is considered *tso'ya*—"dynamic, exciting, new varied, multicolored, chromatic, clear, beautiful" (Tedlock 1984, 1986, 1992).

Even though kachinas are religious beings, and thus kachina art might be misinterpreted by non-Zunis as art by metamorphosis, Zunis represent kachinas in artworks destined for an external art market, and thus their kachina art is art by destination. This fact, however, does not indicate that Zuni religion has recently become secularized since, according to oral tradition, "the kachina cult was instituted solely as a means of enjoyment" (Bunzel 1932:517). That

this may not be understood by non-Zunis seems likely, given a state-ment to the press two weeks before the painting-over of the Zuni Sha-lako mural by order of Delfin Lovato, the director of the All Indian Pueblo Council. He announced, "The governors decided that the mu-ral was contrary to a long-standing policy of the council. We do not want the public display of any painting or artifacts or anything that depicts religious scenes" (*Albuquerque Journal* 1981b). After the painting was destroyed, Zuni Governor Robert Lewis, who was not at the decision-making meeting of pueblo governors, said, "We were never contacted or consulted. We support the painting. We don't see any problems with it. The tribe gave its consent to the painting before it was done, and so did the Pueblo Council. It's not something anyone has ever complained about. Everyone in the tribe sees the Shalako during several days of ceremonies and even non-Indian people are allowed to see it during our ceremonies" (Ehn 1981:A-6).

Since Zuni and Hopi are the only pueblos that allow non-Indians to witness kachina dances, and since Zuni Pueblo is within the New Mexico jurisdiction of the All Indian Pueblo Council and Hopi is not, this conflict in values between Zuni and the other New Mexico pueb-los may have been unavoidable, especially given that the All Indian Pueblo Council was led by men from the Rio Grande pueblos, where even the *depiction* of kachinas by tribal members in a public forum is strictly forbidden (Wade 1986:246).

However, what might at first appear to be an interpueblo disagree-ment about the relationship between art and religion may actually refer to aesthetics and politics. At the time, several people said both publicly and privately that what lay behind the painting-out of the mu-ral in 1981 was politics rather than religion (*Albuquerque Tribune* 1981:A-1; McCrossen 1981). And one critic called the entire issue "a red herring," pointing out that other pueblos also share their reli-gious and cultural themes with non-Indian people (Sandoval 1981). Nevertheless, the leadership of the All Indian Pueblo Council hired men to paint-over the example of Zuni art by destination.

Zuni War Gods have been stolen from their shrines and/or dupli-cated and then metamorphosed into art under the name "primitive," then further metamorphosed as examples of the art-historical con-cept of "primitivism." Zuni Pueblo has been reversing this high-handed colonialist process with the aid of new laws, recovering and re-placing museum War Gods in their proper outdoor shines, thus

completing their interrupted life course as *attanni*—"powerful, old, taboo, dark, shaggy, dangerous, static, muffled, untouchable"—religious beings. On the other hand, kachinas are appropriate spiritual beings to be depicted by Zuni artists in whatever medium, collected by museums, and proudly displayed as examples of current Zuni art, for they are *tso'ya*: "dynamic, new, clear, bright, sharp, eliciting, multicolored, chromatic, varied, beautiful." When they appear in art, the appropriate Zuni expression for the beholder's aesthetic experience is *Hish tso'ya*, "So very beautiful."

Zuni Pueblo may have been successful in directly confronting a century of Western colonialism by removing certain religious icons (War Gods) from the international art market place, but, locally, Zunis have had difficulty making it clear why representations of different gods (Kachinas) should be allowed into that same international art market place. An explication of Zuni aesthetic categories helps to resolve this apparent conflict between religion, economics, and art.

NOTES

1. The Museum of Modern Art's *Primitivism* exhibition produced much discussion and debate among curators, art and cultural critics, art historians, and anthropologists (see Peppiatt 1984; Danto 1984; Kramer 1984; McEvilley 1984, 1985a, 1985b; Clifford 1985, 1988; Krauss 1985; Foster 1985; Rubin 1985a, 1985b; Varnedoe 1985, Malcolm 1986; Price 1986, 1989; Torgovnick 1990; and Araeen 1991).

2. For more on the art-historical concept of "primitivism," see Krauss 1985; Williams 1985; Goldwater 1986; Torgovnick 1990; Araeen 1991; Hiller 1991; and Solomon-Godeau 1991.

3. The orthography used here, for the Zuni language, is a practical one in which the vowels (a, e, i, o, u) should be given their continental values and most consonants should be pronounced as in English, except that "p" and "t" are unaspirated, the sounds in "lh" should be pronounced simultaneously, and "ts" is like the "ts" in English "bats." The glottal stop (') is like the "tt" in the Scottish pronunciation of "bottle." Double consonants are either held a bit longer than single ones or else repeated.

4. More information on the meaning and function of kachinas among the Southwestern pueblos can be found in Adams 1991. At Zuni, young boys are first initiated into the Kachina Society when they are between five and nine years of age (Stevenson 1887:547–53; Bunzel 1932:516–21).

5. For more details about the controversy concerning the obliteration of this Zuni mural, whose painting was funded by the National Endowment for

the Arts, see *Albuquerque Journal* 1981a, 1981b; *Albuquerque Tribune* 1981; Ehn 1981; McCrossen 1981; and Sandoval 1981.

REFERENCES

Adams, E. Charles
1991 *The Origin and Development of the Pueblo Katsina Culture.* Tucson: University of Arizona Press.
Albuquerque Journal
1981a "All Indian Pueblo Council Destroys Shalako Mural." December 23, p. C-10.
1981b "A Zuni Governor Wants Mural Intact." November 25, pp. A-1, A-3.
Albuquerque Tribune
1981 "Shalako Painting Destroyed." December 22, pp. A-1, A-10.
Araeen, Rasheed
1991 "From Primitivism to Ethnic Arts." Pp. 158–82 in *The Myth of Primitivism*, ed. Susan Hiller. New York: Routledge.
Bunzel, Ruth
1932 "Introduction to Zuñi Ceremonialism." *Annual Report of the Bureau of American Ethnology* 47:467–544.
Canfield, Anne Sutton
1980 "Ahayu:da . . . Art or Icon?" *Native Arts West* 1(1):1, 24–26.
Clifford, James
1985 "Histories of the Tribal and the Modern." *Art in America* (April):164–77, 215.
1988 *The Predicament of Culture: Twentieth-Century Ethnography, Literature, and Art.* Cambridge: Harvard University Press.
Cushing, Frank Hamilton
1895a "The Arrow." *Proceedings of the American Association for the Advancement of Science* 44:199–240.
1895b Katalog einer Sammlung von Idolen, Fetischen und priesterlichen Ausrüstungsgegenständen de Zuñi-oder Ashiwi-Indianer von Neu Mexiko (U.S.A.). *Veröffentlichungen aus dem königlichen Museum für Völkerkunde* 4(pt. 1):1–2.
1901 *Zuñi Folk Tales.* New York: G. P. Putnam's Sons.
1920 *Zuñi Breadstuff.* Indian Notes and Monographs, no. 8. New York: Museum of the American Indian Heye Foundation.
Danto, Arthur
1984 "Defective Affinities." *Nation* (December 1):59–92.
Durrie, Hope
1981 *Murals of the Indian Pueblo Cultural Center.* Albuquerque: Friends of the Indian Pueblo Cultural Center.
Ehn, Jack
1981 "Mural to Be Destroyed: Zuni Artwork Offends Other Pueblos." *Albuquerque Tribune*, November 24, pp. A-1, A-6.

Eriacho, Wilfred
1978 "Statement of the Religious Leaders of the Pueblo of Zuni Concerning Sacred Zuni Religious Items/Artifacts." *U.S. House of Representatives Process*, September 20.
Eriacho, Wilfred, and T. J. Ferguson
1979 "The Zuni War Gods: Art, Artifact or Religious Beings: A Conflict in Values, Beliefs, and Use." Paper presented at the New Directions in Native American Art History Symposium, Albuquerque, New Mexico.
Ferguson, T. J., and Wilfred Eriacho
1990 "Ahayu:Da/Zuni War Gods: Cooperation and Repatriation." *Native Peoples* 4 (1):6–12.
Foster, Hal
1985 "The 'Primitive' Unconscious of Modern Art." *October* 34:45–70.
Goldwater, Robert
1986 *Primitivism in Modern Painting.* Cambridge: Harvard University Press.
Green, Jesse
1990 *Cushing at Zuni: The Correspondence and Journals of Frank Hamilton Cushing 1879–1884.* Albuquerque: University of New Mexico Press.
Hiller, Susan
1991 *The Myth of Primitivism: Perspectives on Art.* New York: Routledge.
Klee, Feliz
1957 *Tagebücher von Paul Klee 1898–1918.* Cologne: M. DuMont Schauberg.
Kramer, Hilton
1984 "The 'Primitivism' Conundrum." *New Criterion* (December):1–7.
Krauss, Rosalind
1985 "Preying on 'Primitivism.'" *Art and Text* 17:58–62.
Malcolm, Janet
1986 "A Girl of the Zeitgeist—1." *New Yorker* 62 (35):49–89.
Malraux, André
1949 *The Psychology of Art: Museum Without Walls.* Translated by Stuart Gilbert. The Bollingen Series, no. 24. New York: Pantheon Books.
Maxwell, Hamish
1984 "Opening Statement." In *"Primitivism" in 20th Century Art: Affinity of the Tribal and the Modern*, ed. William Rubin. New York: Museum of Modern Art.
McCrossen, Eric
1981 "Controversy May Destroy More Than Zuni Shalako Mural." *Albuquerque Tribune* November 24, p. A-1.
McEvilley, Thomas
1984 "Doctor Lawyer Indian Chief: 'Primitivism' in 20th Century Art at the Museum of Modern Art." *Artforum* 23(3):54–61.
1985a Letters on "Doctor Lawyer Indian Chief: 'Primitivism' in 20th Century Art at the Museum of Modern Art" in 1984. *Artforum* 23(6): 46–51.

1985b Letters on "Doctor Lawyer Indian Chief": Part II. *Artforum* 23(8):65–71.

Merrill, William L., Edmund J. Ladd, and T. J. Ferguson
1993 "The Return of the *Ahayu:da*: Lessons for Repatriation from Zuni Pueblo and the Smithsonian Institution." *Current Anthropology* 34 (5):523–67.

Messenger, Phyllis Mauch
1989 *The Ethics of Collecting Cultural Property: Whose Culture? Whose Property?* Albuquerque: University of New Mexico Press.

Parsons, Elsie Clews
1918 "War God Shrines of Laguna and Zuñi." *American Anthropologist* 20: 381–405.

Peppiatt, Michael
1984 "Sujet tabou exposition risquée." *Connaissance des arts* 391:84–95.

Pierce, James Smith
1976 *Paul Klee and Primitive Art.* New York: Garland.

Plant, Margaret
1978 *Paul Klee: Figures and Faces.* London: Thames and Hudson.

Price, Sally
1986 "Primitive Art in Civilized Places." *Art in America* (January):9–13.
1989 *Primitive Art in Civilized Places.* Chicago: University of Chicago Press.

Rubin, William
1984a "Modernist Primitivism: An Introduction." Pp. 1–81 in *"Primitivism" in 20th Century Art: Affinity of the Tribal and the Modern,* ed. William Rubin. New York: Museum of Modern Art.
1984b "Picasso." Pp. 240–343 in *"Primitivism" in 20th Century Art: Affinity of the Tribal and the Modern,* ed. William Rubin. New York: Museum of Modern Art.
1985a Letters on "Doctor Lawyer Indian Chief: 'Primitivism' in 20th Century Art at the Museum of Modern Art" in 1984. *Artforum* 23(6):42–45.
1985b Letters on "Doctor Lawyer Indian Chief": Part II. *Artforum* 23(8):63–65.
———, ed.
1984c *"Primitivism" in 20th Century Art: Affinity of the Tribal and the Modern.* New York: Museum of Modern Art.

Sandoval, S. A.
1981 "Others Open to View." *Albuquerque Journal,* December 4, p. A-3.

Silverman, Debora
1986 *Selling Culture: Bloomingdale's, Diana Vreeland, and the New Aristocracy of Taste in Reagan's America.* New York: Pantheon.

Solomon-Godeau, Abigail
1991 "The Primitivism Problem." *Art in America* 79(2):41, 43, 45.

Stevenson, Matilda Coxe
1887 "The Religious Life of the Zuñi Child." Pp. 535–55 in *Fifth Annual Report of the Bureau of American Ethnology for the Years 1883–1884.* Washington, D.C.: Government Printing Office.

1904 *The Zuñi Indians: Their Mythology, Esoteric Fraternities, and Ceremonies.* Twenty-Third Annual Report of the Bureau of American Ethnology. Washington, D.C.: Government Printing Office.

Talbot, Steve
1985 "Desecration and American Indian Religious Freedom." *Journal of Ethnic Studies* 12(4):1–18.

Tedlock, Barbara
1984 "The Beautiful and the Dangerous: Zuni Ritual and Cosmology as an Aesthetic System." *Conjunctions* 6:246–65.
1986 "Crossing the Sensory Domains in Native American Aesthetics." Pp. 187–98 in *Explorations in Ethnomusicology: Essays in Honor of David P. McAllester*, ed. Charlotte J. Frisbie. Detroit Monographs in Musicology, no. 9. Detroit: Information Coordinators.
1990 "Cultural Artifacts: Who Owns Them?" *Art in America* 78(7):39–43.
1991 "From Participant Observation to the Observation of Participation: The Emergence of Narrative Ethnography." *Journal of Anthropological Research* 47(1):69–94.
1992 *The Beautiful and the Dangerous: Dialogues with the Zuni Indians.* New York: Viking.

Torgovnick, Marianna
1990 *Gone Primitive: Savage Intellects, Modern Lives.* Chicago: University of Chicago Press.

Varnedoe, Kirk
1985 Letters on "Doctor Lawyer Indian Chief: 'Primitivism' in 20th Century Art at the Museum of Modern Art" in 1984. *Artforum* 23(6): 45–46.

Wade, Edwin L.
1986 "Straddling the Cultural Fence: The Conflict for Ethnic Artists Within Pueblo Societies." Pp. 243–54 in *The Arts of the North American Indian: Native Traditions in Evolution*, ed. Edwin L. Wade. New York: Hudson Hills.

Williams, Elizabeth A.
1985 "Art and Artifact at the Trocadero: *Ars Americana* and the Primitivist Revolution." Pp. 146–66 in *Objects and Others*, ed. George W. Stocking. Vol. 3, *History of Anthropology.* Madison: University of Wisconsin Press.

7 MIDDLEBROW INTO HIGHBROW AT

THE J. PAUL GETTY TRUST, LOS ANGELES

GEORGE E. MARCUS

Andrew Ross begins his recent book *No Respect: Intellectuals and Popular Culture* (1989) with a discussion of the Rosenberg spy case of the 1950s, and an analysis of the prison letters between Julius and Ethel Rosenberg. He dwells especially on the contempt that academic literary intellectuals such as Leslie Fiedler had for the high-culture pretensions such "ordinary" people exhibited in their manner of writing and allusions. Ross comments on "the *unhappy* relationship of what Fiedler called the 'petty-bourgeois mind' to the practiced forms of legitimate culture; an unhappiness that is the result of having little choice but to take 'literature' and its signifying codes too seriously" (27). Ross then concludes, "The problem of petty-bourgeois taste, cul-

ture, and expression remains to this day a largely neglected question for cultural studies and a formidable obstacle to a left cultural politics. For many Cold War liberals, this problem was not, and perhaps could not, be directly confronted. The political climate was such that they could only identify the language of these ordinary people with a dying political discourse—that of cultural Stalinism. In so doing, the untidy problematic of lower-middle-class culture was (conveniently) displaced" (29).

The form of this argument that I want to distill for my purpose here is that in the much-noted collapse of the distinction between high and low culture as defining of our postmodern condition, the weight of attention has been on how elements of popular consumer culture— music, advertising, film, television, and video—have become fully legitimated taste for a well-educated, sophisticated, if not hip, American middle class in their twenties through forties. What has been missed is how much and for how long highbrow taste and allusions, or rather the tyranny of highbrow taste in its seriousness, have themselves been a part of popular culture. Here "popular" refers to what Barbara and John Ehrenreich (1979:12) call the American professional-managerial class: "salaried mental workers who do not own the means of production and whose major function in the social division of labor may be described broadly as the reproduction of capitalist culture and capitalist class relations"—in other words, *us*.

American academics who specialize in the liberal arts or humanities recreate as a condition of their work a high-culture taste and ideology and thus flee from the middlebrow origins of their own high-culture interests—origins that included the hopes of their parents and teachers for their social mobility, leading them to college and liberal arts appreciation courses and ultimately to a life in academic scholarship, rather than in law, science, business, or medicine. We tend not to look back, but to flee into our other world specialities to cover over the uncomfortable aspects of the popularization of high-culture objects and taste that in one way or another propelled so many of us into academic life. Instead, the subversion of the now-brittle construct and mystification of high-culture taste is practiced by academic intellectuals through reveling in and legitimating the value of youth culture, street life, soap operas, rock, Harlequin romances, and so on. Mostly, academic intellectuals have failed to gaze unflinchingly at their own middlebrow, low appropriations of high culture, and until

they do, aspects of high culture will always be absolutely Other, rather than what they are: a formative dimension of the anxieties and aspirations of post–World War II American middle-class life, including those of academic intellectuals. Exorcizing the stiff, mythical, intolerant aspects of the canons of high culture in art and literature requires as much coming to terms with the middlebrow popularizations of high-culture conceits in American life as it does posing against them difference and diversity in the form of alternative popular or subaltern cultures of the street, the ghetto, the factory, and the recording studio.

Indeed, our finest monuments to high culture—museums, opera and dance companies, libraries—rest on petty-bourgeois foundations of earnest taste and aspiration. These monuments have been for much of the nineteenth and twentieth centuries the popular culture of the "educated" American middle class. In this sense, Ethel and Julius Rosenberg are no different than, for example, Allan Bloom, and no different than J. Paul Getty and his latter-day art world heirs, to whom I will now turn.

The extravagantly wealthy, but also extravagantly busy and ambitious, J. Paul Getty Trust of Los Angeles, devoted predominantly to Western art and art history,[1] is one site where this gap in the self-critical and reflexive consciousness of American intellectuals can be closely observed and overheard. Here, the highbrow is constantly undermined just as it is earnestly fashioned by managers and scholars of various kinds who share a common neglect of their formative middlebrow desire for culture and success. In 1982, the J. Paul Getty Trust received the bulk of the personal fortune of J. Paul Getty, and by 1988, when I was a visiting scholar at the Getty, the corpus was worth somewhat less than $4 billion. As an operating rather than charitable foundation, the Getty is required to spend 4¼ percent of the average market value of its endowment three out of every four years on its own programs in order to enjoy its relief from taxation. This means spending well over $100 million every year. The art world had anticipated a dramatic destablization of the market value of old Western masterpieces, as the Getty tried to acquire "important" pieces for its museum in Malibu. This museum is a landmark of southern California kitsch, built in the form of a Roman villa. The original was buried in a volcanic eruption at Herculaneum in A.D. 79, and had been faithfully reconstructed by 1974 under Mr. Getty's close

supervision from his expatriate residence at Sutton Place near London.

While the Getty Trust has made several dramatic forays into the art market, large portions of its funds have been devoted to four other ambitious programs behind the museum, so to speak, which contribute to the Getty's already strong presence in the Western world of high art. Awaiting the late-1990s opening of its $500 million complex on a hilltop in Brentwood, the Getty's operations are currently dispersed anonymously throughout the west Los Angeles area. Aside from the signature museum in Malibu, there is the Art Conservation Institute, located in a warehouse complex in Marina del Rey, and the Center for the History of Art and the Humanities (where I was located as a visiting scholar), occupying, along with the Art History Information Program, several floors of a contemporary bank building on Wilshire Boulevard in Santa Monica. The Center for Education in the Arts and the Trust offices are combined in a low-key suite at the Century City corporate complex. The 600 employees dispersed in these programs are led by Harold Williams, former dean of the UCLA Graduate School of Business Management, former chairman of the board of Norton Simon, Inc., and former SEC chairman under President Carter.

From the vantage point of a nine-month period of work and participation as a visiting scholar at the Getty Center for the History of Art and the Humanities during 1988–89,[2] I want to present a series of necessarily brief scenes and subject portraits in which the middlebrow and low pop emerge with a twitch, cringe, or a more severe sense of discomfort among those in the serious pursuit of high-culture taste and acquisition at the continually expending Getty. In my year—the fourth of the invited scholar program at the center—there were eight European and two American scholars: a combination of social historians, anthropologists, and historians of art. As Getty scholars, we were situated rather far from the precious objects of the museum and those who curate them, restore them, guard them, and negotiate to acquire them, but we were at one very relevant locus at which the image, institutional style, and ambition for the Getty were being produced and articulated. In this effort, the scholars were a different sort of annual collection of cultural capital that the center and museum were developing aside from their continual acquisition of libraries, photographic collections, prints, and one-of-a-kind master

works (collection itself was indeed an important and diffuse metaphor of purpose in redundant use around the Getty).

The following is an early excerpt from my notebook, summarizing the first impression or feel of the Getty of someone plucked from academia and situated with ambiguous luxury in its environment:

10/17/88

"401 Wilshire: Neither a Bed of Roses nor a Crown of Thorns"— nice title for an ethnography of the Getty, suggested to me by Jack Goody [the anthropologist, and the only other one among the 1988–89 scholars].

Although the reflexive focus on the ethnographer's self is getting to be a bit much in ethnographic writing these days, it seems irresistible here since we are undeniably the focus of special attention and creation at the Getty, in order to (obviously?) improve their cultural capital; in order to enhance their budding power as a cultural institution.

The thing to explain is the contrasting plushness and freedom provided for us amid gaps, secrets, and boundary rules that are quite stoutly held to—budgetary, etc.—with all the wealth there seems to be little surplus around the Getty.

Initially and impressionistically there are three dimensions that seem to shape experience here for us:

1. *restraint*—we are thoroughly ensconced in a corporate regime of discipline—of departments, budgets, rules that seem much firmer than in the academic bureaucracy.
2. *license and indulgence*—within the boundaries, any personal eccentricity is borne with respect; we are walking affirmations of talent, or what it is supposed to evoke behaviorally—unpredictable, irresponsible, but disciplined in scholarly output. Here a patrician trust model seems to be working—we are entitled beneficiaries, expected to be a little difficult. We are also part of the Getty expenditure—its collected valuables, at least temporarily.
3. *veils*—we only gradually discover of what larger entity we are a part, and what the grand design is (we think there must be one, but it always remains a mystery and partially viewed by us). The Getty has the aura and celebrity conferred by wealth—as with its

namesake—but among older institutions the Getty still remains unestablished and undefined, either in L.A., nationally, or internationally (which seems to matter most to it). It is still getting its clout together, and in the meantime has a certain amount of status anxiety that extends to keeping its "live" stock—the scholars on their pedestals, who indeed are carriers of the Getty's reputation in academic networks—in the dark. The struggle for status in high-culture worlds should probably not be allowed to show in the Getty's presentation of self to us as powerful benefactor.

So while the vantage point of scholars at the center is certainly not panoptic in relation to the many interests—corporate, scholarly, artistic, secretarial, security—of this complex organization, it can provide illuminations concerning the Getty's explicit pursuit of high culture in the United States and what that more popularly means for those of us who, by being there as scholars or as corporate bureaucrats, bask and share ambivalently in its claims to the "finest" that Western civilization has had to offer. The Getty, like many now well established American cultural institutions before it, is in the nervous, getting-started phase of creating legitimacy for itself—a phase that reveals its affinity to a petty-bourgeois tradition of earnestly pursuing objects of high culture. The fascinating question is whether it will be as lucky in the particular historical era of modern culture in which it is being born as were its predecessors of the late nineteenth and early twentieth centuries.

In presenting a few selected illuminations from my time at the Getty, I want first to establish the basic identity between J. Paul Getty and those who manage his legacy. While not heirs by blood, these managers and scholars are certainly heirs to Mr. Getty's pursuit of taste, who, to slightly alter Andrew Ross's comment on Leslie Fiedler's attitude about the Rosenbergs, have little choice but to take "art" and its signifying codes too seriously.

TASTE AS A FLOATING SIGNIFIER

The argument made in this paper can be compared with Pierre Bourdieu's influential sociological study (1984) of judgments of taste and the production of class identity in contemporary France.[3] My analysis and Bourdieu's share a similar center of gravity: the broad-based, per-

meably bounded petty-bourgeois category and the key importance of variations in tasteful consumption in constituting class identities and fantasies among those whom one might want to so categorize. But for Bourdieu, there is a real apex of aristocratic or upper-class taste in French society, which, however mythical and mystified it may be in the late twentieth century, nonetheless is something substantive and distinctly "other" for petty-bourgeois consumers, and, indeed, for Bourdieu himself.

Bourdieu seems unaware that those same French petty-bourgeois persons/consumers in various specialized settings of work are indeed the contemporary creators and producers of things highbrow at the very top of the hierarchy. Bourdieu's almost self-conscious and ste- reotypical application of sociological methodology (questionnaires, interviews, sampling) addresses only the production of values in tasteful consumption. My equally self-conscious and stereotypical ap- plication of ethnography is about how the variant tasteful consumers of high culture among the American middle class are, in one focused setting, through a complex division of labor, also the producers of high cultural value in a cultural/corporate organization that, while distinguished by its singular wealth and founding, is not *so* different from other organizations that have long produced high-culture values in the United States.

In France, a class analysis is still possible, and certain hierarchies of taste form on the belief in a highbrow upper class or aristocracy that actually still lives and breathes high culture as a condition of everyday life. In the United States, high-culture organizations and set- tings still require a hierarchy, but it cannot be firmly based on a per- ception that there is integrity at the top of the class/taste pyramid. Activity at the Getty, for instance, in bidding to create value at the top of the hierarchy, all too often reveals the petty-bourgeois character of this enterprise. Still, the intimidations of wealth, the strenuous re- quirements of technical scholarly knowledge, and the behaviorial mystifications and signs of connoisseurship are always strong enough to defeat the possible subversions and lapses of moments of exposure and possible illumination as will be described in this paper. Simula- tions of European distinction are successfully achieved.

The alternative possibility would be for the middlebrow to make the highbrow finally its own, to live in comfort with it, less seriously, more securely, and more interestingly. This is unlikely to happen at

the Getty, however illuminating its working conditions are relative to the contradictions of trying to establish distinction and create hierarchy in an American setting. Instead, the explicit development of the intimate, unacknowledged role that the middlebrow has played in the creation of highbrow taste seems to be one of the possibilities, and perhaps one of the motivations, that might be read into the much-noted contemporary desire within the realm of so-called postmodern culture (Connor 1989) to fuse, without regard to their separate histories, high and low culture, the highbrow and pop. This is apparently not a job for aristocrats, the high bourgeoisie, working classes, or ethnic minorities, however, but for the middlebrow, petty-bourgeois middle class, itself distinguished by an often-unacknowledged distinctive popular culture of its own that is shaped by earnest highbrow aspiration and learning. The petty-bourgeois middle class has long been the main producer of high culture in America, but without a sense of its direct experience and creation of it. Once the spell of seriousness, of earnestness, is broken—perhaps initially by a postmodern strategy of fusing high and low—the venerated objects of Western tradition might then develop new possibilities of meaning and expression in the contexts of the lives that its middlebrow, petty-bourgeois admirers and caretakers actually live, for example, in a setting such as late-twentieth-century Los Angeles.

J. PAUL GETTY AND HIS L.A. HEIRS

It has long been my belief that some important generalizations may safely be made about art collectors and collecting.

First, I firmly believe that almost anyone can become a collector, and that he or she can start collecting at almost any period of life. One need not be an expert or have large amounts of time or money to start an art collection.

Second, I hold that few human activities provide an individual with a greater sense of personal gratification than the assembling of a collection of art objects that appeal to him and that he feels have true and lasting beauty.

Third, I maintain that the true worth of a collection cannot—and should not—be measured solely in terms of its monetary value. Artistic merit does not necessarily follow the values set in the market. Although price tags can be—and are—attached to works of

art, the beauty an individual sees in an object and the pleasure and satisfaction he derives from possessing it cannot be accurately or even properly gauged exclusively in terms of dollars and cents.

Last, I am convinced that the true collector does not acquire objects of art for himself alone. His is no selfish drive or desire to have and hold a painting, a sculpture, or a fine example of antique furniture so that only he may see and enjoy it. Appreciating the beauty of the object, he is willing and even eager to have others share his pleasure. (Getty 1965)

The following are miscellaneous items listed among the "Personal Effects of Mr. J. Paul Getty" on his death in 1976:

3. Book—*Stale Food vs Fresh Food*, by Robert S. Ford, B. S. 5th edition.
5. United States Steel—scissors and letter opener presented to Mr. Getty by *U.S. News & World Report* to mark appearance of the 1976 advertising program.
6. Book—*Mother and Child—100 Works of Art with Commentaries by 106 Distinguished People*. Compiled by Mary Lawrence, preface by Helen Hayes.
14. Book—*Critical Issues in Public Relations*, by Hill and Knowlton Executives.
16. Boxed plaque of the Ten Commandments encased in a purple velvet envelope (lined).
20. Course in Bar-bells.

Quite like Julius and Ethel Rosenberg, J. Paul Getty was an "ordinary" person of the same era in American history who took "legitimate" culture very seriously.[4] Extraordinary wealth merely permitted him to distort the same tendency. At the time of the Great Depression, he began collecting objets d'art at bargain prices, eventually turning his Malibu ranch home into a museum after leaving the United States for permanent residence in Europe in 1951. Acquiring art with much advice from European art dealers and museum professionals, Getty collected in the manner of a great bourgeois connoisseur of the late nineteenth and early twentieth centuries—he mixed classical antiquities with pre-1900 painting and decorative arts. His collecting was Hollywood-ish in its imagining of Western history. Indeed, in his co-authored *Collector's Choice* (LeVane and Getty 1955),

he fictionalized the ancient life of some of his Roman pieces. Still, he had first-rate academic curators working for him, who operated effectively within the constraints of his earnest yet economizing taste.

The situation with his heirs at the Getty Trust is perhaps more complicated, but not all that dissimilar from Mr. Getty's uncomfortable assumption of the role of connoisseur. The definition and appreciation of "fine art" control image, style, and self-presentation for workers at the Getty. There is simply much more status anxiety at the Getty about levels of sophistication in connoisseurship than there was for Mr. Getty himself, who was protected by the power of his wealth and could intimidate and silence all those with whom he came into contact. His legacy is in part the relative freedom of his "heirs" at the Getty Trust to make light of his taste so that they can take theirs all the more seriously. Indeed, the present-day Getty is full of such tensions, as individuals measure themselves against each other according to a mystified standard of connoisseurship. The most important tension in this regard is between the "authentic" Europeans at the Getty and the "inauthentic" Americans, or the Americans who can "pass" only as a result of breeding or years of education.

The fact that the Getty predominantly collects and studies classic European art, certified as such by an art market and an establishment of art historians, means that the mystique of connoisseurship is all the more settled, studied, specialized, and, indeed, substantive. An informed opinion about Getty collections really does require an intimidating degree of knowledge, so that a hierarchy, based on refinement of taste concerning these objects, easily forms. If the Getty speculated on the current avant-garde, or art of the moment, or even classic American art, then the attribution of connoisseurship would likely be a much more open sort of status game. Cultural authority would not weigh as heavily.

Yet it would be wrong to give the impression that this atmosphere where high-culture taste reigns is stuffy or is one in which the worth of individuals as cultured persons is cruelly differentiated. Certain individuals are viewed as "geniuses," who can communicate the wonder of art, or as having refined skills—a good eye or feel for details of certain kinds of art—or as having mythical backgrounds of privilege in which they grew up with great art, that is, as embodying the real thing, as being connoisseurs. But mostly there is an acceptance of the character-affirming value of appreciating high art. In other

words, the tone within the Getty is overwhelmingly American middle-brow, in which the ideas of art appreciation and self-improvement are of key importance.

The pulse of an organization that continually spends is in its acquisitions, particularly of master works. The latest "coup," the secrecy surrounding its public announcement, and the professional and media response all are part of a drama of assessment and evaluation that is discussed, in various contexts, by administrators at Century City, scholars, guards, technicians, and assistants. These internal discussions, speculations, and judgments about acquisitions reveal the status anxieties that prevail throughout the Getty, for this is where middlebrow and connoisseur investments in the wonder of art objects are most put at risk.

A RENOIR ACQUIRED

For Release Immediately, April 5, 1989. Lori Starr, Head of Public Information.
GETTY MUSEUM PURCHASES IMPORTANT PAINTING BY PIERRE-AUGUSTE RENOIR
The J. Paul Getty Museum announced today that it has acquired one of the most beautiful and important of early Impressionist paintings, *La Promenade*, by Pierre-Auguste Renoir (1841–1919). The painting was sold at auction by Sotheby's in London yesterday and had been the property of the British Rail Pension Fund. "We are overjoyed to have the picture. It is one of Renoir's most delightful works, and it comes from a great moment in the history of painting," said Museum Director John Walsh. [The story announcing this purchase in local newspapers emphasized the $17 million paid for this painting.]

Prior to this announcement, and in the final stage of acquisition, the deal was presented to the Getty Trust Board, at that point composed mainly of prominent L.A. financiers, for approval. It had been the task of one board member, an elderly man with a distinguished career as a museum director, art scholar, and collector, to serve as liaison between the board and the Getty Museum director and to make the case to other members of the board for acquisition. While I was never party to such meetings, the skill of this crucial connoisseur

manager was to balance and interrelate two discourses of value—that of the wonder of art and that of profit, or of the "bottom line" objectives of nonprofit organizations.

Following board approval and public announcement, John Walsh provided a briefing for Getty staff only in the museum auditorium. This was a slide show, in which the special qualities of the acquisitions were described by Walsh in a professorial way. The dual message was one of transcendant value and wonder in these acquisitions, as well as of their importance to the health and progress of the Getty as an organization. This was the discourse of wonder in the service of high culture. Like the History of Art 101 lectures with the great Vincent Scully that I remember from undergraduate days at Yale, Walsh sometimes connected, and sometimes did not. With the Renoir he connected—the slide was glimmering and brilliant, and his enthusiastic description/reaction to the painting enhanced the slide.

Several days later, a group of the Getty visiting scholars were touring the back restoration rooms of the museum, and came upon a ragged, colorful little canvas lying on a table. There was a sudden recognition and shock that this was the Renoir "in the flesh," so to speak, but on its operating table, it looked nothing like the slide seen at Walsh's lecture. The reactions of the scholars were interesting: various expressions of wonder in reverse. A German art historian was embarrassed by this unadorned, unframed masterpiece, and he could only whisper that the Getty had been "had"—it got a bad Renoir. Another historian present, with no art background but with a well-submerged radical-left past, and who had been intimidated by the Getty and its serious pursuit of the beautiful, was shocked by this unmade-up masterpiece, noting with a vengeful humor that it could be mistaken at first glance for a $17 million painter's rag.

Aside from the bedrock class basis of true connoisseurship, that requires both breeding and great wealth, the aspects of the connoisseur that can be acquired by "ordinary" people is first a discourse and response of wonder, free of context, to sacred relics of art (Greenblatt 1991), and second an obsessional appetite for detail and fine point that requires heightened visual and tactile skill. The middlebrow seriousness that attaches to high-culture art depends on the relative claim to and embodiment of these two aspects of connoisseurship. Close attention and responses to the transformation of the sacred objects in acquisition and preparation for display, such as those just de-

scribed, constitute Erving Goffman–like (often backstage) moments, when the middlebrow construction of high culture, as the everyday at the Getty, is likely to become undone. But far from these moments being dangerous to the moral order of sociality, as Goffman might have it, they are instead moments of illumination, when the question of the petty-bourgeois taste of American intellectuals and high-culture specialists could be explored and new initiatives in cultural politics that Andrew Ross envisions might finally become a real possibility.

OTHER MAGICAL MUNDANE MOMENTS

The Getty's ambitions for the production of European high culture can only be achieved by a carefully planned order in which certain clear boundaries are maintained between scholarship and corporate concerns, between culture and money, and most importantly, between the inside concerns with high cultural production in the realm of Old World European history, and the outside contemporary conditions of late-twentieth-century New World culture in southern California. Potential moments of critical illumination arise in the course of Getty activities (particularly those that might be observed and experienced by me, situated as a visiting scholar) when, as frequently occurs, boundaries are blurred and transgressed, and, in the conception of the anthropologist Mary Douglas (1967), a state of pollution (and danger) exists. What is held apart becomes connected or juxtaposed. The cultural outside of the middle- and lowbrow intrudes or suddenly appears within the Getty environment. High art appears more mundane backstage than the aura created for it, as in the case of the acquired Renoir; or, as in the following anecdotes, ironic or uncomfortable juxtapositions can raise questions, even if only for a moment, about the course on which the Getty has set itself, and more importantly, about the integrity of the kind of cultural hierarchy of taste and value it supports. These moments, arising in the planned aspects of programs, create a certain magic for critical consciousness at work in and on the Getty. Anecdotes like the following—a long excerpt concerning a challenging parallel to the Getty, and two short takes— in which the Getty self-image is adulterated to varying degrees by more or less playful transgressions of boundaries, provide the insight for alternatives to something other than a too-serious, petty-bourgeois approach to high culture.

"SUBVERSIONS"

The dissonance experienced by scholars living and working in a combined contemplative/corporate environment at the Getty is registered in a number of ways: some practice a studied indifference to their environment; those with left/liberal or Marxist reputations are probably the most uncomfortable with the honor and luxury showered upon them by corporate (albeit nonprofit) largesse. This dissonance results in mild subversions and critiques, offhand wry remarks about their conditions, and perhaps an occasional act of rebellion against the "rules." During my year, the most interesting though perhaps unintentional case of such critique of the Getty's very purpose and desired self-representation came in the form of discussions of an eccentric project similar to that of the Getty being pursued by one of the visiting scholars, a Swiss art historian, who for many years had been at Florida State University in Tallahassee. On several occasions, he spoke informally to us about his Nautilus Foundation, which, always with dry humor that blurred the line between parody and earnestness, he presented as a sort of "counter-Getty." Finally, he gave us a formal lecture on his project, a copy of the text of which he passed to me with the inscription "for George's indiscreet archive." I present extended excerpts from this fascinating document:

The Nautilus Foundation and Its Precedents

In 544, Cassiodorus, former minister at the court of Theodoric the Goth, ruler of Italy, retired to his family holdings near Catanzaro to serve the floundering *Latinitas*, and especially to preserve and transmit texts of the Christian Fathers in a disintegrating society. In 1970 I bought 161 acres of densely wooded land near Tallahassee with the intention to create a community of scholars, innovative thinkers and artists and eventually decided to create a nonprofit Foundation dedicated to the survival of the Humanities in a declining age. Details of the circumstances which led to the eventual construction of the facilities of the Nautilus Foundation parallel past experiences of medieval cultural foundations so vividly that they demand a brief analysis of the history and characteristics of precedents.

Cultural centers, be they abbeys, academies or private learning establishments, are based on the mistrust of existing power struc-

tures and assume the perfectability of humanity through sets of criteria defining and demanding excellence. Excellence implies the preservation, transmission and creation of objects, ideas, and patterns of work which are so fundamentally useful as to guarantee their existence over time. . . .

The motivation for the founding of Nautilus closely parallels the history of institutions which originated in periods of decline, including ours, in which vigorous learning and contemplatively active innovation were and are considered as elitist. The increased urgency toward the development of bodies dedicated to creative and global relevance, such as the Club of Rome, became obvious after the negation of the Geneva Convention through the continued manufacture of nuclear weapons, surrogate wars such as Viet Nam and Afghanistan and the increasing poisoning of the planet, which clearly signalled the failure of the second postwar generation which was to initiate the Age of Aquarius. . . .

When Reagan was reelected in 1984 I began to feel like Benedict, ready to roll in thorns to chase away obscene horrors. The times demanded an anti-bomb, a coenobitic fortress of thought, a stable institution which would attract settlers and visitors in search of an intellectual "maquis." The Nautilus, a magnificently proportioned (Fibonacci series) ever-expanding shell, would become the symbol of a Foundation which would preserve artifacts and documents of the past for the children of the future, and through symposia, performances, tutorials and fellowships generate solutions addressed to uncertain times. We planned a crushed car mobile to celebrate the end of the industrial age; installed a large painting exhibit for the education of termites, who ate the art; defended ourselves against poachers, vandals and thieves; built Steel Henge; and more seriously tried to evaluate the criticism levied against us by a human of the future, who saw us planning a fortified shell, preserving fetishized scraps of writing and cult objects of adoration which necessitate their evisceration in order to embalm them and which should be attacked with explosives. . . . We began target practice, caught poachers, wrote bylaws, elected trustees, received nonprofit status on July 18, 1988, and guided by Cassiodorus, defined our aims. . . .

When, in the spring of 1989, I was invited to the Getty Center, which is now in full planning for a large facility on a prominent hill

overlooking Los Angeles, I was delighted to accept since it would also allow me to compare two similar developing institutions with historical precedents, and to analyze the reasons for the continuity, growth or demise of focussed and independent cultural centers. I decided to observe the strengths and weaknesses of the Getty, the Nautilus and other institutions through a 500-year lens, or in other words a timespan that would highlight and almost caricature as many physical and societal changes, obstacles and mishaps as possible. These could range from the greenhouse effect, water and food shortages, and breakdowns in the technological infrastructure, to possible violence and vandalism of an impoverished society. In short, I attempted to visualize the worst scenarios of Murphy's Law. . . . Thus armed with our semi-millennial lens, it might be of interest to the Nautilus and J. Paul Getty Foundations, now in nearly identical planning stages, to tentatively assess our strengths and weaknesses and thus to gauge our long-term chances for success.

The Getty will have 1 million square feet and cost $300 million. The Nautilus Trivium and audiovisual building will have 10,000 square feet and cost $300,000, that is, 1,000 times less, or 10 times less per square foot. The Getty's hill location, with its numerous structures, will make it highly visible. Its long access; open plan; extensive, landscaped squares; and lack of water on the site will make it technologically dependent and more vulnerable to vandalism or mob attacks by a volatile population from the nearby megacity, which, threatened by a major earthquake, may experience a renaissance, or develop into a huge slum. Its fully blown, extraordinarily rich program will require a staff of 600, which in a stringent emergency could be reduced to 100 including guards and groundkeepers. Fencing or high walls seem a last resort for either of the two institutions, which by definition should remain hospitable and benevolent.

In contrast, Nautilus is tucked away in the boondocks, and, short of a minimal supply of electricity, autonomous. The three buildings, the longest of which measures 157 feet, are close together, energy friendly, and can, if need be, be turned into easily defended "soft" fortresses. . . . The weak financial position, which must be improved, and the eccentric geographical location might preclude the

hiring of extraordinary talent, which will have to be lured to the Foundation through a challenging, solidly international reputation, which in the long run is a must for the survival of any cultural institution. Finally both centers must have the facilities for large public festivals, such as concerts and contemporary or traditional theater, necessitating toilets and in our case voluntary student clean-up squads.

The long-term minimal and absolutely essential expenses for the Getty over 500 years will have to be about $10 million annually, adding up to $5,000 million or $5 billion, that is, $27,397 daily, while the 500-year Nautilus minimum budget will require $50 million, or $274 a day, here again 1,000 times less.

All cultural institutions intent on independence from an often unpredictable, even whimsical government control contain a streak of utopia, and their future is heavily tied to social and economic ups and downs which could extend, at worst, to a confiscation of assets and eminent domain expropriation, such as a transformation of the facility into a quarantine station. *The future of both institutions will therefore heavily depend on program flexibility; a vital, exciting and relevant response to societal needs; and the ability to expand or contract. In Benedictine terminology the institution must avoid sin defined as asocial behavior.* [emphasis mine]

In the present and it seems future American society, governed by ever more aimless mediocracies in charge of an ever more passive and uncertain voter population and wounded, ever more indigent consumers, it will be even more essential for cultural institutions to preserve excellence. They will have to continue to provide extraordinary artifacts, innovative ideas, and brilliant creations, which will have to be vital enough to remain useful engines for human development over time.

Without fake nostalgia or arrogant sentimentality and giving at least the appearance of elegant simplicity, the original aims of their mission will have to be reaffirmed over and over again. Only then will large institutions be forgiven arrogant humility, while poor ones will be allowed humble arrogance. . . .

Is this a send-up, or what? A question that neither I nor anyone else at the Getty could answer with certainty, and thus a tribute to the

skills of this scholar as visionary and cultural critic. We can see that the author is one who takes high culture very seriously, but not too seriously. This kind of parody tied to passionate vision is precisely what is out of place and critically effective at the earnest Getty. The author offers for discussion within its confines a more extreme version of itself, bringing out reflexive issues of historic moment and social context in which the Getty exists, but that it does not confront. The Nautilus, for all its eccentricity, at least does not commit the Benedictine sin of asocial behavior, as its director says.

The author is clearly on the side of high culture in the Western tradition and protecting it from adulteration by the conditions of late, or post, modernity, which is obviously for him a form of new and threatening barbarism (although in the frame of all the classic references, he mixes avant-garde inclinations and installations).

However, unlike the Getty, this eccentric preserver of high culture is very attuned to his social context of rural Florida and to the Getty's of urban Los Angeles. He tries, at least, to make the great tradition respond to its times. Like the Getty, but more explicitly, the keynote is elitist separation and autonomy from the polluting environment of late modernity. Ideologically stronger than the Getty's rhetoric of purpose, the author's vision does acknowledge the specific contemporary conditions under which the tradition of highbrow must be sustained. The Getty, perhaps wisely, articulates no such vision about its times or the society in which it has been generated.

The author sees his own fortified palace of high-culture treasure to be more shrewdly adapted to troubles ahead and all around than the Getty's. In a very distorted mirror, his project holds up to the Getty, with which he is aligned and sympathetic regarding the integrity of taste and highbrow aesthetics, the dangers that it does not choose to face. If the ominous cultural conditions outside are not inside, then they are menacingly at the gates. This nightmare vision of the return to the medieval in late-twentieth-century America, when juxtaposed to the rather more mundane aspirations of the Getty, might jolt one into thinking about the latter more realistically, in contrast to the Nautilus Foundation in the swamps. Who, after all, one might ask the director of the Nautilus, has created, inhabits, and oversees the Getty, if not neobarbarians?

"A FESTIVE NIGHT AT THE VILLA"

Major fine art museums in this country frequently have an alternative, usually after-hours function as the extravagant setting for social events, including dining, dancing, and music. These events, while sometimes held in connection with charitable benefits, often are private, elite functions for important and powerful persons who are patrons or trustees. The Getty is no exception, and in fact the Roman villa that is its museum provides an especially fantastic setting for dinner parties and receptions. However, there is one annual occasion at the museum—the Christmas Party—that in carnivalesque splendor brings all the Trust's personnel together and reveals it in a way that no other activity of the organization does. On this one night, the villa is open to all the personnel of the Getty and their guests and families. Board members, directors of programs, scholars, curators, janitors, guards, technicians, and accountants mingle amid the gardens and atria of the museum, enjoying lavishly catered food and a variety of music options: carrolling around a piano along one colonnade, dancing to rock music along another, elsewhere a classic quartet, and ballroom dancing to the music of a big band era combo. For this one night, many taste, in a garish, brassy way, the sort of pleasures that the powerful at the Getty can enjoy more routinely.

The Christmas Party is clearly a production of what I have been calling the middlebrow social conditions behind the the otherwise highbrow front of the Getty. It is a tribute to the Getty as an organization that it has enough of a sense of humor to lower its middlebrow guard and to reveal spectacularly in carnivalesque its thoroughly American, L.A. makeup, and this amid, and in the shadow of, the precious objects that define its serious effort to preserve high-culture values. On no other occasion at the Getty is there such a massing of its diverse personnel, among whom there is a thorough mixing. It is perhaps only the music options that show any sorting-out by class and standing—for example, the director of the museum leading trustees, other directors, and administrators in carolling, as guards, younger assistants, and technicians boogie to rock.

No one would want to claim that the Getty is an egalitarian place—various sorts of cultural and corporate hierarchies thrive in this organization—but the mere unselfconscious spectacle of this event attests to and reveals, however momentarily, the relatively unmystified

nature of the hierarchy at the Getty. Connoisseurs and sensitive schol-
ars abound, but they do not define an aristocratic apex to the hier-
archy. Rather, the center of gravity seems to be, as argued in this
paper, in the earnestly middlebrow tastes of petty-bourgeois, Ameri-
can consumer culture, as evidenced at the party by the choices in
music, food, and company all mixed together within the elegant con-
fines of J. Paul Getty's scrupulously authenticated replica of an arti-
fact of the wonder that was Rome.

"A FIELD TRIP TO THE HOME OF A BEVERLY HILLS VULGARIAN"

A wonderful feature of the visiting scholars' year at the Getty Center
was periodic field trips, organized by the center staff, to sites that
might be of interest to historians of art, such as the visit to the Hearst
castle in San Simeon, and an architectural tour of Los Angeles homes.
The latter included a privately arranged stop at a Beverly Hills estate,
formerly owned by Harold Lloyd but now the property of Ted Field,
an heir to the Marshall Field department store fortune and a success-
ful movie producer. The personal assistant who took us around the
mansion and grounds made it clear that we were being granted a rare
privilege. The scholars expected to experience an exemplary token
of mythic Hollywood vulgarity, and they (we) were not disappointed.
My own memory of the tour recalls the flash of chrome in the machin-
ery of the crowded weight and exercise room, the bar and lounge
decorated with movie posters of Field's successful projects, a chil-
dren's playhouse that adults could walk around in, a pack of great
danes as big as deer, and a stately interior of living and dining rooms
that hardly looked lived in. The walls of these latter rooms were cov-
ered with large Italian paintings, and at the base of each painting on
a table was a coffeetable type book on art history opened to the page
that had an illustration of the painting on the wall.

The visitors endured with forebearance the condescension that
seemed to be shown by their guide, as if they should be reverent and
grateful for being allowed into this palace of "tastefully" expended
wealth. But the mode of authenticating the paintings on the walls of
the living and dining rooms was too much. Whispers were audible
and smirks were hard to repress. This literal flaunting of high-culture
possession in the realm of the lowest of the middlebrow was one of
those telling moments, when an extreme (this time, vulgarly ex-

treme) distorted mirror was held up to the Getty. Just as the account of the Nautilus Foundation confronted the Getty from within with a fantastic, paranoid, and apocalyptic version of its own committed high-culture aspiration, so the flaunting of authentic high art to a momentarily captive group of Getty visitors gave it a distorted version of the serious middlebrow dimension of its own high-culture aspiration.

Another boundary was momentarily transgressed here, however easy was this effort at high-culture taste to ridicule, dismiss, and distance. Still, the paintings were after all authentic—they might have been desirable museum pieces. It was just that their location and manner of presentation was so offensive. Here, for a moment, one "serious" collector faced another. The moment passed, but not without a register of discomfort, in the acknowledgment of a slight kinship between the middle-highbrow of the Getty and the vulgar-middlebrow of the Field mansion. The art of the Getty and the art of Ted Field are somehow part of the same broad popular culture of highbrow taste located in the history of Western art: authenticated and written about by recognized scholars, experts, and connoisseurs employed by the Getty or made use of by Field.

THE BUZZ OF POP—HOW THE OUTSIDE IS PRESENT INSIDE

Actually, corridor talk at the Getty is not about Europe, nor does it take the form of academic gossip in the main. Rather, it is mostly about Los Angeles and its diverse and strange cultural ways, which the Getty's employees and visitors otherwise inhabit. While European high culture is the organization's object and the subject of its plans and projects, the teatime and coffeebreak concerns of the Getty are with the buzz of pop and ethnic culture, new restaurants, music, clothes, movies and the movie business, and contemporary art and architecture, which surround the Getty and define the spaces among its current locations, but do not formally penetrate it. Evidence of Los Angeles is nowhere to be seen inside the physical confines of the Getty, but, contrastingly, it is everywhere to be heard.[5]

It is perhaps most ironic that the European visitors at the Getty (eight out of ten scholars during my year, as I mentioned, and a steady flow of more-temporary visitors) were, with some exceptions (those, the few, who buried themselves in their studies), the most single-mindedly interested in the metropolitan culture outside the

center and museum. They spoke often, usually in either impassionedly critical or enthusiastic terms, about the landscape, speed, climate, and amorphous urban character of L.A., trying to fit European models of the city and the role of culture to it. For example, the fact that the new Getty complex is being constructed on a hilltop cut off and out of sight is deeply disturbing to some of them, who see it as the responsibility of a great cultural institution to be prominently located—perhaps along the central area of Wilshire Boulevard; but they are defeated finally in their efforts to define a center or organizing point for the city. The inability to do so keeps their curiosity projected outward, just as they pursue specific research into classic periods of European art and history within the remarkable collections and library holdings of the Getty.

The limitation of this quite-salient European bringing-of-the-outside-in at the Getty is that it is purely recreational and exotic—few take the pop and subaltern cultures around them as objects of sustained reflection as they do their own traditions, however fascinated they are by the former. They "pump up the volume," so to speak, of internal talk about the external at the Getty, but they do not make a fusing or serious connection between the high and the low. This might rather come from among those who are the continuing workers at the Getty, that is, from among the petty-bourgeois Americans with serious middlebrow interests in things of high culture. At present this connection between their daily concerns outside the Getty as residents of Los Angeles, and their otherworldly ones inside, is only made as corridor talk—accidentally, ironically, embarrassedly, and, occasionally, humorously. The critical issue for an imagined, progressive, but offbeat agenda for the Getty would thus be how the middle-highbrow of the Getty inside might be recognized and articulated as such, and then be merged explicitly with the low pop of its immediate environs, which constantly intrudes anyhow as everyday life experiences of Getty personnel.

NOTES

1. To be accurate, I should note that the exceptions to the predominant interest in European "fine art" before 1900, defined by J. P. Getty's personal pattern of collecting, are the museum's emerging collection of Pre-Columbian art, and an ambitious effort in photography collection, including American photographs. Further, there have been some minor efforts, following my stay, in the form of seminars and visitors to the Center for the History

of Art and the Humanities, to discuss ethnic art in contemporary Los Angeles and to support the recent (multicultural) Los Angeles Festival. The Art Conservation Institute is often concerned with projects in Asia, and, particularly, Latin America, and the Getty Grants Program does fund a diverse array of individual scholars' projects. Nonetheless, all of this is marginal to the main direction of Getty spending and collection.

2. For a more systematic ethnographic treatment of the Getty, see Marcus 1990. Being an organization of great resources, ambition, and sensitivity to how its projects are perceived by a broad range of constituencies, the Getty continually changes. Certainly, the changing composition of the Scholars Program each year affects somewhat the precise atmosphere of at least the Getty Center for the History of Art and Humanities. However, in the five years since I resided at the Getty Center, and in the two years since I have written this paper (at this writing, it is the fall of 1993), my major argument and most of the conditions that I describe still hold (e.g., on the perennial and symptomatic discontents of the scholars, see the *Los Angeles Times* article by Amy Wallace [1993]). Still, it is worth pointing out some of the distinctive changes that have occurred since 1988–89. This review is facilitated by the inclusion of Getty scholarly "alumni" among those who are regularly mailed Getty public relations communiqués. Recently, I received the Trust's Annual Report for 1991–92, the second of its kind and a useful, fascinating document for my purposes.

—The design of the monumental hilltop Getty Center was formally made public in 1991. Under construction, the center is now scheduled for opening in 1997. The trust offices have moved from Century City to 401 Wilshire in Santa Monica, consolidating in spatial terms the Getty's diverse projects in Santa Monica.

—From the vantage point of my familiarity with the Center for the History of Art and Humanities, the Getty has seemed to pay much more explicit attention to multicultural themes than it did in the late 1980s (e.g., the 1991–92 annual report highlights the work of the Conservation Institute, the one project that has been deeply cross-cultural from the start) and to the mundanely subversive cultural studies movement, which stands in part for the blurring of high-low distinctions in art, aesthetics, and culture. Partially, this is a function of the Getty's habitual following and assimilation of major trends in the humanities and the arts. It also arises from active and calculated (in the best, open-minded sense) response to criticisms that have been articulated about the Getty's programs. And finally, it may have something to do with the Los Angeles uprising/riots, which shook all levels of Los Angeles society. Notably, the 1991–92 report connects a somewhat higher level of community involvement by the Trust with the violence.

—With regard to personnel changes, there has been an important turnover of older trustees with figures such as Norris Bramlett (an associate of J. Paul Getty), Jennifer Jones Simon (the wife of the late Norton Si-

mon), and Franklin Murphy retiring. Notably, the founding, dynamic director of the Center for the History of Art and Humanities, Kurt Forster, resigned, and has been replaced by Salvatore Settis, a scholar of Greek and Roman antiquity as well as medieval and Renaissance art, who was at the Scuola Normale Superiore in Pisa and who was a fellow visiting scholar during my year there.

—The trust's endowment growth continues its modest steady rise. It was valued at $3.85 billion in 1992.

3. The other recent work to which the argument of this paper should be related is Lawrence Levine's interesting *Highbrow, Lowbrow* (1989). While consistent with the interpretation in this paper, particularly with regard to his account of how cultural hierarchy has been established in the United States as opposed to Europe, Levine does not give sufficient attention to the middling category of "middlebrow" and the broad and crucially important twentieth-century petty-bourgeois formation among the American middle class (including most academics who write about these matters) to which it might be applied. It is precisely among the middlebrow petty bourgeois that dramatic and unpredictable shifts in cultural identifications can occur, so as to confound traditional, largely European-conceived analyses of class in American life—especially when the focus of interest is on the broad and amorphous American middle class. What I presume Andrew Ross meant is that the emergence of cultural hierarchy in America, based on highbrow-lowbrow polar distinctions, cannot be fully understood or described until the often-elided term in-between—the middlebrow—is deeply and reflexively probed by those who write about culture, especially in its slavish affinity for and often authoritative construction of the highbrow in American life, as at the Getty, and at its now appropriately venerated high-culture forebears.

4. Given his celebrity from the 1950s on as the "richest man in the world," it might indeed seem inappropriate to label Getty as "ordinary" and class him with the Rosenbergs. He, after all, came from a wealthy Midwestern family, and had made his own first million by his twenties in dealing in oil leases. Yet, it is precisely my point that in relation to character improvement and self-representation, he shared with the Rosenbergs, and many other Americans (including, e.g., the quintessential fictional character Jay Gatsby), the petty-bourgeois desire to be cultured by indulging in a popular culture of gentility and finer things. His resources allowed Getty to indulge this desire more extravagantly than most Americans. But, at base, he shared a seriousness about these matters with many other Americans of very different backgrounds that defines both a fluidity and commonality in the shaping of American class identity, an identity that rests in the condition of petty-bourgeois taste. Once developed by wealth, this taste is just as earnestly enacted as "the real thing," and becomes the ground of fulfillment for similar aspirations among those who populate the institutions that the wealthy petty bourgeoisie found, such as the Getty Trust. By this time, the similarity of cultural origins with the founder is thoroughly misrecognized by and mystified for those who

work for and enjoy the cultural capital of his legacy by so doing. A flavor for the exemplification of petty-bourgeois ordinariness in Getty's family, business, and social life, even as he assumed the trappings of English nobility at Sutton Place, is available in two detailed biographies (Lenzer 1985; Miller 1985) and in his own autobiographical writing (Getty 1963, 1965).

5. One of the distinctive characteristics of elite, wealthy Los Angeles, of which the Getty is certainly a part, is indeed the capacity to deny locale by the creation of enclosed private worlds anywhere and everywhere on the west side of the city.

REFERENCES

Bourdieu, Pierre
1984 *Distinction: A Social Critique of the Judgement of Taste.* Cambridge: Harvard University Press.
Connor, Steven
1989 *Postmodern Culture: An Introduction to Theories of the Contemporary.* Oxford: Basil Blackwell.
Douglas, Mary
1967 *Purity and Danger.* London: Routledge and Kegan Paul.
Ehrenreich, Barbara, and John Ehrenreich
1979 "The Professional-Managerial Class." Pp. 5–45 in *Between Labor and Capital,* ed. Pat Walker. Boston: South End Press.
Getty, J. Paul
1963 *My Life and Fortunes.* New York: Duell, Sloan and Pierce.
1965 *The Joys of Collecting.* New York: Hawthorn Books.
1976 *As I See It.* New York: Prentice-Hall.
J. Paul Getty Trust
1992 *J. Paul Getty Trust Report 1991–1992.* Santa Monica, California.
Greenblatt, Stephen
1991 "Resonance and Wonder." Pp. 85–106 in *Exhibiting Cultures: The Poetics and Politics of Museum Display,* ed. Ivan Karp and Steven D. Lavine. Washington and London: Smithsonian Institution Press.
Lenzner, Robert
1985 *Great Getty.* New York: Crown Publishers.
LeVane, Ethel, and J. Paul Getty
1955 *Collector's Choice: The Chronicle of an Artistic Odyssey Through Europe.* London: W. H. Allen.
Levine, Lawrence W.
1989 *Highbrow, Lowbrow: The Emergence of Cultural Hierarchy in America.* Cambridge: Harvard University Press.
Marcus, George E.
1990 "The Production of European High Culture in Los Angeles: The J. Paul Getty Trust as Artificial Curiosity." *Cultural Anthropology* 5(3): 314–30.

Miller, Russell
1985 *The House of Getty.* New York: Henry Holt.
Ross, Andrew
1989 *No Respect: Intellectuals and Popular Culture.* New York: Routledge.
Rubin, William, ed.
1984 *"Primitivism" in 20th Century Art.* New York: Museum of Modern Art.
Wallace, Amy
1993 "Pampered Scholars Not Pleased." *Los Angeles Times*, July 15, p. A22.

INDEX

Abel, Ernest, and Barbara Buckley,
81n. 21
Abu-Lughod, Lila, 114, 115
Academia Real de San Carlos, 23
Adams, E. Charles, 168n. 4
Aesthetics: low riders, aesthetic de-
velopment of, 105–107; and oth-
erness, 145; and surveillance,
93–96; Zuni, 162, 165–168
Agrarian Leader Zapata (Diego Ri-
vera), **33**
Akwalhi, 162

All Indian Pueblo Council, and Zuni
Shalako mural, 167
Alt, Dr., 24
Althusser, Louis, 147n. 12
Amate painting, 28–30; as arte popu-
lar, 30
American Indian Religious Freedom
Act, 162
Americans for Indian Opportunity,
161
Appadurai, Arjun, 3, 4
Araeen, Rasheed, 168nn. 1, 2

CONTRIBUTORS

BARBARA A. BABCOCK is Regents Professor and Director of the Program in Comparative Cultural and Literary Studies at the University of Arizona. She has authored, co-authored, and edited numerous essays on Southwestern anthropology, on the invention of the Southwest, and on Pueblo art and culture, notably *The Pueblo Storyteller* (1986) and *Daughters of the Desert* (1988). She is presently completing *Stories Told in Clay,* a study of the art and experience of Helen Cordero, and *Mudwomen and Whitemen,* a collection of critical essays, in addition to editing Elsie Clews Parsons's unpublished personal essays about her first years of Pueblo fieldwork.

LIZA BAKEWELL is an assistant professor at Brown, where she teaches courses on Latin American anthropology and linguistics. Her work is in the area of contemporary culture and art theory in Latin America and the United States. She is the co-author of *Object Image Inquiry: The Art Historian at Work* (1988)

and the author of two forthcoming books, *Remembrances of Open Wounds: Betrayal, Nationalism, and the Legacy of Frida Kahlo* (1996) and *The Worthless Women and the Politics of Language: Qué Padre, Me Vale Madre* (1996). She is currently producing a CD-ROM, *Vision and Voice: Rethinking Human Communication*, on language and art.

BRENDA JO BRIGHT is an anthropologist and Mellon Visiting Assistant Professor in the Latin American and Caribbean Studies Program at Dartmouth College, where she teaches courses on Latino cultures in the United States. She is currently completing a book on Chicano popular culture and low rider communities in the Southwest.

GEORGE E. MARCUS is a professor of anthropology at Rice University. He is the author of *Lives in Trust* (1992); co-author, with Michael Fischer, of *Anthropology as Cultural Critique* (1986); and editor, with James Clifford, of *Writing Culture* (1986). He was the inaugural editor of *Cultural Anthropology*. He has started a series of annuals for the University of Chicago Press entitled *Late Editions*, which explores watershed changes in society and culture at the end of the century through the interview form. He is also the co-editor with Fred Myers of a forthcoming volume of critical essays on the anthropology of art.

MARCOS SANCHEZ-TRANQUILINO is an art historian. He has published numerous essays and articles on Chicano art and culture. One of the originators of the landmark exhibition *Chicano Art: Resistance and Affirmation*, he also served as its co-project coordinator, co-curator, and catalog essay contributor. His book *Mi Casa No Es Su Casa*, on the dynamic between Chicano graffiti and murals in the 1970s in East Los Angeles, is forthcoming from Temple University Press.

BARBARA TEDLOCK is a professor of anthropology at State University of New York at Buffalo and editor-in-chief of *American Anthropologist*. Her research has been among the Zuni Indians of New Mexico and among the Mayan Indians of Guatemala and Belize. She is the author of numerous articles and books on language, aesthetics, and art. Her most recent book is *The Beautiful and the Dangerous: Dialogues with the Zuni Indians* (1992).